ART & DESIGN

KU-268-692

EDITORIAL OFFICES:
42 LEINSTER GARDENS, LONDON W2 3AN
TEL: 071-402 2141 FAX: 071-723 9540

HOUSE EDITOR: Nicola Hodges; EDITORIAL TEAM: Ramona Khambatta, Katherine MacInnes; SENIOR DESIGNER: Andrea Bettella; DESIGN CO-ORDINATOR: Mario Bettella; DESIGN TEAM: Jacqueline Grosvenor, Gregory Mills

SUBSCRIPTION OFFICES:
UK: VCH PUBLISHERS (UK) LTD
8 WELLINGTON COURT, WELLINGTON STREET
CAMBRIDGE CB1 1HZ UK

USA: VCH PUBLISHERS INC
303 NW 12TH AVENUE DEERFIELD BEECH,
FLORIDA 33442-1788 USA

ALL OTHER COUNTRIES:
VCH VERLAGSGESELLSCHAFT MBH
BOSCHSTRASSE 12, POSTFACH 101161
D-6940 WEINHEIM GERMANY

CONTENTS

ART & DESIGN **MAGAZINE**

Books • Exhibitions • Latin American Art Symposium

Tina Modotti, Roses, *1925*

ART & DESIGN **PROFILE** No 32

TIME AND TIDE: The Tyne International Exhibition of Contemporary Art
Mike **Collier** Foreword • Corinne **Diserens** Introduction • Brian **Hatton** The Place of Art – The Art of Place • Rémy **Zaugg** • Cildo **Meireles** • Amikam **Toren** • Readymades Belong to Everyone • Rodney **Graham** • Christine **Borland** • Sam **Samore** • **Tunga** • Orshi **Drozdik** • Vito **Acconci** • Shirazeh **Houshiary** • Wendy **Kirkup** and Pat **Naldi** • Gonzalo **Diaz** • John **Adams** • Nan **Goldin** • Raul **Ruiz** Between Two Exiles • Corinne **Diserens** TRANS • Tony **Fretton** • Artists' Biographies

Carlos Anesi, Carigo, *1993*

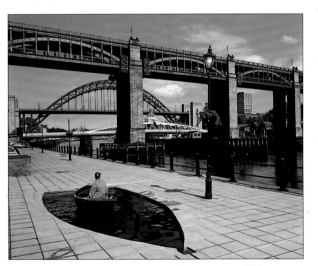

Vito Acconci, Personal River, *boat, pool, waterpump, 1993*

BOOKS

BOOKS RECEIVED:

THE AESTHETICS OF POWER, Essays in Critical Art History by Carol Duncan, Cambridge University Press, 1993, 229 pp, b/w ills, PB £11.95

VICTORIAN PAINTING by Julian Treuherz, Thames and Hudson, London, 1993, 216 pp, b/w and colour ills, PB £6.95

COLOUR HARMONIES by Augusto Garau, University of Chicago Press, Chicago and London, 1993, 76 pp, colour ills, PB Price N/A

THE DAY I GO INTO THE FOREST by Katsura Funakoshi, Kyuryudo Art Publishing Co, Tokyo, 1992, 137 pp, colour ills, PB Price N/A

LOS ANGELES APARTMENTS by Edward Ruscha, Whitney Museum of American Art, New York, 1990, b/w ills, PB £6.95

UTOPIAS AND THE MILLENNIUM edited by Krishan Kumar and Stephen Bann, Reaktion Books, London, 1993, 164 pp, PB £10.95

GERTRUDE JEKYLL, 1843-1932, Museum of Garden History, 57 pp, colour ills PB, Price N/A

REVISION DER MODERNE UNTERM HAKENKREUZ by Andrea Bärnreuther, Klinkhardt & Biermann, 274 pp, b/w ills, PB DM 48.00

HIGH RENAISSANCE ART IN ST. PETER'S AND THE VATICAN, An Interpretive Guide by George L Hersey, University of Chicago Press, 1993, 304 pp, b/w ills, PB Price N/A

SPLENDOURS OF FLANDERS, Late Medieval Art in Cambridge collections by Alain Arnould and Jean-Michel Massing, Cambridge University Press, 1993, 239 pp, b/w ills, HB £29.95, PB £17.95

The books and exhibitions pages in this issue of Art & Design *magazine reflect the recent upsurge of interest in Latin American Art internationally.*

RUBENS, A Double Life by Marie-Anne Lescourret, Allison & Busby, June 1993, 288 pp, b/w ills, HB £16.99.

In her unstinting search for authenticity, Marie-Anne Lescourret has been to all the places Rubens visited studying descriptions by poets and writers of the time in order to recreate the context through which to understand the man. The result is a vivid portrait of Rubens the prolific painter and shrewd diplomat, for although he is traditionally celebrated as one of Europe's greatest artists, he was also one of the Continent's most sought-after secret agents. While working as an artist for the Duke of Mantua, he was sent on his first diplomatic mission in 1603 to the court of Philip III of Spain. Later as the go-between for Philip IV of Spain and Charles I of England he managed to negotiate a non-aggression treaty at a time when Europe was in the throes of the Thirty Years' War. Set against a background of war-torn Europe and court intrigue, Lescourret's study provides a fascinating analysis of one of Europe's greatest master painters.

THE LETTERS OF LUCIEN TO CAMILLE PISSARRO edited by Anne Thorold 1883-1903, Cambridge University Press, Cambridge, June 1993, 796 pp, b/w ills, HB £110.

Lucien Pissarro's travelling gave rise to a substantial exchange of letters between him and his father the impressionist painter Camille Pissarro, the first complete set of which are presented here. Although Camille Pissarro's letters are well-known, Lucien's replies, which describe the world of post-William Morris London, are not. Intimate views are expressed on the work of the Pissarros' now famous friends – mainly painters, writers or anarchist theoreticians in Paris, or contemporary painters reacting to the Pre-Raphaelites and the Private Press movement inspired by William Morris in England. Discussion on current art trends, family matters, and the Pissarros' struggles for recognition can be found in this academic yet intimate set of letters.

THE MOMENT OF SELF-PORTRAITURE IN GERMAN RENAISSANCE ART by Joseph Leo Koerner, University of Chicago Press, Chicago, May 1993, 564 pp, 233 b/w ills, Cloth £47.95/$68.95.

The self-portrait has become a model of what art is, 'The artwork is the image of its maker and understanding the work means recovering from it an original vision of the artist'. Koerner analyses the historical origin of this model in the art of Albrecht Dürer and Hans Baldung Grien, the first modern self-portraitist and his principal disciple. Self-portraiture thus becomes legible less through a history leading up to it, than through its historical sight-line to the present.

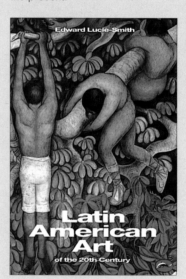

LATIN AMERICAN ART OF THE 20TH CENTURY by Edward Lucie-Smith, Thames and Hudson, 216 pp, colour ills, PB £6.95.

The art of 20th-century Latin America was all but dismissed by European and North American critics on two counts: firstly it was considered to be derivative, imitative of main stream European Modernism and secondly it was regarded as a fusion of traditions weaker than any of its progenitors. Edward Lucie-Smith argues that on the contrary this hybridisation is the root of its vitality and that the close relation between Latin American art and its social and political context, is unique. This political involvement can be seen in David Alfaro Siqueiros' murals where Marxist theory reveals a powerful influence, for others art was a means of communicating their dissent safely. Muralism started in Mexico but rapidly became a Latin American style, Lucie-Smith claims that it checked rather than promoted the development of Modernism. Unlike Muralism the Kinetic art of the 60s is abstract it cannot be used as a vehicle for politics. Other movements analysed are Magic Realism and Expressionism and the 'indigenist' movement. The eloquent and informative text creates a pursuasive arguement for the importance of Latin American art in this century.

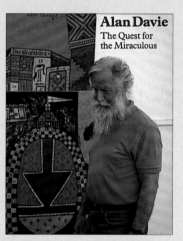

ALAN DAVIE, The Quest for the Miraculous, University of Brighton Gallery/Lund Humphries, 96 pp, colour ills, PB £16.50.

Alan Davie is a distinctive painter, a talented musician, poet and writer. Through the discipline of Zen, Davie overcomes the constraints of the conscious mind, its preconceptions and judgments. Zen advocates the greatest economy of expression to regain unselfconscious perception and reveal the unknown forces which animate our lives. His naive style at first seems culturally specific, vaguely South Pacific but it is the product of a process of actual and abstract assimilation of cultures and emotive images. Davie empathises with the Dadaist Jean Arp, who spoke of how he hoped his work might help people to dream with their eyes open.

BOOKS RECEIVED:

TRADITIONAL ARCHITECTURE OF MEXICO *by Mariana Yampolsky and Chloé Sayer, Thames and Hudson, 208 pages, colour ills, HB £24.95*

LATIN AMERICAN ARTISTS OF THE 20th CENTURY *by Waldo Rasmussen, Fatima Beroht and Elixabeth Ferrer, Thames and Hudson, 416 pp, colour ills, HB £44.00*

TUMI Magazine, *Tumi Publications, 25 pp, colour illls, PB £1.25*

SKELETON AT THE FEAST *by Elizabeth Carmichael, British Museum Press, 160 pp, colour ills, PB £9.95*

THE AIRMAIL PAINTINGS OF EUGENIO DITTBORN 1984-1992, *Institute of Contemporary Art, London in association with Witte de With, The Netherlands, 111 pp, b/w ills, PB £18.95*

TINA MODOTTI, Photographer and Revolutionary *by Margaret Hooks, HarperCollins, 288 pp, b/w ills, HB £25.*

TINA MODOTTI, A fragile life *by Mildred Constantine, Bloomsbury 1993, 98 pp, b/w ills, PB £16.99*

CROSS CULTURAL CURRENTS IN CONTEMPORARY LATIN AMERICAN ART *edited by Sylvia Chittenden de Condylis, Latin American Arts Association, 52 pp, colour ills, PB Price N/A*

DRAWING THE LINE *by Dr Oriana Baddeley, Verso, 176 pages, b/w ills, PB £11.95*

SCRIBES, WARRIORS & KINGS, The City of Copán and the Ancient Maya *by William L Fash, Thames and Hudson, 192 pp, 120 ills b/w and colour, PB, N/A*

TEOTIHUACAN, Art from the City of the Gods, *edited by Kathleen Berrin and Esther Pasztory, Thames and Hudson, 288 pp, colour ills, HB, N/A*

THE AZTECS *by Richard F Townsend, Thames and Hudson, 224 pp, b/w ills, HB Price N/A*

PORTRAIT OF LATIN AMERICA by Mo Fini, Tumi Publications, 1990, b/w photos, 121pp, £13.95.

'A Tumi is a knife with a tapering handle and a distinctive semicircular blade. They first appeared in Peru during the Moche culture (200BC-600AD) and were associated with human sacrifice and war. 500 years later the Incas were using tumi for surgical operations.' Mo Fini choose the name TUMI for his trading company evoking the transformation from exploitive to symbiotic enterprise. It trades with nine South and Central American countries from Mexico down to Chile and its philosophy is based on the fostering of traditional skills, designs and resources and exchanging goods for a fair price. Referring to the book, 'these photographs are a way of introducing the extraordinary communities and individuals I have come to know, love and work with during a decade of travelling in Latin America and the book is designed to give the full story behind Tumi without saying it all in words'.

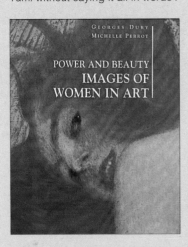

POWER AND BEAUTY, Images of Women in Art by Georges Duby and Michelle Perrot, Tauris Parke Books, London, 1992, 189 pp, colour ills, HB £32.

The authors discuss the fact that women have usually been painted or sculpted by men. They analyse the conditions and fashions under which the images were produced, outlining artistic developments at any given time and questioning whether women now have more power over their image when used in art and in the media. We have become hardened to accepting 'smoking room' Venuses as works of art – the 20th century is surely the first to pioneer the purely aesthetic object.

PHOTOREALISM SINCE 1980 by Louis K Meisel, Harry N Abrams, New York, June 1993, 368 pp, 1,200 b/w and colour ills, HB £65.

Art dealer, collector and Photorealist expert Meisel's first book *Photorealism* published in 1980 received great critical acclaim for documenting an important contemporary art movement. Covering the years since the first volume, *Photorealism since 1980*, it records the work of 25 photorealists. They range from Charles Bell's luminous pinball machines to Chuck Close's mesmerising portraits and Richard Estes' complex panoramas. These are accompanied by bibliographies which catalogue the careers of the predominant photorealists.

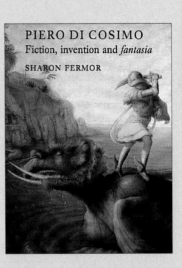

PIERO DI COSIMO, Fiction, Invention and Fantasia by Sharon Fermor, Reaktion Books, London, 1993, 205 pp, b/w and colour ills, HB £29.

As one of the most intriguing figures of the Florentine Renaissance, Piero di Cosimo is an artist whose oeuvre includes works so enigmatic that scholars have traditionally fallen back on Vasari's account of Piero. By identifying the strategies that Vasari employed in his mid-16th-century biography and exposing the misconceptions it created among subsequent writers, Sharon Fermor redefines the nature of Piero's art, and his place within the culture of his time.

Piero's ability to visualise unusual subjects in a vivid and convincing way and his talent for producing pleasing and original landscapes, were particularly valued. She offers new solutions to aspects of function and iconography that have hitherto puzzled critics. 'Nature had filled his soul with a continuously seething fantasy' said Wilhelm Wackenroder. This intriguing fantastical aspect of his work is responsible for its enduring popularity.

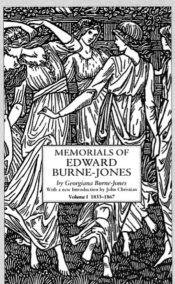

MEMORIALS OF EDWARD BURNE-JONES by Georgiana Burne-Jones, volume one 1833-1867, volume two 1868-1898, Lund Humphries Publishers, London, 1993, 300 pp each, b/w ills, HB Price N/A.

This comprehensive account of the life of the painter and decorative artist Edward Burne-Jones was written by his wife Georgiana shortly after the artist's death. The account begins with Burne-Jones' childhood, his school days in Birmingham and his student days at Oxford. It moves on to describe his lifelong friendship with William Morris and the important influence on him of Rossetti. Burne-Jones was a formidable scholar and antiquarian and took a lively interest in current events: the memoirs include his reflections on a wide range of art philosophy issues.

EXHIBITIONS

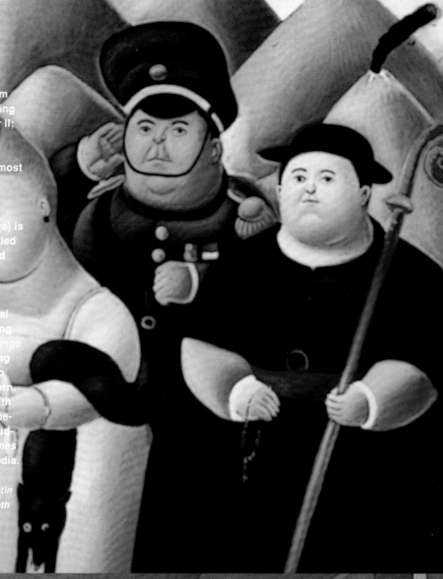

LATIN AMERICAN ARTISTS OF THE TWENTIETH CENTURY, Museum of Modern Art, New York, curator Walter Rasmussen, July- Sept 1993

More than 90 artists are represented in this exhibition through nearly 300 works. From the first generation of modernists in 1914, it follows the development of Latin American Art through to the present day. The exhibition is loosely divided into eight sections: 'Early Modernism' explores the effects of advanced European art, an example of which can be seen in the work of the Brazilian artist, Tarsila do Amaral's *Antropofagia*, 1929; 'Expressionism and Landscape Painting', which comprises of works that evince highly personal interpretations of the European landscape tradition; 'Mexican Painting and Social Realism' demonstrates the variety of ways in which politics affected the art of Mexico; 'Surrealism and Lyric Abstraction' shows the effects of the

emigration of the artists from Europe to the Americas during the years around World War II; 'Geometric Abstraction and Kinetic Art' begins with Constructivism, one of the most important currents in Latin American art; Botero's *The Presidential Family* 1967 (a detail of which is shown here) is included in the section entitled 'New Figuration, Pop Art and Assemblage' examines the variety of means with which artists from the late 1950s onward have created political commentary; 'Recent painting and Sculpture' explores a range of contemporary art including installations by Tunga, Cildo Meireles and Eugenio Dittboim. The exhibition concludes with three installations made especially for the exhibition including a wall drawing, *Star Comes to Light the Way* by José Bedia.

Related publications include *Latin American Artists of the Twentieth Century*, ed Waldo Rasmussen, MOMA, New York

RAMIRO ARANGO & CARLOS ANESI, Durani Gallery in association with the Latin American Arts Association, London, July 1993

Ramiro Arango and Carlos Anesi might have been selected because they present opposite approaches to the treatment by Latin Americans of Western art. For Arango the European masterpieces are essential while Anesi believes that the Western tendency to categorise artists into movements and the resultant race for originality, leads to impoverished work. Anesi reveals his national sensibilities through a rejection of Western art values, Arango expresses his nationalism through his choice of subject matter, 'Pumpkins have been used by indigenous peoples long before the first conquerors stepped on the American continent. This is the element which makes my work an ancestral evocation'. While they are both figurative, Arango's preference for pastels

contrasts with the heavy lacquered effect of Anesi's work and Arango's subtle ingenuity is set against the straightforward simplicity of Anesi's subject matter.

The question of symbolism has largely been ignored by Ramiro Arango's critics but surely it is pivotal to the work of this Colombian artist. If the 'salt cellar' in *La Ultima Cena* ('The Last Supper' shown here) is directly and meaningfully representative of Judas Iscariot then his work is more than a parody, it is a reinterpretation of European methods of representation through Latin American eyes. The eerie 'De Chirico-esque' treatment of space evokes the sinister nature of this event reinforcing the narrative in a refreshingly abstract rather than associative way. Plasticity, a feature of much contemporary Latin American art, is startlingly in evidence here. By reinforcing the substantiality of matter, art functions as a vehicle for

security in the same way that artists themselves tend to become representative of nationalities as the constant in a flux. The cumulative affect of this confidence can be seen in Arango's provocative work which follows in the tradition of his fellow countryman, Botero. The Argentinian Carlos Anesi is a self-taught artist. His painting reveals a disciplined technique and faithfulness to simple themes. Always starting from a monochromatic background, Anesi studies the proportions of the canvases in relation to the figure and seeks a luminosity capable of endowing his objects with a brightness. He seeks originality not through modern methods but by pursuing technical perfection.

The juxtaposition of Arango and Anesi's art in this exhibition, sharpens the senses, enhancing the work of both artists.

TINA MODOTTI, Photographers Gallery, (sponsored by HarperCollins) London, September 1993.

Modotti was a truly remarkable woman, whose legendary beauty, independence and committed political beliefs were to unite her name with some of the most exceptional artists and notorious revolutionaries of her time. Until now the romance and intrigue associated with the myth of Modotti, has threatened to eclipse the unquestionable genius of her art. She was born in Italy in 1896, spent the war years and the early 1920s on the west coast of America, where she married the poet and painter Roubaix de l'Abrie and also became the lover of photographer Edward Weston. She and Weston went to Mexico where she took many of her most famous photographs. Her contact with Mexico's Muralists, including a brief affair with Diego Rivera, led to her involvement in radical politics. In 1929

she was framed for the murder of her Cuban lover, who was gunned down at her side on a Mexico City street. A scapegoat of government repression, she was publicly slandered in a sensational scandal before being actually expelled from the country. Disillusioned and thrown out of the Soviet Union in 1931, she abandoned photography for political activism. She died in Mexico in 1942. 50 years later in April 1991 a world record $165,000 was paid for her black and white photograph *Roses*.

A detailed and fascinating account of Modotti is available in *Tina Modotti – Photographer and Revolutionary* by Margaret Hooks, HarperCollins, (full details in Books Received)

SYMPOSIUM

LATIN AMERICAN ART SYMPOSIUM organised by the Atrium Book Shop as part of a week of Latin American Events

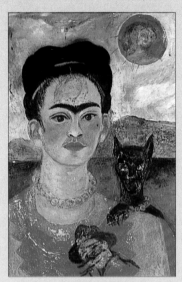

Frida Kahlo, Self Portrait with Diego and My Dog, *1953-4*

Shaunagh Heneage: Is there such a thing as contemporary Latin American Art?

Dr Oriana Baddeley: A logical semantic analysis would posit that since there is art being made in Latin America today, there must be contemporary Latin American Art. The focus then becomes a question of definition: the whole, Latin America, or the part, eg Columbia.

Elizabeth Carmichael: Latin Americans comprise 56 language groups – how can we use a definition of the 'whole'? Change is expressed in Latin American art through urban themes such as pollution and modern materials like acrylic paints and plastics.

Edward Lucie-Smith: Latin American art is made up of overlapping oppositions – it expresses itself through contradictions. The Colombian critic Marta Traba, perceived Latin America as a combination of open and closed countries. Open countries were either costal or easily accessible by water and were thus colonised early. Closed countries are generally landbound, less accessible and thus less influenced by European culture. Traditionally, the culture of the Southern Cone has been analysed through Mexico. A more effective appreciation of what is indigenous to this area would be to let it stand on its own.

Sylvia Condyles: The manifestation of contemporary Latin American Art in the extensive exhibition at the MOMA in New York, makes the question of its reality somewhat rhetorical. The artist in Latin America has a very special position as a visionary and a leader – he reflects society, its values and its images. The Mexican Rufino Tamayo epitomises the synthesis of indigenous and Western traditions that characterises the contemporary art of that continent.

SH: Is the role of the artist in South American different to that in Europe?

EC: The fundamental involvement of the artist in popular art such as the 'Day of the Dead' is not found in Europe anymore.

OB: Only popular art is considered to be an authentic representation of the culture. Latin American artists tread a fine line between the self-consciousness found in contemporary European art and appreciate the values of indigenous popular art. The ability to straddle contradictions and forge an identity makes a contemporary artist.

ELS: Latin American art is amongst the minority of popular arts that continue to evolve. It is not as static as its repetitive nature implies. Ceramics with the Pope's helicopter appeared after the Pope visited Columbia. In a series of collages using urban narrative made by the Argentine artist Antonio Berni, the main characters are an urchin and a prostitute. A reflection of the accumulation of urban debris. The spectrum of Mexican art defies synopsis because it encompasses the folk art of the Mexican artist Frida Kahlo through Rufino Tamayo to artists like Alejadro Colunga.

SC: Surrealism and Expressionism were not intellectually premeditated movements. Although artificially provoked they derive from indigenous feelings which when expressed through art, manifested themselves in a way that could be compared with Western art movements of the time. André Breton reinforced this when he said that Mexico was naturally surrealist.

ELS: Expressionism is the eternal 'anti-style'. Modernism started in the 20s in San Paulo, Buenos Aires and later in Cuba, it was checked by Mexican Muralism which, incidentally, pursues 19th-century ends and is not original – in the 40s Modernism resumed. Latin American art critics dislike my 'menu theory' – bit of this and a bit of that – but through this spontaneous mixture of external inspiration they expressed Latin Americanism. It was not eclectic but used the politics and development of society as its themes.

OB: What kind of a heritage are we building on? Why do we accept the traditional art historical valuations which claim that 1907-10 in France was essential, while marginalising whole areas such as Latin American Art on which there are very few publications?

SH: Because Latin Americans cannot rely on their political system, it relies on its artists to provide a sense and a focus for national identity. Do you anticipate that as we become Europeanised we will do the same?

ELS: It is difficult to draw parallels since art is not detached from real life as seems to happen in Europe.

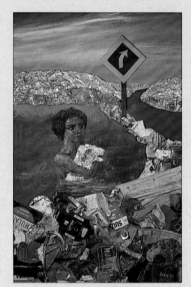

Antonio Berni, Juanito in La Laguna, *1974*

SC: Ecology is a leading theme in Brazilian art. The increasing interest of artists in ecology has influenced a young generation of artists not yet 'recognised'. Elizabeth Gonzalez has organised events around this.

Elizabeth Gonzalez: I organised an art exhibition to promote a programme of ecological awareness to coincide with the 'Venezuelan Embassy Congress on National Parks', March 1993. We took a group of Venezuelan and British artists to Venezuela and took them to spectacular areas, many of which even the Venezuelans hadn't seen. There were 125 works in the original exhibition, 50 of which were also shown in London. It was interesting to compare the British watercolourist's approach with the big canvases used by the Venezuelans and to see how much they influenced each other.

OB: The rainforests provide an example of interaction between cultures. They should not be solely the responsibility of the area in which they happen to be indigenous. It should be recognised that oxygen as well as pictures should be valued and paid for.

ELS: Fernando Botero provides a fascinating picture of Columbia but in order to understand the commentary it is essential to familiarise oneself with the background, for example in Africa it is always assumed that people who carry a lot of flesh will last through lean times. Botero always denied that his fat people were satirical 'The deformation you see is the result of my involvement with painting. The monumental and, in my eyes sensually provocative volumes stem from this. Whether they appear fat or not does not interest me. It has hardly any meaning for my painting. My concern is with formal fullness, abundance. And that is something completely different.' His brothel scenes are realistic in that the brothels there are rather like European men's clubs as in Toulouse-Lautrec's time. This specific link to things outside art does not occur in Europe.

Ana Placencia: I belong to a group of Columbian artists in exile, we present the cultural exchange as we feel it, the result is eclectic – a mixture of the middle ages and life in the 20th century. Modernisation is seldom acknowledged as it is considered to be an 'import'.

SH: Do artists consider themselves and their work to be specifically Columbian or Ecuadorian or more generally Latin American.

AP: We are not called Latin American as a marketing ploy, you wouldn't separate areas of Spain.

Cathy Dean: How do Latin American critics see Latin American art?

ELS: Quality Latin American Art has always been Marxist. For example, the Mexican muralist David Alfaro Siqueiros. Marta Traba used art criticism to attack the system saying that Mexican Muralism was destroying South American Culture. Criticism was a cover for political debate which couldn't be conducted in a more specific form because of repressive regimes.

Excerpts paraphrased from the symposium held at St James' Piccadilly, London, transcribed by Cathy Dean

BACK ISSUES

ART & DESIGN

Going beyond the transience of much contemporary art criticism, *Art & Design* offers an in-depth exploration of the underlying patterns of contemporary art. The magazine draws its themes from new exhibitions, symposia and critical definitions and establishes a forum through which to confront the accelerating history of an art world dominated by the quest for the new. Leading international artists, critics, philosophers, curators and collectors contributing to the debate include Robert Rosenblum, Demosthenes Davvetas, Donald Kuspit, Walter Grasskamp, Thomas Lawson, Jeff Koons, Victor Burgin, Jean-François Lyotard, Daniel Buren and Joseph Kosuth. Critical essays are combined with interviews and artists' statements in an attempt to create a dialogue between art and criticism, frequently highlighting the tension existing between critical philosophical interpretations and the intentions of the artists themselves.

Each issue is founded on a new theme, exploring the art of individual centres such as Berlin, London and New York, examining the work of artists experimenting in particular media, or expanding on definitions and issues such as the use of photography and new computer technology, the appropriation of the mass media or the interaction between art and architecture – particularly in new museum design. The magazine also casts a critical glance back to the early decades of the 20th century in an attempt to redefine the past and establish the significance and credibility of new art in the context of historical movements.

Recent issues have included, *New Art International, Art & the Tectonic, Art meets Science and Spirituality, New Museology, The Ruralists, Pop Art, Marking the City Boundaries, Contemporary Painting, Patrick Caulfield, Fluxus: Today and Yesterday, The Great Russian Utopia, Installation Art, Video Art*

Subscribe Now!

TIME AND TIDE

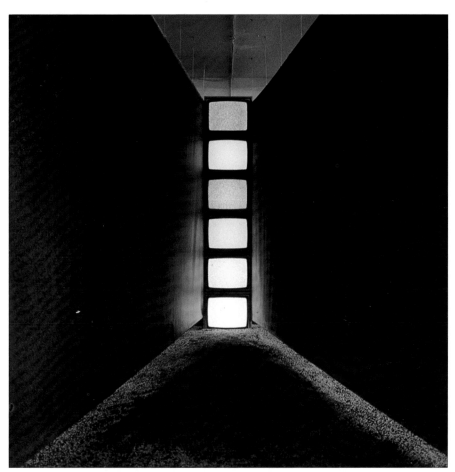

Cildo Meireles, Para Pedro, *oil on canvas, gravel, video monitor, soundtrack, 1984-93 (detail)*

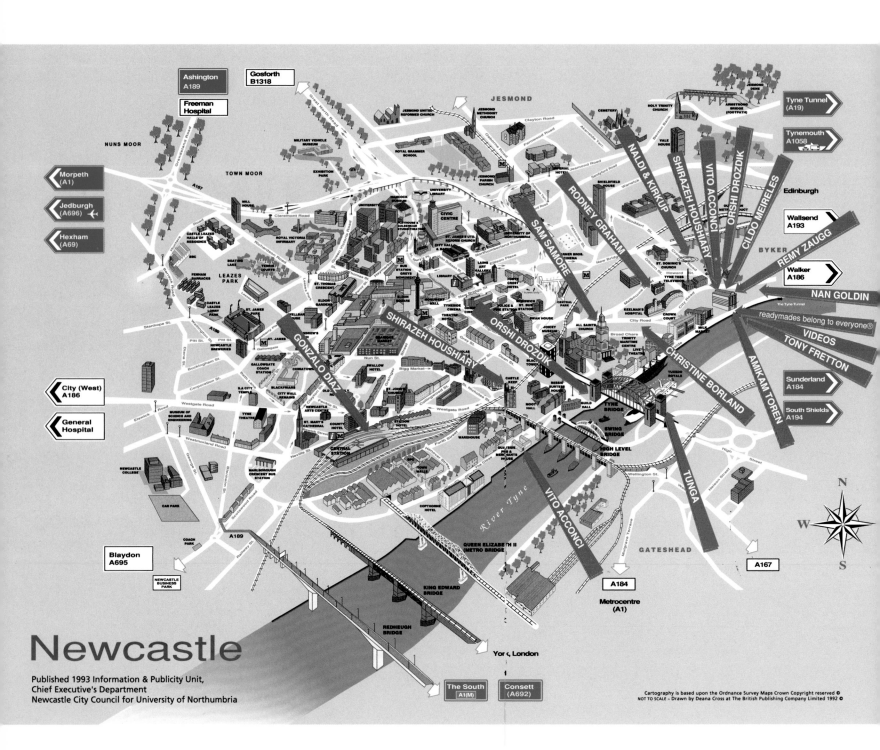

Newcastle

Published 1993 Information & Publicity Unit,
Chief Executive's Department
Newcastle City Council for University of Northumbria

Cartography is based upon the Ordnance Survey Maps Crown Copyright reserved ©
NOT TO SCALE - Drawn by Deana Cross at The British Publishing Company Limited 1992 ©

Art & Design

TIME AND TIDE
The Tyne International Exhibition of Contemporary Art

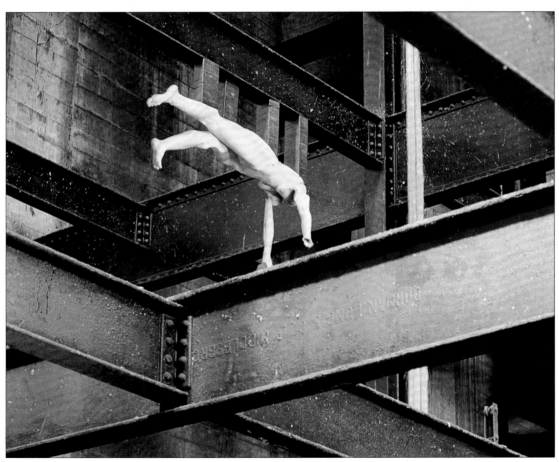

ABOVE: Tunga, Seeding Mermaids, *cast iron, rubber, copper wire, resin, latex, 1993 (detail);*
OPPOSITE: Map of Newcastle upon Tyne showing installation sites

A.D. ACADEMY EDITIONS • LONDON

Acknowledgements

This publication was made possible by a collaboration between
Art & Design magazine and Tyne International 1993, 6 Higham Place, Newcastle upon Tyne NE1 8AF

Tyne International was initiated by the Art Development Strategy of the Laing Art Gallery (Tyne & Wear Museums), in collaboration with the Arts Council of Great Britain and Northern Arts.

Supported by: Arts Council of Great Britain, Northern Arts, Foundation for Sport and the Arts, International Initiatives Fund of the Arts Council of Great Britain, Tyne and Wear Development Corporation, Kaleidoscope Programme of Cultural Events of the European Commission, Henry Moore Sculpture Trust, Paul Hamlyn Foundation, Henry Moore Foundation, Stanley Thomas Johnson Foundation, Visiting Arts, The Government of Canada, bsis Funded.

Sponsored by: English Estates, Newcastle Quayside Developments Ltd, Northern Electric, Hartington Building Design, Yamaha Kemble, Beck's, Tyne Tees Television, INTERCITY, Tyne and Wear PTE, Wingate and Johnston, Laing Art Gallery Business Club, Busways, Carless Refining and Marketing Ltd, Powderhall Bronze, Fine Art Founders, Edinburgh.

In collaboration with: Locus +, Tyneside Cinema, Academy Group Ltd, Artists' Agency, Northumbria Police.

The exhibition would not have been possible without the commitment and involvement of all the artists as well as the collaboration and assistance of a number of organisations and individuals: **The patrons** Catherine David, Rose Finn-Kelcey, Kasper König, Declan McGonagle, Muntadas, Sandy Nairne; **Tyne and Wear Development Corporation** Michael Baker, Cliff Jessett, Graham Snowdon, Lin Simmonds; **Newcastle Quayside Developments Ltd** Adrian Goodall, Keith Parrett, Ruth Mansfield; **Northern Arts** Peter Hewitt, Alan Haydon, James Bustard, John Bradshaw, Jenny Attala; **Newcastle City Council** Colin Haylock, Arthur Parker, Claire Phillipson, Rob Newton, David Cobb, Andrew Rothwell; **Foundation for Sport and the Arts** Grattan Endicott; **North of England Museums Service** Sue Underwood, Stella Mason, Sheila Chapman; **Arts Council of Great Britain** Marjorie Allthorpe-Guyton, David Curtis, Sally Stote, Rory Coonan; **Lisson Gallery** Nicholas Logsdail, Sharon Essor, Elisabeth McCrae; **Henry Moore Sculpture Trust** Robert Hopper, Ben Heywood; **Visiting Arts** Malcolm Hardy; **Government of Canada** Michael Regan, Yves Pepin; **Paul Hamlyn Foundation** Camilla Whitworth-Jones, Jane Hamlyn; **English Estates** Ron Parsons; **Northern Electric** Steve Crosland; **Hartington Building Design** Christopher Lee; **Yamaha Kemble** Roy Kemble; **Beck's** Anthony Fawcett, Caroline Hines; **Artists' Agency** Lucy Milton; **Academy Group** Nicola Hodges, Andrea Bettella; **Tyneside Cinema** Briony Hanson; **Locus +** Jon Bewley, Simon Herbert; **INTERCITY** Geoff Nicholls; **Tyne Tees Television** Peter Moth, Howard Beebe; **The Stanley Thomas Foundation** Joseph Schnyder; **Scientific Aids Dept, Northumbria Police** Chief Inspector Bowman, Gavin Findlay; **Kunstverein, Hamburg** Stephan Schmidt Wölffen; **Long Beach Museum of Art** Carole Ann Klonarides. We would also like to thank American Fine Arts, Anthony Reynolds Gallery, Geoff Armstrong, Phil Bailey, Barbara Gladstone Gallery, Iwona Blazwick, Gary Bourgeois, Julia Bunnage, Galerie Claire Burrus, David Copeland, Pascale Dauman, Louisa Duncan, Nuria Enguita, Francis Gomila, Richard Flood, Juan Guardiola, Simon Henderson, Michelle Jenkins, Bridget Kennedy, Liz Knight, Fabrice Langlade, Thomas Lawson, James Lingwood, Andy McDermott, Gonçalo de BC Mello Mourão, Ian Mitchell, LG Mouchel and Partners Ltd, Roger Neville, Galerie Nelson, Pace McGill Gallery, Cat Newton-Groves, Marga Paz, Ben Ponton, Stonehills, Alistair Teale, Tom Cugliani Gallery, Florencia Varas, Isabel Vasseur, Luis Vera, Tracey Warr, Nigel Wild, Sue Williams, Louise Wilson, Cyril Winskell, Rex Winter.

Gonzalo Diaz residency: The Gonzalo Diaz residency was organised by Artists' Agency and funded by Tyne International, Calouste Gulbenkian Foundation, Northern Arts, Arts Council of Great Britain, Visiting Arts, North Tyneside Council, NEP Group, NALGO, University of Durham, TGWU, UCATT and NUPE.

Tyne International staff: Curator Corinne Diserens; **Exhibitions Manager** James Peto; **Buildings Manager** Paul Holloway; **Co-ordinator on behalf of Tyne & Wear Museums** Mike Collier; **Adminstrator** (part-time) Janet Ross with assistance from **PA** Vicky Sykes; **Catalogue Co-ordinator** Susan Jones; **Audio Visual** Tom Cullen and Jane Stanton; **Exhibition Guide Editor** Stephanie Brown; **Design** Erika Fowles; **Research** Gordon Fraser, Paul Keenan, **Project Assistants** Andrew Mackenzie, John Smith, Chris Osborne (Artserve), Penny Hoy, Neville Blaszk, Jane Corbett, Linda Mansfield, Mat Forrester, Kevin Bailey, Sharon Henry, John Close. **With thanks to Tyne & Wear Museums Staff: Director** David Fleming; **Director's Secretary** Marilyn Allan; **Senior Curator Newcastle Museums** John Millard; **Curator's Assistant** Christine Dawson; **Technical Services Manager** Andy Morgan; **Transport & Personnel** Peter Cartman; **Finance & Administration** Sharon Granville, Ruth Hardy, Mabel Amann, Annetta Hayles; **Marketing** Alex Saint; **Press** Bradley O'Mahoney Public Relations; **Education** Norman Tomlin, Gwen Carr.

Newcastle Quayside Developments Ltd is an award winner under the Business Sponsorship Incentive Scheme for its support of Tyne International 1993. The BSIS is a Government Scheme administered by the Association for Business Sponsorship of the Arts.

Photos © the artists except: catalogue cover © John Davies; p59 © Tamas Szalzer; pp5-28 © Ed Woodman; pp40, 41 © Simon Starling; p39 © Hugo Glendinning; p42 © Douglas Gordon; pp19, 24, 29-31, 33-34, 43-44, 49-50, 59-60, 65-66, 68, 79-80 © Stephen White; Mario Bettella (*Art & Design* cover); John Davies (*Art & Design* inside covers); additional photographs by Steve Collins, Gordon Fraser, Tom Cullen.

HOUSE EDITOR: Nicola Hodges EDITORIAL TEAM: Ramona Khambatta
SENIOR DESIGNER: Andrea Bettella DESIGN CO-ORDINATOR: Mario Bettella DESIGN TEAM: Jacqueline Grosvenor

First published in Great Britain in 1993 by *Art & Design* an imprint of the
ACADEMY GROUP LTD, 42 LEINSTER GARDENS, LONDON W2 3AN
MEMBER OF THE VCH PUBLISHING GROUP

ISBN: 1 85490 215 6

Printed and bound in Italy

Contents

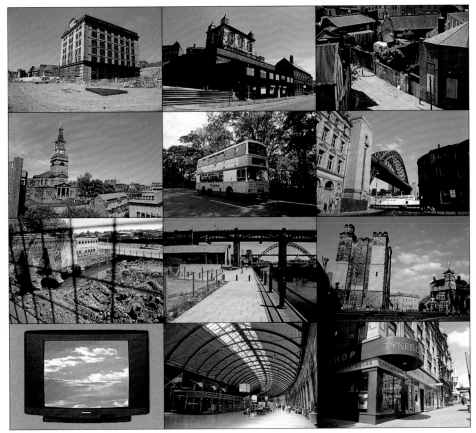

FROM ABOVE, L TO R: CWS Warehouse, Sally Port Tower, Broad Chare, All Saints Church, Busways, Tyne Bridge, Outdoor Screen-Quayside, Quayside, Castle, Tyne Tees TV, Central Station, Tyneside Cinema

ART & DESIGN PROFILE No 32

TIME AND TIDE

MIKE COLLIER

FOREWORD

Newcastle's history of commissioning temporary works out of doors dates from the late 50s and 60s when Victor Pasmore produced murals for Newcastle Civic Centre, and worked with planners and architects on the environmental redevelopment of areas of the North East, especially the new town of Peterlee. More recently, the artist-led groups in Newcastle – the Basement Group in the late 1970s and Projects UK in the early 1980s – promoted temporary works by artists in spaces outside galleries. It is no coincidence such activity was generated by artists 300 miles from London in a city with a strong sense of identity and history, expressed through its architecture and social spaces.

These spaces, many of which are now redundant, carry traces of people and their industry, their struggle and their leisure, spaces which were appropriated by artists, ironically at a time when the property boom took root. At that time, areas of historical significance were often ignored or renovated to form leisure or theme parks, although such urban regeneration did not stem the movement of people from city centres to the suburbs. Temporary art is being created because it can better address the social meaning of urban spaces, providing more artistic freedom and more impact than art displayed in galleries. Artists are capitalising on opportunities to use the city as a public arena, extending to involve radio, television and newspapers, challenging social and political issues of ownership, gender and cultural identity.

The establishment of Tyne International in 1987 coincided with a shift of emphasis in presentation of live work in Newcastle, a shift which brought this innovative, often ephemeral and controversial area of work to centre-stage. Working through Tyne & Wear Museums – the region's largest and most visible cultural organisation – Tyne International set out to extend audiences for the visual arts and engage a broad spectrum of people in the debates which ensued. The first Tyne International in 1990, curated by Declan McGonagle, formed part of a festival of new art from around the world; works made on Tyneside for specific sites and presented in collaboration with programmes by Edge, Projects UK and TSWA. Calling the exhibition 'A New Necessity', Declan argued,

> In Britain . . . the definition of public art has narrowed to emphasise physical location . . . but hopefully this particular bandwagon is questioned by this exhibition . . . The project depends on defining people as participants in a cultural process already rather than being simply consumers of cultural products . . . It addresses the locality and wider constituency beyond Tyneside, and it challenges the increasingly inadequate metropolitan hierarchies.

Now Director of the Irish Museum of Modern Art in Dublin, in 1992 Declan led a series of debates organised by Tyne International in Newcastle which examined the role of art and architecture in building an identity for the city.

In appointing Corinne Diserens – Exhibitions Curator at IVAM Valencia for the last four years – to select the 1993 Tyne International, we have been fortunate again to choose a curator with a clear and forthright vision. As she suggests,

> Like Newcastle, Valencia is a strong place, full of potential, but it's not a cultural capital. More and more I am interested in this kind of situation, outside 'cultural centres', where the relationships between you, artist, project and public are much more direct. You are closer to the realities of the urban situation. You don't get the same people going from one exhibition opening to another. Everything you do in places like Valencia or Newcastle will be highly criticised, but that's not a bad thing . . . Every artist who has come here – and they have come from all over the world and most of them don't know Newcastle – has got very involved and struck by the city. You don't have to be in a 'cultural centre' to create interesting art.

Corinne has shared our vision to establish a centre for temporary contemporary art on Tyneside. We hope using the CWS Warehouse on Newcastle's historic quayside might provide the catalyst for its development into a space comparable with New York's Dia Center for the Arts or Dean Clough in Halifax; a space with historical conviction where artists can create new work. Corinne believes, as we do, that the Tyne International should be led primarily by artists whose investigations and work closely interact with the locality, ultimately determining the nature of the exhibition. The clarity of her curatorial thinking and sensitive selection of artists are testimony to her vision. All artists have made new work for the Tyne International and, at the time of writing this – five weeks before the opening – none has been completed. We are part of an exciting process: working with artists to help them realise their ideas and seeing how they interact with the spaces which they have independently chosen.

Our future is full of promise. Tyne International played a major part in the Northern Region's successful bid to host UK Year of Visual Arts in 1996, a programme of arts years generated by the Arts Council for Arts 2000, the Millennium Project. Locus + has risen like a phoenix from the ashes of Projects UK and has collaborated with Tyne International on one of this year's artists' projects. Tyne & Wear Museums is under new management, and Northern Arts has a new Visual Arts Department and Director.

CORINNE DISERENS
INTRODUCTION
Time and Tide

*T*he stream of time in rapid current *sweeps away all people's deeds and sinks in an abyss of forgetting.* Derzhavin (from Brian Hatton 'Alexander Brodsky, Ilya Utkin')

A cityscape crossed by a river, a river which seems abandoned, mirroring a recent history: the memory of an economy based on colonialism, its peak and its failure. From Acconci's little boat on his personal river, to Kirkup & Naldi's video featuring themselves in the city surveillance system, I like to remember Foucault's words, 'The boat is either a dream or a nightmare. Or rather, both. A no place. "A place without a place, that exists by itself (and) is closed on itself, and at the same time is given over to the infinity of the sea." For Western civilisation the boat has not only been the great instrument of economic development, going from port to port as far as the colonies in search of treasures and slaves, but it has also been a reserve of the imagination. It is said that "in civilisation, without boats dreams dry up, espionage takes the place of adventure, and the police take the place of pirates."'

Newcastle upon Tyne, neither a small city, nor a capital, has the special character of a place searching for its identity. Its layers of architecture, from Hadrian's Wall to the 60s motorway, form a collage of histories with a strong physical presence, both striking and chaotic. Today many of these architectural components are empty shelves – lonely places where memory is slave.

English cities seem not to know how to return to their rivers, left without boats but full of ghosts of the workers and the wealth of a recent past. A river in the middle of a city is its fluid soul, and Newcastle is researching how to reintegrate the life along its waters. (The name of the Tyne river derives from a Celtic word *Till*, meaning to dissolve or flow.)

For Tyne International, the desire to activate the quayside area – the downtown, seemed natural. It is also the most 'humanised' and accessible part of the city. The uptown – the 'real' centre with its shopping malls – seems to me a congested and disturbing environment. The 'up' and 'down' were physically separated in the 60s, by the construction of a motorway into the centre, destroying the layout of the city, and forming a barrier for pedestrians. We wanted to choose an area in which all sites were within easy walking distance and not scattered across the entire city. We focused on an area from the CWS Warehouse on the quayside, to the Central Station, passing by Sally Port Tower, All Saints Church, the Quay, and the Castle Keep.

Faced with such strong industrial architecture – bridges, towers, warehouses, and traces of the 'masculine' sciences of the industrial period – the

reaction was not to erect further outdoor artefacts, but to enter the nucleus of the city, activating the empty shelves from inside. I remember the history of science as a voyage through scales of reality which become more and more rarefied, as space increases when knowledge increases. The limitations of the physical approach are revealed slowly as we advance towards the end of the mechanical era. In the software era, we transform the scale into information, into language. We penetrate the enormous close-up of human hair, we approach the images of the molecules in action, we meet a DNA branch – the code, the configuration of the information – and a new depth can be created.

To invest the spaces between the objects of the physical world we believe to be real, and the surround of electronic and transmitted images, Tyne International has invited 17 artists to make proposals for different spaces, as well as organising video and film programmes. The idea of a specific theme was rejected, and the emphasis was placed on giving enough attention to each individual, while at the same time revealing, through the co-habitation of these artists, some intuitive connections between their works. The project also aims to question the notion of public art – where is public space today? It is certainly no longer possible to see it as the public plaza. It has vanished into numerous kinds of spaces, including different facets of the privatisation of public space: television, satellite, atrium spaces, advertising – spheres in which 'the public' is defined as a mass of consumers. The exhibition is not showing sculpture in the park. It seeks to infiltrate spaces, searching across vast spatial networks for identity and a place where the marginal but resistant personal voice can be expressed in the age of information.

With the reconstruction of works by Acconci from the 70s, I wish to look back to a period which fermented ideas about how to encounter the spectator on different grounds. If *VD Lives/TV/ Must Die* brings the audience into the search for body/sexual identity, to the sound of the B-movie voice of the artist, *Where are we now (Who are we anyway?)* breaks the limit of the exhibition space and is suspended in the void, jumping into the 'outspace' to look for a new sphere. I like to imagine it as a utopia as much as a necessity to create a new space in which to casually encounter the spectator. It seems important to remember that many artists working over the last decade in so-called 'public space', come out of 70s performance activity and its strong relationship to language and body. Wilhelm Reich, the Austrian psychologist, whose work caused him to be imprisoned in his own country, pointed out that the body was neglected in fragmented industrial societies. His therapy was based on the curing of the body by touching to reach the spirit:

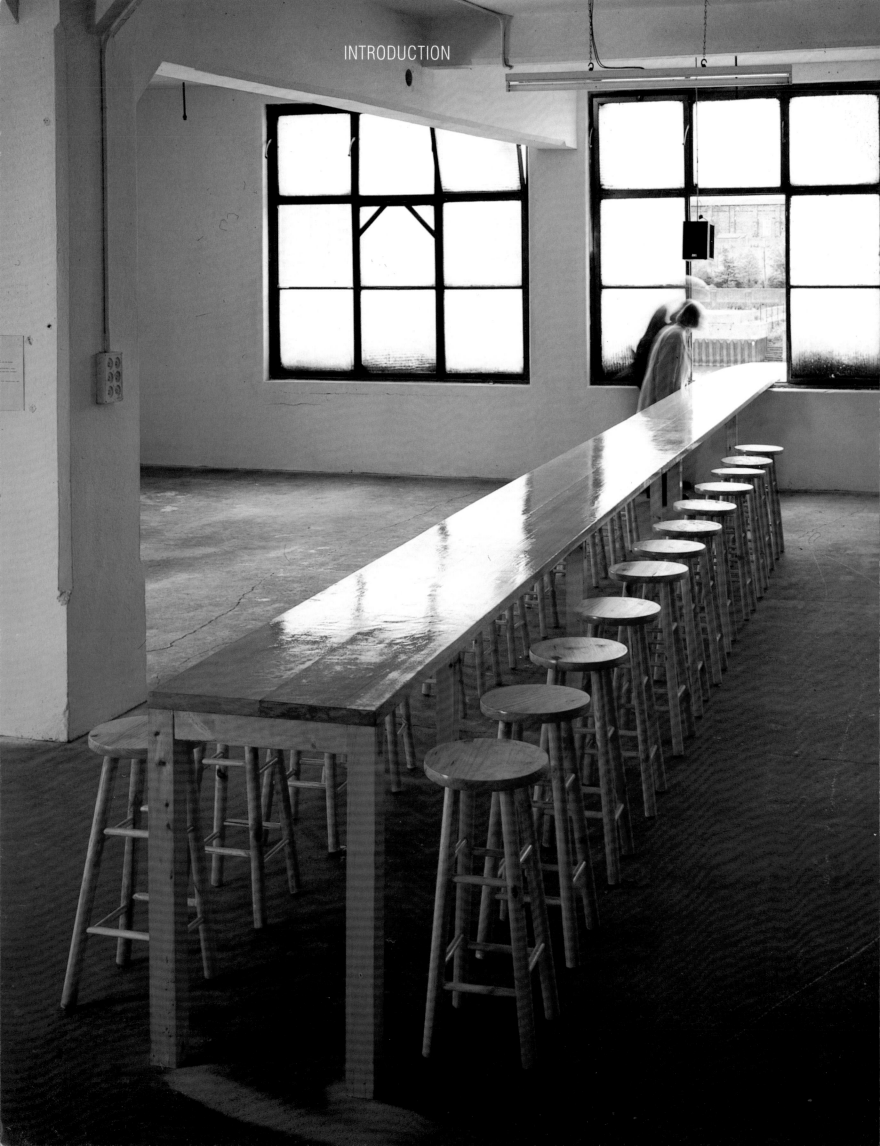

INTRODUCTION

'When I lay my hands on the body, I lay my hands on the unconscious.' Together, the works in the exhibition question the dialogue between this body and the media world of today.

'Ne plus croire ses yeux' est devenu une 'objection de conscience' qui s'oppose désormais à l'emprise de l'image objective, d'une image médiatisée, non seulement par la retransmission télévisée en direct ou en léger différé, mais encore par l'abus d'une mobilisation de l'espace public où les escaliers et les trottoirs roulants complètent la chaîne qui mène de l'automobilité domestique des transports en commun, à l'ascenseur des tours de grande hauteur de l'immeuble cablé. Ainsi, à la ligne d'horizon qui borne la perspective de nos deplacements, s'adjoint, aujourd'hui, l'horizon au carré de la television ou de la lucarne de l'avion et du TGV.

Le défilement optique ne cessant plus, il devient difficile, voire impossible de croire à la stabilité du réel, à la fixation d'un visible qui ne cesse de fuir; l'espace public de l'immeuble cédant soudain le pas à l'instabilité d'une image publique devenue omniprésente. (P Virilio)

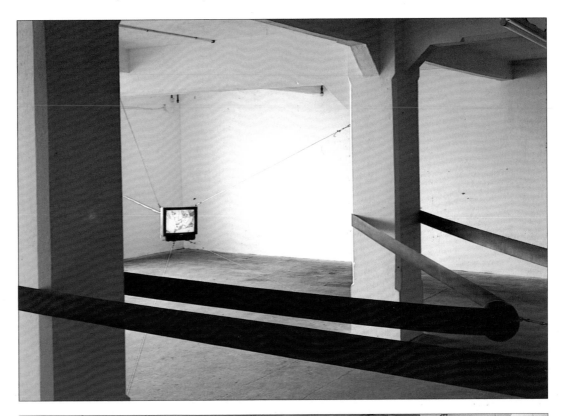

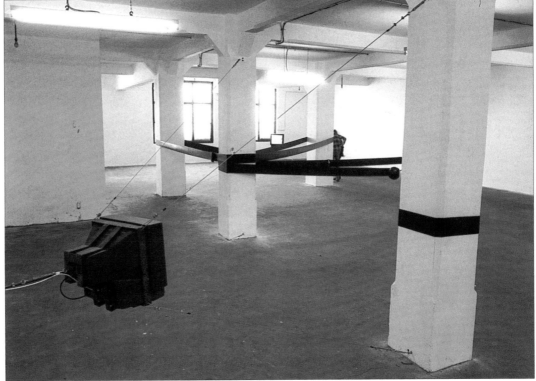

ABOVE AND BELOW: Vito Acconci, VD Lives/TV Must Die, rubber, cable, bowling balls, videotape, first installed at the Kitchen, New York, February 1978, reconstructed in the CWS Warehouse, 1993; OPPOSITE: Vito Acconci, Where are we now (who are we anyway?), wooden construction, painted wall, four-channel audiotape, first installed at the Sonnabend Gallery, New York, November 1976, reconstructed in the CWS Warehouse, 1993

BRIAN HATTON

THE PLACE OF ART – THE ART OF PLACE

*A*rt isn't where it used to be. It used to be in temples and shrines; then it got to be in palaces and houses, and around the end of the 18th century, it started to be put into museums. Indeed, the museum was the place where art finally and fully became art. Not storytelling, not decoration, but absolute aesthetic object. The museum gallery became a place which enabled, indeed ensured, that you could do nothing else with an object but contemplate it. Actually, as we all know, museums rapidly became many other things. You could, for instance, promenade there, take the children on a rainy day, or go fishing for lovers. In fact the museum became a kind of indoor public park, and like the park, it held a certain relation to the city. We might say that whereas the park was a domain of culturalised 'nature', the gallery put works of culture into a sort of 'natural state' – natural in the sense that the French speak of *au naturel* to mean naked. And naked in the sense that they were no longer attired in civic frames, symbolic settings, or narrative ensembles. In fact, at the time that museums were burgeoning, the traditional ambiences of art were being evacuated. The modern movement, which witnessed such an expansion and 'emancipation' of artistic forms and media, was an experiment that was carried out in the laboratories of studio and gallery, for the first work undertaken by the parallel movement in architecture was the disornamenting of the public realm. Buildings, too, went *au naturel,* or as Louis Sullivan, apostle of functionalism put it, 'proud and comely in the nude'. Actually, 'nude' is not the same as naked, and Sullivan never took his own advice, but articulated his skyscrapers in rhythms of ravishing motifs.

Let's reflect on this change in the ratio of nude to naked in public art, for visitors to the Tyne International find an exhibition that is a temporary museum of a kind but recently invented and still evolving.

Here, the protocols of specialisation and pure contemplation that defined the museum have been loosened; art's relations to the city and the beholder altered, conditions of installation and reception recast. Art is not where it was, but has shifted its ground in order to *Search* (a work that relays to the CWS Warehouse video surveillance) for where it could be. For on where it could be turns what it can be, and in turn what it can be turns out to represent who or what we can be. Tyne International art is a genial exile, paradoxically cosmopolitan and site-specific. On the Tyne as much as in New York or Iran, it asks *Where are we now? (Who are we anyway?)* Vito Acconci's question, like Manet's

Déjeuner Sur L'Herbe, which took the museum nude for a naked lunch in the public park, is posed in the form of a table-diving board that abrogates the gallery's boundaries – '*A place where nothing has happened'* (but everything signifies) for the streets – where everything happens but nothing signifies.

In retrospect, the modern movement's 'ornamentoclasm' looks to have been the herald of a general emptying of the public realm. It's not just decoration and monuments that have disappeared from the streets, but social life as a whole. Certain paintings by the surrealist Paul Delvaux illustrate in this respect a widespread and indicative fantasy. We all know his somnambulant nudes, sleepwalking between temples and railways in a moonlit ghost-town. The great acts of affirmation and identity that were 'public works' are replaced by driftworks, floating signifiers, hauntings. Corinne Diserens said in an interview 'The Tyne is full of the ghosts of workers', but the works in this exhibition along the river are not monuments to lost heroes. No, the sites of ghosts are chosen to supplement daily life with presences that both disturb and enrich (like Plato's *Pharmakon*, the cure-and-poison) in divers ways, whereof the proletarian past is but one part.

To engage art outside the museum (or to turn the outside into the museum, or, as Rémy Zaugg effects in his project, to turn the museum inside out) is, in the context of urban life today, to work in the ambit of the *uncanny*. Uncanny because it is not 'at home' – *unheimlich*, as Freud called it. Notions of identity, relations between the inside of identity and the outside of identity, are commonly thought through as home: the subject as a place. But for this work there is no proper place – not accidentally is it installed in 'spaces', and to reach the meaning of such works no more immediate method is at hand than to enquire of their setting: Where is this? What was it before? What is it now?

Or: *Who is (in) this place? Who's that there?* Vito Acconci's voice, beneath the floorboards in *Seed Bed*, breathing, groping: '*I want you, I feel you, I'm coming'.* Yet even if you wanted/feared to oblige this comic/sinister (again, the *Pharmakon*) wanker, you remain frustrated/safe because he's stuck 'down there' (so often, in so many ways, are we all 'stuck down there!'). Whereas in *Claim*, Acconci again haunts a building from below, as a madman in the basement '*I'm staying here. You're not coming down . . .'* yet his mania poses no threat because you won't go down and he won't come up. Acconci's fantasies remain beyond reach whilst being utterly present. Like phantom limbs that beg

to be embraced, they ache with unnameable recognition; they ask insistently *Where do they belong (where are we anyway?)*

The answers to these questions will not nominate a place where none was before; indeed there may be no answering of them. But in the questioning and opening and wondering (and wandering, a dreamer's wandering) the questioner will return to the city where *it's not there; it's not there at all.* So in turn, re-imagining the city, the subject re-identifies her/himself. The role of monumental sculpture was edificial, homiletic, didactic, celebratory. This work, whereas, is a poetic critique, through detour of desire and dream, of received consciousness and official space.

Consider the two works installed within the north and south towers of the Tyne Bridge. They are two urban hauntings within edifices that are quite literally 'empty rhetoric', being functionally redundant, monumental supplements to the naked steel structure of the bridge. Ghost stories originated within the house but transmigrated to the industrial city as a metropolitan sublime to which the subject reacted with fear and dread.[1] Claustrophobia and agoraphobia are experiences of a city dweller for whom the city has become strange. Objects intended to reassure as traditional signs of place, such as gateway towers, become instead unspoken portals to what they repress: the city's unconscious. The installations within them by Tunga and Orshi Drozdik pick up their 'chthonic' qualities, and among their girders weave dreams of bodies, of parts of bodies, of essences of bodies: the body's passions and juices cystallised in the industrial minerals of the city: coal, iron, copper. Here, beneath the ceaseless thunder of traffic, we seem to be underground or at the bottom of the Tyne. This is no stage for civic sculpture; we are back at the origin of things, far back, where seed and ring twine filaments that reach up from depths to consciousness as copper cables and glass bubbles rising to break surface in the city's day, 'while time clears / Our lenses, lifts a focus, resurrects / periscope to glimpse what joys or pain / Our eyes can share or answer then deflects / Us, shunting to a labyrinth submersed / There each sees only his dim past reversed.' (Hart Crane, *The Bridge*)

The theme of above and below, and of a periscope to communicate between them threads through this exhibition, and indeed through the city, with its upper and lower towns and towers which, if they do not actually could quite well work as periscopes. Rémy Zaugg describes the warehouse as if it were such a device: 'It resembles a watch-tower keeping an eye on the region . . . if the building were not there the landscape would not exist as it appears from the upper floors, and if the landscape and river did not exist there would have been no reason for the building to exist.'

We have already mentioned *Search*, and what else is TV but an elaborate periscope? From the depths of the warehouse, we range (care of the police) far and wide across the city, pan across

rooftops, zoom onto individuals in doorways. Periscope becomes panoptikon with this 'angelic' surveillance.[2] Once we were overlooked from skylines by messengers of heaven and history; their lapidary gaze lent sibylline reference to the quotidian below – think of the column at the head of Grey Street. Now we look up at advertisements while cameras look down at us. This isn't an area for art to draw 'uncanny' figures from our depths; the control systems of the public air call forth direct intervention in the apparatus. Provoked by the spectacle of power and the power of spectacle, artists have sought to throw the switches, open the closed circuits, access the systems to free imagination, general diffusion, and popular debate. When Krzysztof Wodiczko projects alteric emblems onto monuments, or Jenny Holzer hijacks a billboard with her homilies and truisms, a hole is punched in the carapace of eidolons (Roland Barthes called them 'Mythologies') that compass and indocile mass consciousness. Advertising and surveillance are both phenomena of alienation; negative aspects of mass communication, like the vacancy of towns created by transfer to suburbs linked by television to an increasingly virtual community. That's why it is important that Wendy Kirkup and Pat Naldi, though born far away in Hong Kong and Gibraltar, live now in Newcastle, and that their *Search* will be broadcast in advertising slots on local TV as well as in the CWS Warehouse. It is a search as much for a new relation between television and architecture as it is for local identity and *demos*. As space gets dispersed by telecommunications, as time is rendered fragile and memory volatile[3] by transient use and interest in impermanent fabrics, and, as Nan Goldin admits of her photography[4] we've 'realised the limits of what can be preserved', then the distinct values of each medium will be clear. TV can relate the distant and different as never the tower of Babel did; through dark glass fibres as scintillant as tresses streaming from Tunga's mermaids, we shall see omnimutuality made present. But the specific site is architecture's gift, and its connecting power is not to elsewhere but to time. And time caught within walls, decelerated in inverse proportion to the acceleration of a falling body, repeated in a perpetual diurnal cycle of piano notes within the classical upper chamber of the Sally Port Tower, is Rodney Graham's theme in *The School of Velocity*. There's a unique poetry going on there, above the city. Alone, continuously, precisely, to a programme as exhaustive as it is purposeless, a metronome-automaton is making music into the most exquisite nonsense. Torrential keyboard notes are slowed down to a sublime felicity of intervals. In a limpid cell of space and silence and light, a rational ghost of systematic mischief suddenly strikes a chord as if from nowhere (*Where are we now?*), let's hang a wait upon the next before another sound, as inexplicable as the previous and from as unforeheard a quarter, resonates again the architecture of the room. Purposeless purposiveness was Kant's

definition of that aesthesis unique to absolute art, to chamber music or the ideal harmonics of classical form. And as the Sally Port gallery is the most museum-like of the exhibition's sites, as well as literally the most elevated (as the Bridgeworks are the lowest), it fits Graham's infinitesimal unwinding of time into thin, cerebral air.

At Sally Tower, a door is opened, via sublime play, to lofty spirit: Idealism, albeit an idealism gone slightly batty with its own perfect solipsism, but one which we want, nevertheless, to abide somewhere with us, up there, far away from the chthonic monsters in the dungeon of the bridge, or Acconci's nutter raving down below. At Sally Tower we 'breathe the air of higher spheres'[5] rejoin the airwaves without recourse to television, and look back over all the sites. We realise that for each episode of the exhibition corresponds a building: for the unconscious chasm of self and subject, the Bridge; for the traces of *A Place Where Nothing Has Happened*, Christine Borland's forensic portakabin; for Shirazeh Houshiary's innerkeep of warm wellbeing, the castle; for Sam Samore's lens of gathered qualities, All Saints Church; for entrepot 'Of The Times', of universal Readymades, of Open Secrets, and of global video, the Warehouse. In each, the building is immersed in, emerges from, a common pool of memory. As John Ruskin might have said of Venice, it is a lamp in that pool. Lamp and witness.

John Adams' *Goldfish Memories And The Think Tank* makes a hybrid allegory of television/architecture: It submerses a TV in liquid. In the window of this sunken tower, we see people talking about the past, memory, and identity. One of them is the architect Tony Fretton who designed the video installations on the warehouse groundfloor. They are disposed in discrete yet intervisible sitings. Some are viewed within booths, but others form open, free-standing events in the dim interior expanse. So at certain points, the viewer may see seven or eight screens simultaneously, each aglow and active with their own inner narrative, rather like buildings in an urban dusk, as their lights come on and private lives are windowed to the world: Ur-material of soap opera: theatre inside-out, the audience as dramatic spectacle. Fretton describes the floor as an urban microcosm: 'The layout for the videos is not intended as a particular sequence. So – as in a city – you can get sidetracked, recover your way, and make your own sense of the place you are in.' This phrase sums up an unspoken parable in the method of this exhibition. It ingathers artists and works from the wide world, and they make personal responses to particular sites that bear symbolic value for the urban whole. When Acconci emerges, smiling, benign from under the floorboards, he sinks a boat-like basin in the quay, floods it with a tiny, personal Tyne, and on it floats a playboat. He calls it *Virtual River* but it is the boat that brings reality to the river and the river to reality. As Rémy Zaugg said of the warehouse, the region and place are indistinguishable from their witness of each other.

'Make your own sense of the place you are in.' Well, we have seen how video might be involved in that. But there is a more genial and familiar method: the buses. What is a bus? *Omnibus*: All & Everything. Everyone to Everywhere. In *Ulysses,* James Joyce's one-day Odyssey through Dublin, Bloom muses on the world seen by taxi drivers, forever roving without repeating a route through the city. Busroutes are fixed, but their network charts a certain universal map of the community, whilst each vehicle, especially its upper deck, offers to common view a moving survey of the streets. They are wheeled pavilions which, given time, will show you all the city, each route a tale or movie. Consider now a relation between the bus and the interior of All Saints – another *Omnibus*, another All. The bus (the mythic bus, the archetypal bus) is a mobile viewing device, a moving *camera* (ie room) which, a workaday utility in itself, reveals the world through its windows by moving through it all. All Saints does not move literally, but it moves the spirit; the world does not pass its windows, which are filled with skylight, but in it the world was focused, concentrated, and transfigured by the act of worship.

The bus is secular, All Saints sacred; the bus a directional means to an end, the church a centric oval, an end in itself. But note All Saints' date, from the end of the 18th century, the century of enlightenment, just the time when, as we remarked at the beginning, art was becoming idealised within the museum. Likewise God grew somewhat abstract. Not sculptures, but the pure oval vault represented His gathered hallowed at All Saints: An Enlightenment *aula* as pure as the cell atop the Sally Port. And therefore, when All Saints was secularised, it lent itself quite *naturally* ('nature': an invention of the Enlightenment) to the new cult of Art.

But we are missing the bus here. Where is it now? (*Who are we anyway?*). In the top deck of the bus, cramped but democratic gods, we survey our man-made world. In All Saints' windows we saw only the heavens, the airy countenance of a God who, looking down at us, saw all. In the bus, it is the advert cards that look down on us, with consumer goods in the place of gods. It is into these two places of 'sacred' and profane appearance, the church window and the advert-card, that Sam Samore has placed his installation 'Descriptions'. Circulating the city among the commercial images and copy on the buses will be poems, tales, fables, and ballads from dialects and vernaculars in which speech wove magic spells deeper and truer than publicity campaigns. In the church windows, Samore has suspended in each pane around the hall an adjective derived from some myth or sacred legend. Looking about, we are surrounded by a pantheon of qualities of all kinds, from every quarter, name by name, frame by frame: The Rows of the Names! And aptly adjectives: a window is an architectural adjective, qualifying space through its aperture and describing all contained within the light it lets.

At the opening of the exhibition, All Saints became a recital stage, venue to a telling of stories

by Samore. The austere yet elegant enlightenment temple bore the transformation well, and for an hour the oval's audience became the vital kernel of the international gathering, displacing the CWS Warehouse. And this reiterated a familiar architectural dialectic: between the circle and the grid. The grid is repetitive, open, secular, distributive; the circle (or egg) is concentrative, singular, sacred. In the modern world, the grid has taken on, however, a transcendent significance for social life which is typified in the reinforced concrete frame of the CWS Warehouse. Not accidentally, such industrial magazines became models for art museums. Their naked concrete and manifest structure read as the natural (because neutral) space for expressive painting and sculpture. But two artists at CWS have done more than just exhibit in this regime of neutrality and form; they display the regime, its mediation and distribution in itself; like the work of *Search* on surveillance, they turn the system to display its devices. Amikam Toren's paintings *Of The Times* appear at first as competent but conventional abstract fields of grey pigment which somehow repeat the blank qualities of the warehouse. But they are composed of homogenised *Times* newsprint, a page per painting. It might be said that a page, as such, is much like a warehouse; it could contain anything. But we know that the *Times* front page does not show anything or everything. The print may mix to grey, but the political colours that compose it are anything but neutral, as Toren implies by displaying a sample of the original. Toren's pulping of the *Times* reminds us of Karl Kraus' campaign against the deceits and mendacity of the Austrian press, and his ironic opening 'In these great times'. For Kraus, the press was antimonic to his ideal of 'fantasy', and we might see Toren's monotones as a comparable comment by pairing them dialectically with the Bridgeworks of Tunga and Drozdik. But his *Armchair Paintings*, within his own work, make a different dialectic. Like Samore's windows, they write words on imagespaces that once had special meaning. Only, here, it is phrases quoted from media, signs, and graffiti that are cut out of junkshop paintings, a more cerebral version of the situationist *detournments* perpetrated by Enrico Baj. The warehouse is an

appropriate locus for the *detourning* of media commodities. Philippe Thomas' *Readymades Belong To Everyone* installs his virtual industry of art-subversion within the warehouse virtually to use it as just that – a warehouse for the despatch of readymade copies and copy readymades. Just as the city is also a nexus of social systems as well as a place, so is art a dealing system as well as original works on 'neutral' walls, whose Kantian 'disinterest' is the subject of Rémy Zaugg's project to exhibit works on the exterior walls of the warehouse. In the reflexive *modus operandi* of these three artists, a special symbolic discourse on the museum is made by turning the warehouse back into a parodic function of itself. Zaugg, Toren, and Thomas engage a very current conception of the world, but at some distance from the warehouse, in the shadow of the Law Court, Christine Borland has displayed an investigation, partly archaeological, part forensic, of an old site. A curious pathos of obscurity reigns here, for Borland calls it *A Place Where Nothing Has Happened.* Sundry detritus and litter, traces and scraps are laid out according to standards of evidence, yet just as a readymade is an item not in service, so this whole investigation is forlorn. The effect is to render the evidential scraps as 'natural' aesthetic things – found objects, gathered to elusive, technically arcane criteria, which bear the signature of successive worlds without ever amounting to significance until this collection, this moment, now. The degree (*zero*) here of abjection, of negation makes the portakabin where this salvage from oblivion (*Les Pas Perdus*) is displayed, makes it, by other criteria, another origin or core to the exhibition: a navel of nothingness.

Yet at the heart of the warehouse are some exquisite, intensely realised pictures by Shirazeh Houshiary that eschew all contextual reference for an intimate colloquy of the spirit. She cites a poem: *Only at the direction of the heart you set your head like a pen on the page of eternal love.* These paintings, one could suppose, may be another kind of navel to this exhibition, a singularity into which all the world is drawn and yet annulled in an enduring moment of black light, through dark glass, an inward beholding of 'a place where everything happens'.

Notes

1 See Mark Cousins' review of Anthony Vidler, *The Architectural Uncanny – Essays in the Modern Unhomely*, MIT Press, Cambridge, Mass, 1992, in *Architectural Association Files* 24.

2 The sense of being looked over is profoundly ambiguous. The growth of vision in the infant is psychologically linked to the mother's gaze, and while the myth of the guardian angel is potent even today in Wim Wenders' film *Wings Of Desire* (The Skies Over Berlin) and Gonzalo Diaz' invocation of the celestial hierarchies to correspond to coal mines in his *Debatable Lands*, it also empowers tyrannic coercion: the 'powers' over us, of course, do *really care.*

3 *Volatile Memory,* by Gretchen Bender and Sandra Tait,

showing at the CWS Warehouse, is a video on a cyberpunk theme, dealing with body-obsolescence.

4 *The Ballad Of Sexual Dependency*, shown at Newcastle, is Nan Goldin's photographic diary of her friendships and losses over ten years.

5 The title of a poem by Stephan George set to music by Anton Webern and published in the *Blue Rider Almanac* by Wassily Kandinsky and Franz Marc. The 1912 *Blue Rider* was in some ways a forerunner of mixed site exhibitions like the Tyne International. It was a 'museum without walls' which set no stylistic or geographic limits to the scope of expressive creation. As well as vanguard music and abstract painting, it illustrated folk art, ethnic art, and the art of children.

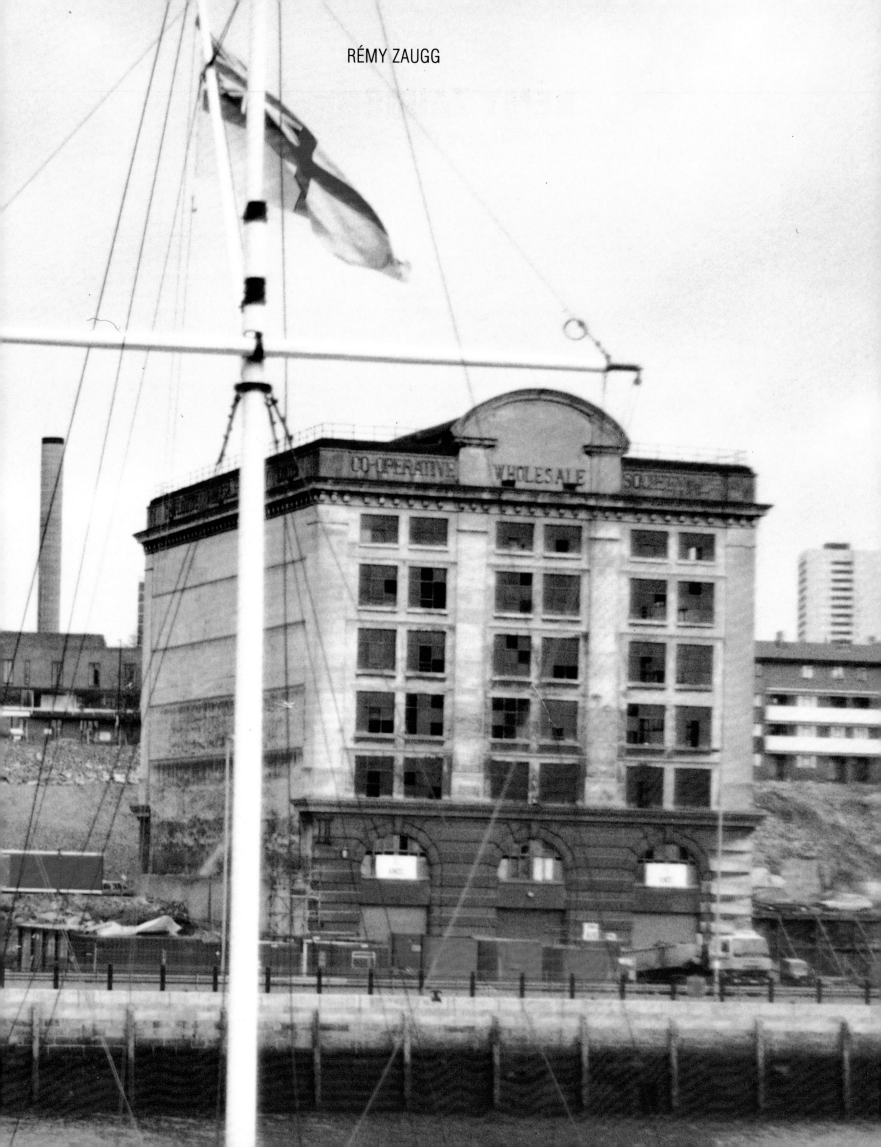

RÉMY ZAUGG

RÉMY ZAUGG
NEWCASTLE UPON TYNE
The Warehouse

On the Quayside, down river from the bridges, stands the former Warehouse of the Co-operative Wholesale Society Limited, whose corporate name still appears on the pediments of all four walls. Construction on it began in 1900 and was completed in 1902. The building has eight floors. In 1909 the hitherto flat roof was heightened along the entire length of its central axis with a metal ribbed vault partially glazed at its base, thereby allowing daylight to penetrate the originally window-less top floor. The building measures 27 metres in width, 35 metres in length and 34 metres in height. The three arched doors at the front with their iron shutters allowed access on the ground floor to a loading and unloading platform. The same was re-peated at the rear of the building, except one floor higher than at the front due to the sloping terrain. Vessels belonging to the large shipping companies such as the 'London' and the 'Continental', as well as other regular lines, would berth alongside the quay in order to unload cereals, butter, fruits and other foodstuffs. The stored produce was then prepared for resale to the wholesalers. One of the floors was used as a free zone for goods liable for import or customs duty.

At the beginning of the 1990s the trading port exists no longer. It fell into disuse and disappeared. The Quayside area is ne-glected. Made redundant, the Warehouse lies deserted. Its doors are bolted and padlocked. Countless windowpanes have been smashed. These square black holes randomly dotted about the walls disturb their calm classical symmetry. On the ground and first floors metal grilles, planking and pieces of cardboard or chipboard block up the gaps. Seagulls and pigeons have colonised the premises. They

perch on the window ledges and roof cornices, fly around the building, enter and leave it. The architectural projections are splattered with excrement, the walls stained with long, thin, whitish traces created by the bird droppings as they fall. The Warehouse is an enormous, nauseating, repugnant, repelling aviary. Left to their animal instincts in artificial and degenerate isolation, and no longer weeded out by any natural predator – sparrow hawks for example – the birds eat, drink and crap, breeding and dying in their own shit amongst the waste and detritus discarded by man. Everywhere, nothing but thick layers of grey shit, feath-ers and whiteish down; mounds of dried-out excrement; fine, acrid, nauseating dust; broken eggshells. Swirling clouds of feathers, down and dust are raised on each take-off. Sick birds, half-dead, lame, mangy partially bereft of feathers, crawl around the floor, or lie collapsed in the shit. Feathered corpses coloured light and dark grey, purplish and greenish grey. Dry carcasses. Bleached skeletons. Pornographic draw-ings scrawled at some time onto the whitewashed walls: testicles and erect penis, vulva, breasts, hair. Stray birds on the staircase, dying slowly in the dark recesses of the steps. Bacteria, microbes. On the top floor: a greyish wall, an excremental concretion 170 centimetres high; just above, near the window frames set in the base of the roof, hundreds of pigeons bill and coo. Water has run inside the building. A brown pool. A mire. A stumbling bird has just got stuck in it. It is going to die, suffocated in shit.

An earnest and reserved Englishman told me about a law forbidding renovation work during the period when the kittiwakes lay their eggs. For my part I thought about the toxic waste pouring out of the British Isles

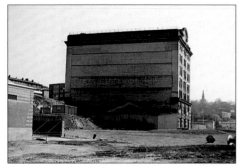

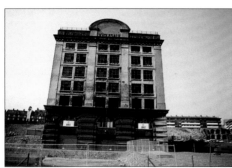

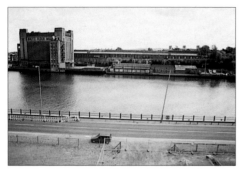

into the North Sea, which, carried along by the temperate current laden with plankton of the Gulf Stream, will end up poisoning the waters of the 'Wattenmeer' on the German and Danish coasts, whose beds, by turns exposed at low tide and submerged at high tide over kilometres of its width, contain a wealth of food essential for the birds populating Northern Europe in summer which stop and linger there during their migration south in the autumn and north in the spring.

A London-based firm of property developers acquired the concession to reconstruct the Quayside development area. They dreamt up a master plan, or rather, a mock-up of the Quayside. The model illustrates architectural styles which are pleasant, nice, amusing, made to satisfy today's fashionable taste. The phoney decor which characterises the new Law Courts sited just upriver could have been the source of inspiration for the property developers and confirmed them in their views.

So demolition was begun. The intention was to clear away every building on the derelict Quayside. Wipe the slate clean and start from scratch. Everything except the Warehouse was demolished. At the last moment the Department of the Environment prevented its destruction.

The building was one of the first to be constructed in the region using the Hennebique system of reinforcement incorporating stressed steel straps: vertical flat rods, integrated into the numerous supporting columns, which cross right through the building. Their tension transforms the architecture into a solid and monolithic whole. A technique of this kind offers a solution to the static problems posed by the instability of the boggy terrain. The building, erected at the foot of a hill on a layer of peat and sand around 20 metres deep, was placed on a sort of raft also made of concrete and steel like the entire edifice. However, this platform was liable to movement. Therefore, the vertical stressed straps not only serve to maintain the building as a solid whole, but they also hold it firmly onto its platform, as a cargo is lashed to a raft. Moreover, the weight of the building is spread evenly over the platform so as to guarantee the stability of the whole.

So the Warehouse remains standing on its own. Despite the survival of the Warehouse, the developers did not modify their plan of action. They simply removed the buildings designated for the spot left occupied and replaced them on the maquette with a scale model of the former warehouse. It must have been assumed that the massive and dignified presence of the Warehouse would have no effect on the development. Perhaps they were unaware that not one element of a solid and coherent development may be altered or replaced by another without the whole and its parts being modified. The belief in the interchangeability of things and of people, like the practice which flows from it, is abhorrent, disastrous. But perhaps I am being unfair. There was, in fact, a slight adjustment: on the model, the majestic blind wall, whose imposing bearing could have posed a threat to the cute and pitiful, delicate and playful edifices scheduled to sit at its feet, has three rows of windows set in its upper level.

The city council has hardly behaved any differently. At a certain stage it was accepted that all the buildings would be razed to the ground. So be it. The advantage of this would be to enable the sloping terrain of the Quayside to be levelled, raising it one-and-a-half metres at its lowest. Whereas, the Warehouse did not disappear. So what conclusions were drawn from this fact? None, without doubt, since work was begun to carry out the initial decision to the letter, just as it continues to be blindly carried out to this day. As a result the building is covered in mud. I hardly need mention the effect of such a state of affairs on the proportions of a building which one would otherwise like to preserve.

By its action the city council has itself replied to the question I asked myself when confronted by the model of the new Quayside: 'In a city built on Hadrian's Wall, how can an area so quantitatively and qualitatively important be surrendered like this to the cruel treatment of a firm of property

RÉMY ZAUGG

developers lacking in both education and culture?'

At the beginning of this year, 1993, the Warehouse, 34 metres high, 27 metres wide and 35 metres long, stands on the Quayside by the river. The massive bulk of its eight floors dominates the site. Established at the foot of the hill and set at right angles to the river, it appears solidly anchored to the spot: the building imposes, and is all the more imposing.

Like a watchtower it stands on a vast area of earth and rubble, demolition materials, the last heaps of which workmen are in the process of levelling. It resembles a watchtower keeping an eye on the region and its inhabitants. Three of the four walls have evenly spaced windows set in them: the front wall, facing the river looks out towards the south, towards England; the long side wall, turned eastward watches the river flowing down towards the sea; the rear wall opening onto the north and Scotland comes up against urbanised hills.

These three great solitary walls are exposed to the landscape, but they each also expose a landscape. Landscape and building are one in thought, they are co-existent and inseparable, consubstantial. If the building were not there, the landscape would not exist, or at least not as it appears from the floors; and if neither the landscape nor the river were there, there would have been no reason for the building to exist. Today, I have come to wonder whether it could exist in the absence of the landscape surrounding it. Would it still have a reason to exist? And when it was decided to preserve it, was it solely for the historic constructional reasons which were given? Were there not yet others, more complex, more confused, more obscure, less explicable, but just as restricting? For example, in conserving the building was there not also a desire to conserve the landscape and the space defined and revealed by it? So the building defines the place, but this place demands the building; it sanctions it, seems to give it its form, in order to finally justify that it is there where it is and that it is there as it really is. The place marks off the

building and the building marks off the place. However, the building does not mark off like a milestone standing by the roadside or like one of the four boundary markers demarcating an area; no, the Warehouse is not a marker amongst others defining a boundary or a frontier, nor is it the marker which divides the world into an over here and an over there; nor indeed, some dichotomous Janus looking simultaneously in two opposite directions; no, it is an enormous marker which serves only to define its own place; I mean, which marks a particular point in the world in the sense in which, in geometry, a point is marked by surrounding it with a concentric circle. Now this enormous marker does not imply a withdrawal or a closure, but quite to the contrary an opening out onto the world which it structures in accordance with the four principal directions. It sets itself up as the fixed centre of the space. In its desire to stand authoritatively at the centre, it asserts its egotism; in claiming uniqueness, it assumes the right to be solipsistic, since it claims to be not one place amongst others, but *the* place. The Warehouse with its walls studded with windows is not really marked off, but merely stubborn: looking down from the height of its eight floors it forcibly and insistently *establishes* a place, whilst at the same time remaining open to the world which surrounds it. In this respect it reminds me of certain sculptures by Giacometti in which the space gathers and concentrates, but also from which this same space spreads out and expands in a dual movement that is contrary and simultaneous, centripetal and centrifugal, paradoxical.

The Warehouse, as prime centre of the space, is nevertheless no Brahman deity with his four faces looking simultaneously in four directions. The west facing wall is blind. Thank goodness it is blind, whereas the three others with windows look out onto the landscape. Too much clear-sightedness is a form of blindness. As long as we see *as if there were nothing of any importance*, then we perceive nothing. It is the opacity rising up all the time in the act of looking which takes its evidence from vision

RÉMY ZAUGG

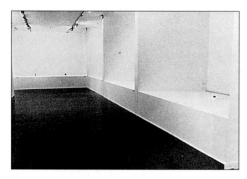

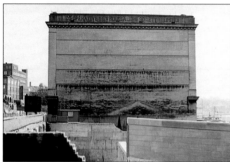

and transforms it into an object of perceptual awareness.

The Warehouse has its back turned to the old city and its bridges. It looks out towards the sea, towards the beyond. It attaches little importance, or so it seems, to where it is very urbanised and over-congested. Perhaps it prefers the open sea and the landscapes in which everything, almost, is still possible, where the incentive to act is a promise of *things to come*. But what if its diverted gaze were only a ruse?

The blankness of the great blind wall stands in stark opposition to the city's excess, its immense tranquillity to its bustle. It flaunts, it taunts. It can be seen from afar. From the bridges. From further still. From a distance of two kilometres upriver, where the city has already drawn away from the banks of the river, through the arches of the bridges. Its flat and homogenous vertical plane, punctuated with very thin horizontals corresponding to the floors, is exceptional. It evokes a gigantic blank sheet of music, its lines printed in very pale ink, barely darker than the sheet of paper. The surface is plain. Elementary. It seems to date from the very beginnings of architecture. It is its rigour and grandeur which give it its dignity and sovereignty; its quiet power, its almost indifferent strength. Free from any architectural detail, its silence is eloquent; better, it is imposing. Yes, that it is, the wall imposes an eloquent silence on the city it confronts. In spite of, or because of its blankness, it attracts attention, so apparent is its dignity. It provokes. It is a provocation which incites to action. The city for example, could come and look at its reflection on its empty surface and perceive itself therein. Thus, the city could see what the blind wall sees.

On my first visit to Newcastle the Ware-

house intrigued me, interested me. The proposal by Corinne Diserens to allow free rein to my creativity on the second floor of the warehouse was a good one and suited my purposes.

My project will take its inspiration from the preceding text and will incorporate the ideas developed therein.

The project is broadly speaking as follows: to bring to life and draw attention to the building and its site; to expose the architecture of the second floor with its pillars, its interior walls and its windows, as well as the landscape. How? With the aid of paintings distributed around the architecture. Paintings, architecture and landscape will form a whole, each element of which will refer to the other two.

Like the sea urchin which, in order to digest large prey, takes out its stomach by turning it inside out, the paintings intended for the blind wall will not be inside but rather on the exterior surface of the building. The artistic intervention will make use of the flatness and plainness of the wall on which the city is to be mirrored and reflected, as if it were a projection screen. The intervention could be inspired by the view of the city had by the blind wall, or again by the way the city imagines itself to be perceived by the blind wall.

The project is ambitious, if only quantitatively – a floor of the warehouse flanked by 24 supporting columns measures around 1,200 square metres. It has not been possible to see it through to a successful conclusion in a few months. So the work will be on show from the month of April, 1994. It will be the first of several projects by other artists; projects which will perhaps help realise the idea of making the place into a museum of contemporary art.

Pages 19-23: Cildo Meireles, Para Pedro, *mixed media, oil on canvas, gravel, video monitor, soundtrack, 1984-93, installed in the CWS Warehouse*

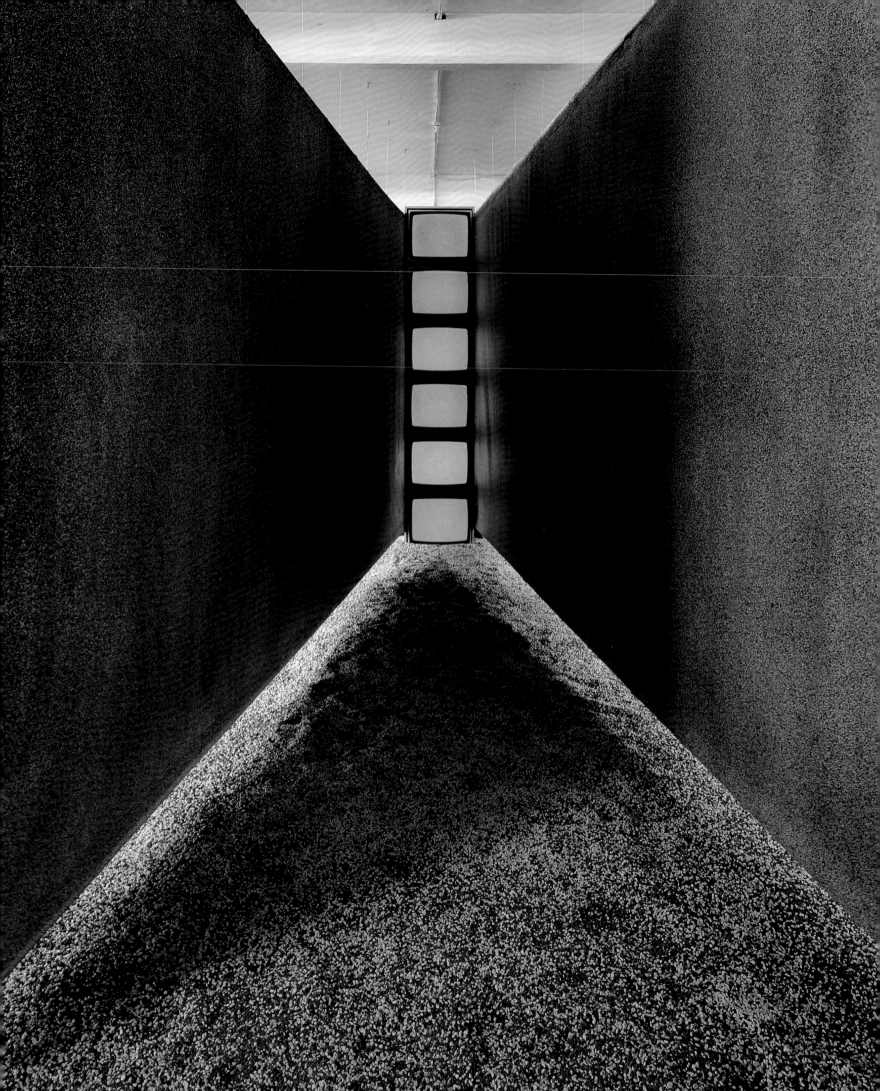

CILDO MEIRELES

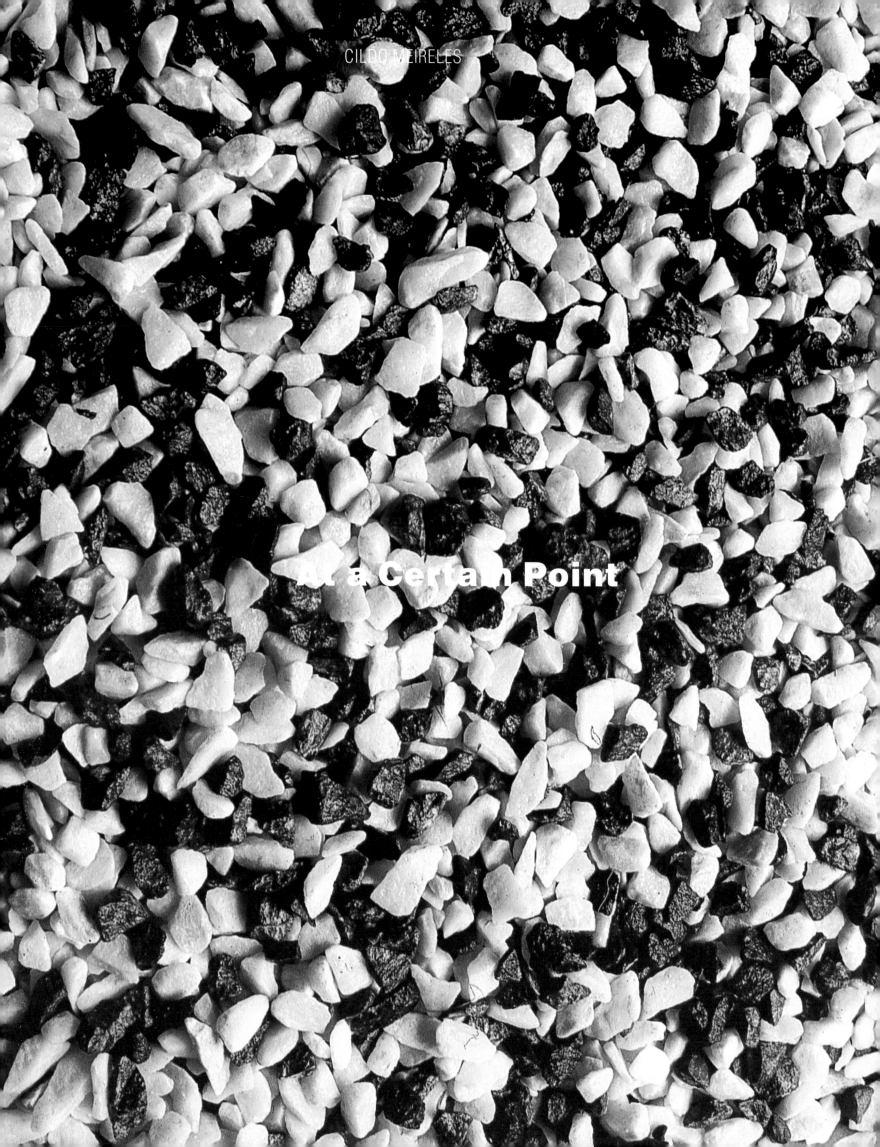

At a Certain Point

Stars

and Ants

Are the Same

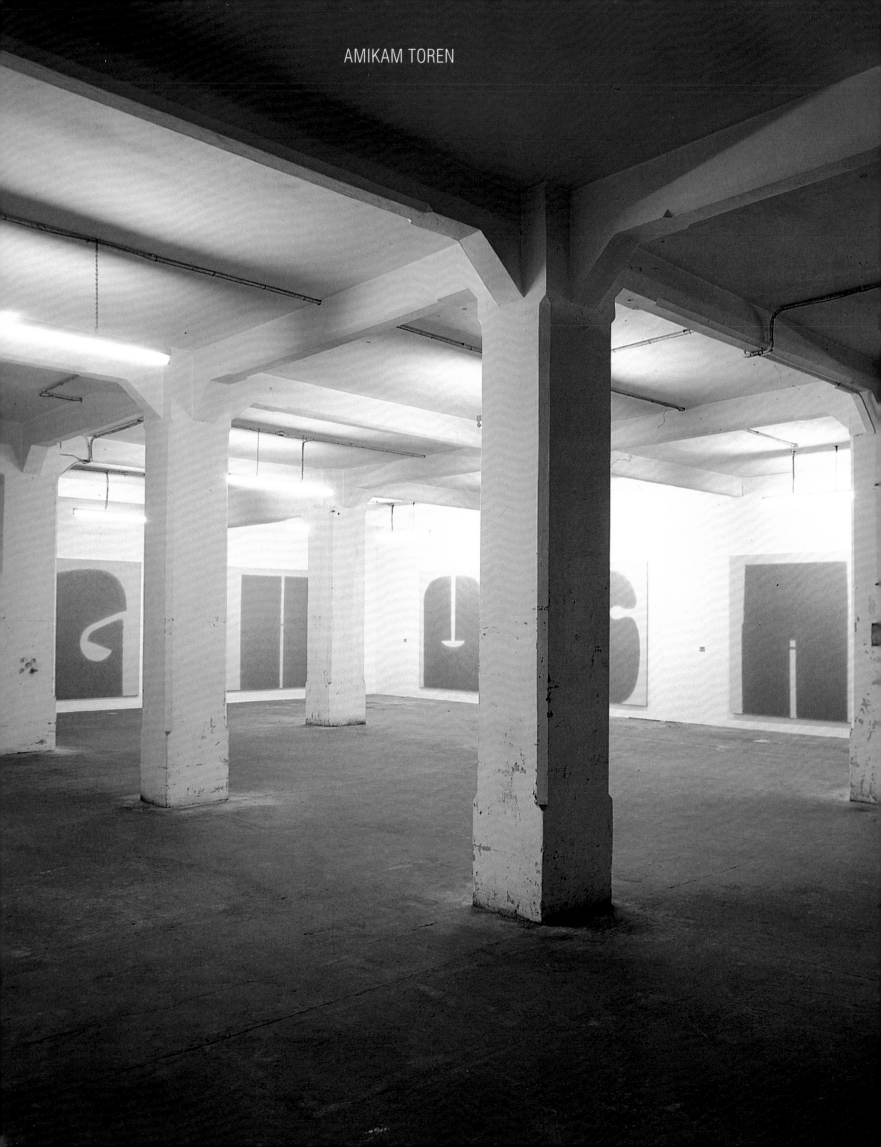

AMIKAM TOREN

ABOVE: Armchair Painting, Untitled, *1991, 76 x 51cm; OPPOSITE:* Of the Times, *pulped newspaper and PVA on canvas, 1983-93, six paintings, each 235 x 220cm, view of installation in the CWS Warehouse*

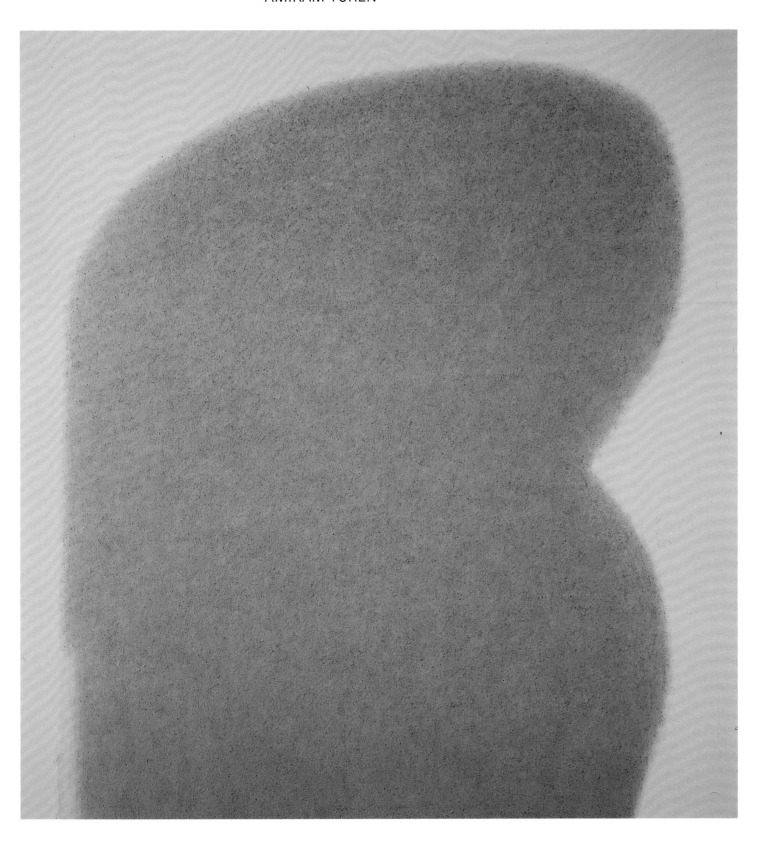

ABOVE: Of The Times, Wednesday August 15, 1990, *pulped newspaper and PVA on canvas, 235 x 220cm; OPPOSITE: a fragment of the front page*

AMIKAM TOREN

Armchair Painting, Untitled, *1993, 53 x 35.5cm,*

readymades belong to everyone®

Since its inception in 1987 in New York by Philippe Thomas, the agency **readymades belong to everyone®** has been offering its clients – private individuals and corporate bodies – the possibility of becoming authors of projects conceived and executed especially for them. This has enabled various characters to emerge in the United States, France, Germany, Italy and Belgium, whose works questioned our preconceived ideas about the origination of a work of art, or about the role and status of the artist.

For its first appearance in the UK, the agency readymades belong to everyone has chosen to focus on these completed productions, not only to let you get to know them, but also to give reality to its own brand name and signature.

ABOVE: poster, 152.4 x 101.6cm, on various Metro sites in Newcastle throughout the exhibition

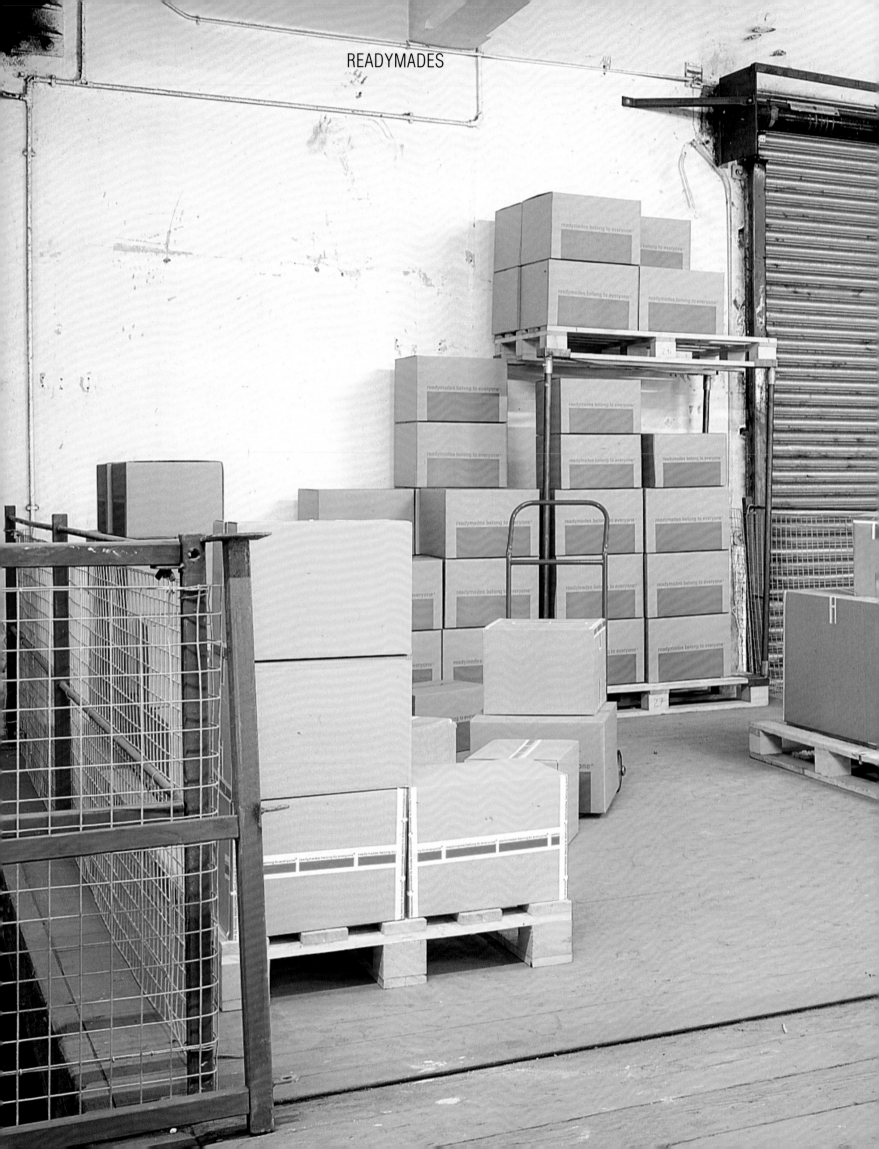

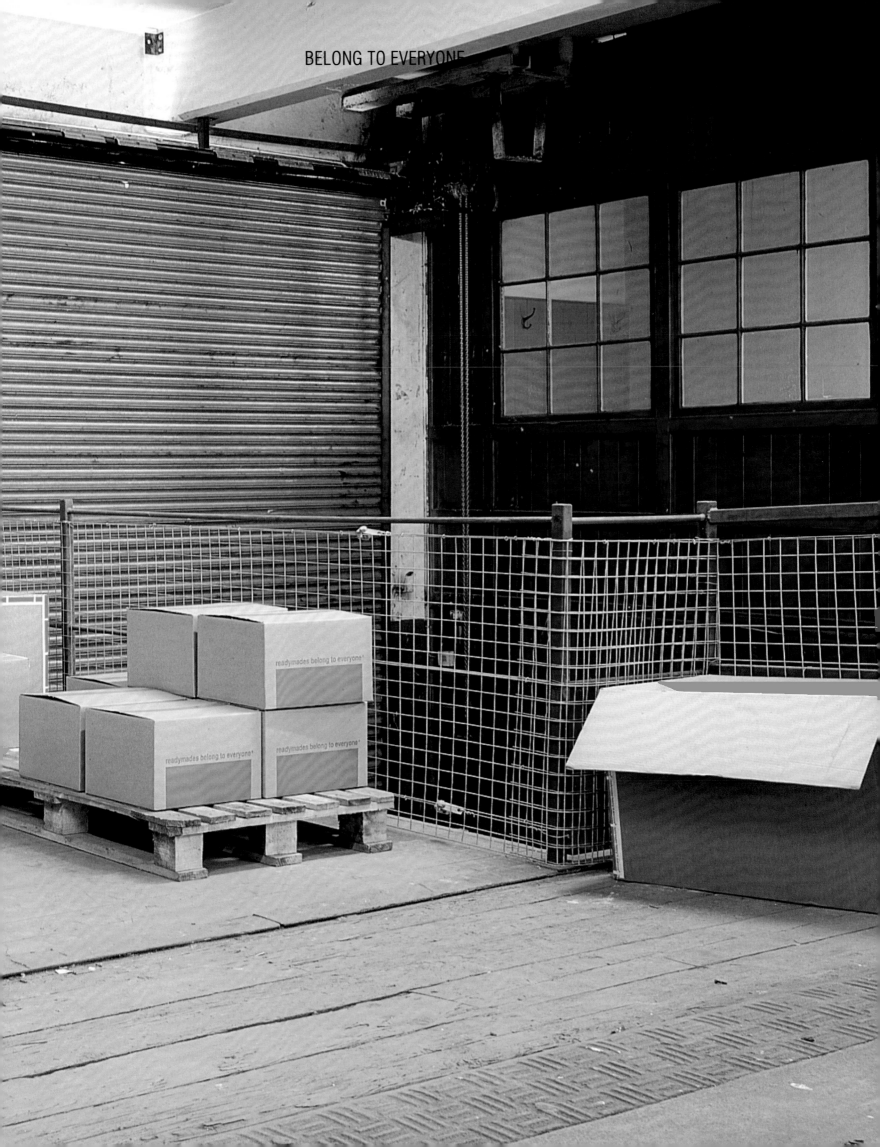

Now Available In POSTCARDS

32 works selected from the story of readymades belong to everyone®
Published by Tyne International and Kunstverein in Hamburg

Marc Blondeau
Paris, 1990
Lisboa, 1991
Bordeaux, 1991

capcMusée d'art contemporain de Bordeaux
Inventaires du mémorable, Feux Pâles, 1990
Inventories of memorabilia, Feux Pâles, 1990
L'art d'accommoder les restes, Feux Pâles, 1990
Creative use of leftovers, Feux Pâles, 1990

Jay Chiat
Insight, 1989
Insight, 1989
Insight, 1989

Chiat/Day/Mojo
Advertising for the agency readymades belong to
everyone, 1990
Publicité pour l'agence readymades belong to
everyone, 1990

Alain Clairet
Grand Fond, 1990
Tiefer Grund, 1990
Passif de la modernité, Feux Pâles, 1990
Passiva der Modernität, Feux Pâles, 1990
capcMusée d'art contemporain de Bordeaux

Dolci dire & Associés
Pour un art de société, 1988
Für eine Gesellschaftskunst, 1988

Christophe Durand-Ruel
Souvenir écran, 1988
Screen-memory, 1988

Denyse Durand-Ruel
®, 1990

Jedermann N. A.
Propriéte privée, 1990
Privatelgentum, 1990
Collection capcMusée d'art contemporain de
Bordeaux

Bertrand Lavier
®, 1989

Leagas Delaney
Advertising for the agency readymades belong to
everyone, 1990
Publicité pour l'agence readymades belong to
everyone, 1990

Tullio Leggeri
Natura Morta & Modernita, 1992
Still life & modernity, 1992

Edouard Merino
Insight, 1989
Insight, 1989

Massimo Minini
®, 1990

Giancarlo Politi
Credito, 1992
Kredit, 1992

readymades belong to everyone®
The agency, 611 Broadway, New York, 1987
Advertising, Advertising, 1988
Publicité, Publicité, 1988
La Pétition de principe, 1988
Grundsatzantrag, 1988
1990
Depôt, Kassel, 1992
Lager, Kassel, 1992

les ready made appartiennent à tout le monde
Un cabinet d'amateur, 1991
Ein Kunstkabinett, 1991

Rottke Werbung
Advertising for the agency readymades belong to
everyone, 1990
Publicité pour l'agence readymades belong to
everyone, 1990

Jacques Salomon
L'obligation de réserve, 1988
The need for reserve, 1988
Etude de cartel No 6, 1990
Studie zur Beschilderung No 6, 1990

Collection of Georges Venzano
Documentation capcMusée d'art contemporain de
Bordeaux, 1990

Georges Verney-Carron
Agencement 88, 1988
Zusammenstellung 88, 1988

Pages 30-31 and OPPOSITE: mixed media installation, 1993, the CWS Warehouse

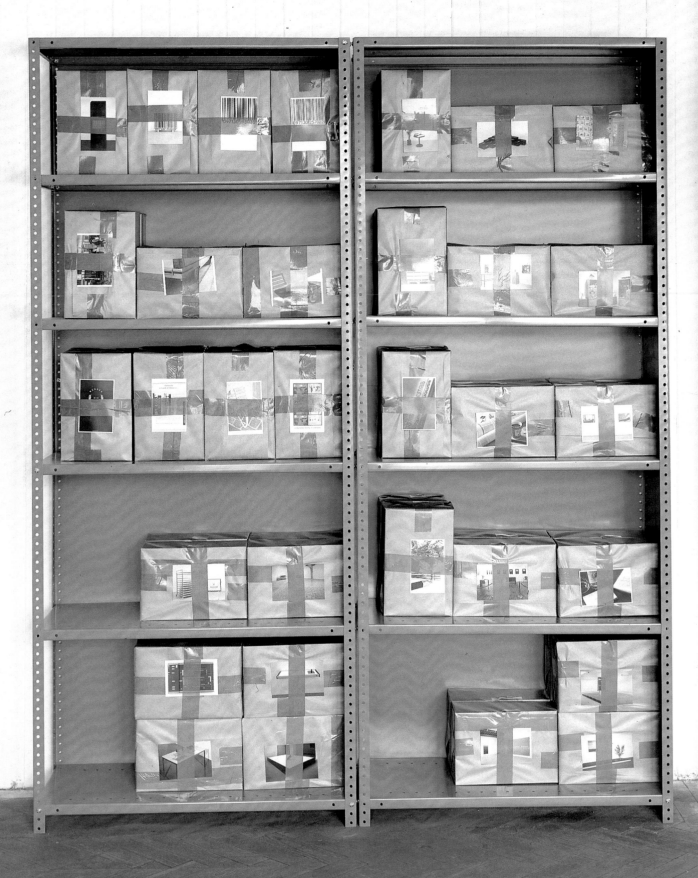

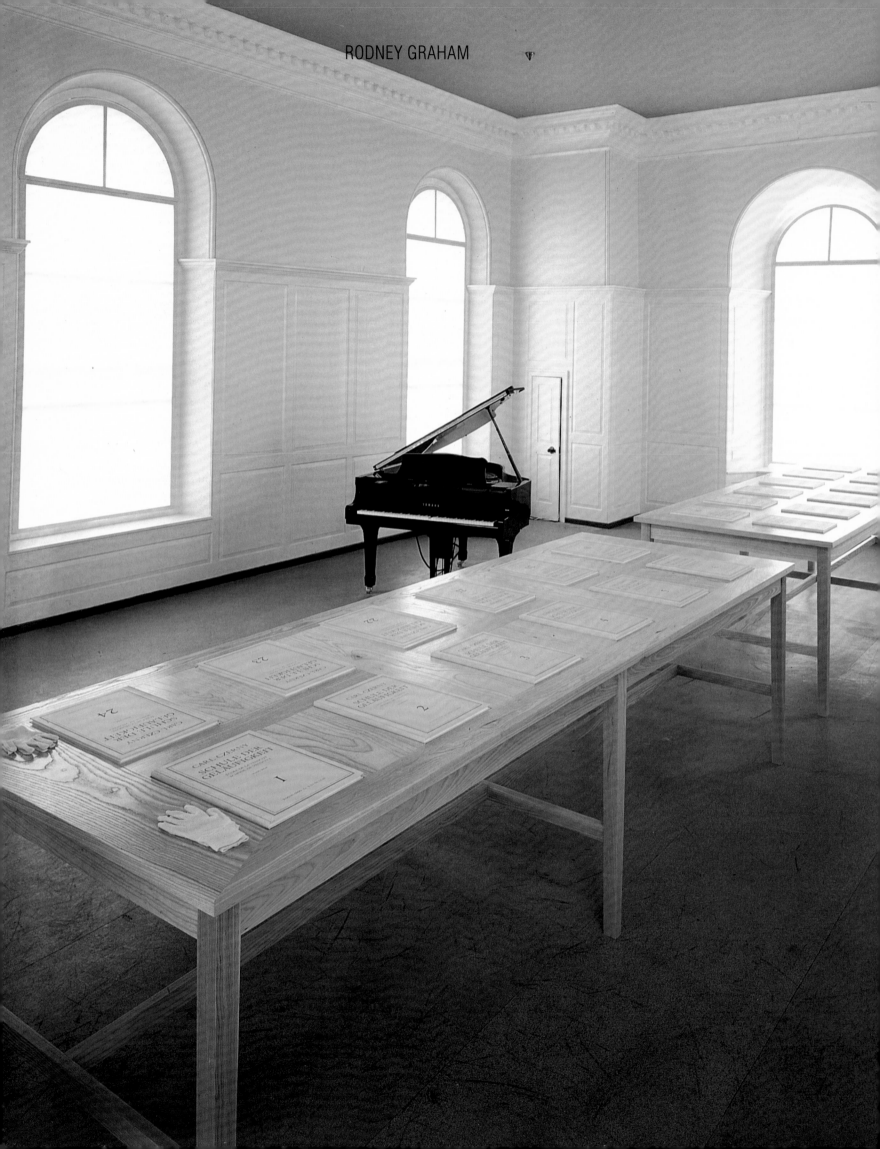

RODNEY GRAHAM

The School of Velocity

The installation for *The School of Velocity* in the Sally Port Tower represents the first fully-realised version of a work which I began around 1978. It was then that I ran across an article in *Scientific American* magazine by the historian of science and Galileo scholar Stillman Drake, which put forward the theory that Galileo's discovery of his Law of Free Fall was deduced from (and not just tested by) direct empirical observation of a ball rolling down a ramp, and that Galileo's experimental technique was aided, or even guided, by an intimate knowledge of music inherited from his father Vincenzo Galilei, a composer and music theorist.

The problem, according to Drake, was how to equalise short intervals of time (there were no time-keeping devices available to Galileo that could do this) and the solution was for Galileo to draw on his own inner sense of time and rhythm, a sense that, as the son of a trained musician, and a skilled lutenist himself, he had developed to a high degree. Drake describes a reconstruction of Galileo's experiment:

> Place a grooved inclined plane about 6.5 feet long at an angle of about 1.7 degrees. Fit a stop at the higher end, against which a steel ball can be held by resting a finger on it lightly. Now sing a simple march such as 'Onward, Christian Soldiers' at a tempo of about two notes per second, very crisply. When the tempo is established, release the ball at some note and mark with chalk the position of the ball at other notes (half-second intervals). In three or four runs eight positions can be marked; put a rubber band around the plane at each mark. (Galileo would have tied gut frets at these places, in the way that adjustable frets were tied around the neck of a lute, but of course today rubber bands are easier to place and adjust.) Then, making many repeated runs, adjust the rubber bands so that the audible bump made by the ball in passing each one always coincides exactly with a note of the march. When the inclined plane has thus become a kind of metronome, measure the distance in millimetres from the resting position of the

ball to the bottom of each rubber band. The ratios of the successive points from rest should be as to the squares of the marked times: 1 4 9 16 25 36 49 . . . from which the Law of Free Fall can be deduced. Drake goes on to observe how Galileo may have been further influenced by his father, who had himself used empirical experimentation in demonstrating that weights loading similar strings of equal length that sound a given musical interval are as the inverse squares of the string lengths sounding the same interval under equal load. 'Music', Drake observes, 'thus appears to have a dual role in the beginnings of experimental science since both pitch and time played their part.'

Drake's account of the experiments of Galileo and his father and the glimpse of the so-called North-West Passage between art and scientific certainty which the account provided, subsequently inspired me to undertake a number of musical projects based on the Law of Free Fall – but all my efforts were unsuccessful.

Eventually, however, a routine exploration of a Vancouver music store yielded a copy of Carl Czerny's *School of Velocity*, a collection of piano exercises whose title alone illuminated my way.

As Beethoven's student and Liszt's teacher, Czerny occupies an important place in the inculcation and transmission of the pianistic technique of romanticism – and ultimately, the aim of Czerny's *School* is quite simply *pure acceleration*, since after completing Czerny's exercises the virtuoso presumably is able to play faster than when he began them.

My own composition, finally completed in 1992, and also entitled *The School of Velocity*, proceeds from this last observation. Employing the interpolating method that I used in many of my text-based works (*The System of Landor's Cottage*, *Freud Supplement 170a-170d*, *The Piaza 4.1*, *Parsifal*) I submitted Czerny's musical text to the following operations:

Taking the first 1116 16th note events (the first three and a portion of the fourth exercise in Czerny) I make these events *fall*

OPPOSITE: The School of Velocity, 1993, Yamaha disklavier grand piano, silk screen, handmade presentation tables, installed in the Sally Port Tower

on their squares according to the Law of Galileo. That is, the first marked 16th note beat of Czerny falls on the first marked beat of my composition, the second 16th note beat falls on the fourth beat of my work, the third 16th note beat of Czerny's *School* falls on the ninth beat of my *School*, the fourth falls on the 16th, the fifth on the 25th etc . . . until the 1116th 16th note beat of Czerny's original falls on the 1,245,456th beat of my (greatly expanded) work. The musical spaces that my composition creates are filled with rests – in fact my *School of Velocity* is nothing more than the systematic interpolation of rests (silences) according to the Law of Free Fall. The composition may be seen as an analogue for the successive points of descent occupied by a pianist performing Czerny's original exercise while freely falling through space *or* as an inversion of Galileo's Law, since the work effectively introduces uniform deceleration (increasing silence) into the performance of the original, and this uniform deceleration is inversely proportional to the Law of Free Fall.

I limited my work to the 'squaring' of the first 1116 notes of Czerny's *School* because the performance of these notes according to the Galilean system takes exactly 24 hours (one solar day) when performance at M.M. \natural = 864.9, a slight modification of the original tempo indicated by Czerny.

As a daily velocity exercise my *School*, which commences at 9.00am, is intended to be performed in a perpetual diurnal cycle the period of which is identical to that of the Earth's daily rotation with reference to the Sun. This cosmic scale is not arbitrary – it is already, in a sense implied in the calibration of Maelzel's metronome (to which Czerny's original tempo indications implicitly refer) whose unit of time is the *astronomical second*, a precise fraction of the mean solar day.

The School of Velocity has been sequenced by Gary Bourgeois for perpetual performance on a Yamaha Disklavier over the entire duration of the exhibition. The complete score of the work in conventional notation is shown here in 24 volumes of 60 pages each. The bars on which Czerny's original note-events fall are highlighted in red.

Wall-Knoll Tower or Sally Port Tower

The short history of the Sally Port Tower which follows has been compiled by Paul Holloway. The accompanying photographs document material from the most recent archaeological strata of the building relating to the musical history of the tower room (which was used as a rehearsal space in the 1980s). This material was uncovered by Paul and myself during my first visit to the site in February of this year.

The tower seems to be referred to under a series of different names, which reflect both the changing use of the building and the demography of the immediate area around the tower.

It seems that the area as a whole was commonly known as Wall-Knoll as early as the 12th or 13th centuries. There was a monastery at Wall-Knoll in 1287, by 1361 this was owned by the Carmelites (or White Friars). Edward III granted the Carmelites permission to sell Wall-Knoll to Sir William de Acton to found the Hospital of St Trinity. This hospital is long since gone, but there is still a hospital within a few yards of the tower – the Keelmans Hospital, which was built in 1701 from private donations.

In 1546 a house at Wall-Knoll was granted to Sir Richard Gresham and Richard Bollingford. In 1548 this passed to William Dent, being described as 'the house or priory of St Michael de Wall-Knoll with a garden and orchard of about an acre of ground, an enclosure or close near the town wall . . .' In 1582, William Dent gave the whole lot to the City, who are still the owners of the Wall-Knoll Tower.

Bourne's History of Newcastle *of 1736 sheds some light on the origin of the name – 'Wall Knoll is a very ancient place, which our historian Grey says positively, was in a part of the Picts Wall and the very name of it speaks as much. For the word WALL upon the KNOLL, which signifies an hill or eminence, cannot be understood of any other than the Roman wall, because it had this name from very ancient times, long before the building of the town wall, to which it adjoins'.*

Brand's History of Newcastle *of 1789 says: 'A street winds up an high hill from the ancient Fisher Gate to the place which still retains the name of Wall-Knoll, which it has, no doubt, derived from the circumstance of the Roman Wall's having gone over the top of it.'*

SALLY PORT TOWER
The tower is also known as the Sally Port Tower. Mackenzie's History of Newcastle *says: 'The ancient postern gate in this tower was usual passage of those divisions of the garrison that so frequently sallied out and attacked the besieging army during the civil wars. It is probably from this circumstance that it is called the Sally-Port Gate'.*

Finally, again referring to the Wall Knoll or Sally Port Tower, Bourne's 1736 History says: 'This is commonly called the Carpenter's Tower because the Company of Carpenters or Shipwrights meet in it, was one of the old

RODNEY GRAHAM

Romans. This company in 1716 built upon the under part of it a very grand and stately square tower, adorned at the top corners with four fair turrets built in the form of a lanthorn'.

So, the tower is more than likely to have Roman foundations, it has a medieval first level and an 18th-century top. The meeting room is accessed from the outside by way of an external stair. Below this are two rooms, the first is the main gateway room with large oak doors on each side, the second is the old guard room, with the remains of an old circular stair, fire-places, etc. The meeting room has been very recently decorated, has a full heating system, sink, etc. There are also toilet facilities on the ground floor. The city has been letting the building out on a casual basis for a range of local activities from Northumbrian Pipers to Tai Chi, Morris Men to Bible groups. No one is using the building at present.

PARSIFAL 1882 – 38, 969, 364, 735

This work was inspired by an anecdote concerning an incident in the life of Richard Wagner. The following story involves some musical material added to Wagner's *Parsifal* by Engelbert Humperdinck:

In 1882, while rehearsing for the premiere performance of *Parsifal* in Bayreuth, Wagner encountered a technical difficulty involving the synchronisation of music and scenery during the so-called Transformation Scene in the opera's first act. In this scene Parsifal ascends the rocky slope to Monsalvat and the Temple of the Holy Grail to the accompaniment of a four minute orchestral passage. The problem concerned the 'transformation curtains' comprised of four vast canvases painted with landscape scenery, and which, carried across the stage by means of rollers, were to create the illusion of Parsifal's movement through a constantly changing landscape. It happened that the curtains were too long and the music too short – the latter invariably ran out before Parsifal reached the Grail Temple. When asked by the scenic designer for more music Wagner refused, reportedly replying, 'I do not write music by the metre!' Fortunately the composer Engelbert Humperdinck, Wagner's assistant, wrote some additional bars which (somewhat to Humperdinck's surprise) the master accepted. Hastily written into the orchestral score, the interpolated passage served to co-ordinate pit and stage for the first few festival performances. Later, when the canvas was trimmed and the stage machinery overhauled, Humperdinck's contribution was no longer needed and was dropped from the score.

In 1987, as part of my research for a project intended for exhibition at La Monnaie Opera House in Brussels, I began looking for Humperdinck's additional music for *Parsifal*, eventually obtaining a copy through Serge Dorny of La Monnaie, who had traced the manuscript to a library in Munich. Serge and I examined the manuscript (a single 26 ½ by 35cm sheet with the heading *Ergänzungsstück zu No 90 der Partitur*, and containing a total of 9 bars of music – 4 recto, 5 verso): we were interested to discover that Humperdinck had, in fact, written no 'new' music, merely manipulating some bars at section No 90 of the Wagner score (see page 212, *Eulenburg Miniature Score*), so that Wagner's music could be joined back to itself at an earlier point – precisely at the beginning of section No 87 (page 206, *Eulenberg Miniature Score*). In other words, by adding nine bars to the 24 bar original, Humperdinck had made, in his *Supplement to No 90*, a loop of 33 bars which could be played as many times as were necessary to synchro-nise with Parsifal's arrival at the Grail Temple.

Parsifal (5.00pm, Wednesday, July 26, 1882 to 7.30pm, Monday, June 18, 38, 969, 364, 735 AD) continues Humperdinck's method, introduc-ing a system of epicycles within his loop, by way of supplementing his supplement. My method was to create a number of musical loops of incommensurable lengths using the 14 prime numbers between three and 47. I began by adding to the seven bars commencing at Wagner section No 89 (which falls within Humperdinck's loop – see page 211, *Eulenburg Miniature Score*) a total of 40 bars to produce a 'new' 47 bar passage. Then working down from the top of the score at No 89 I assigned prime number values in ascending order from three to 47 bars to each of the 14 instrumental sections of the orchestra. Thus, I had the flutes repeat the first three bars of the 47 bar passage, while the second oboe repeated the first five bars, the first oboe the first seven bars, the alto oboe the first 11 (seven bars plus fours bars of rests), the first and second horns the first 13 (seven bars plus six bars of rests) and so on.

Since each prime number is divisible only by itself and one, it is easy to see that these asynchronous loops will cross one another, phasing over many bars. Indeed the whole orchestra does not join up with itself again until 47 x 43 x 41 x 37 x 31 x 29 x 23 x 19 x 17 x 13 x 11 x 7 x 5 x 3 or 307, 444, 891, 294, 246, 706 bars have elapsed. Furthermore, since it is in common time, and since I have assigned to it a slow march tempo of one quarter-note per second, the work unfolds over a period of 1,229,779,565,176, 982,820 seconds, over 39 billion years.

The system of my *Parsifal* elaborates itself within Humperdinck's *Supplement to No 90*. No 90 was reached by the Bayreuth Festival Orchestra at about 5.00pm on Wednesday, July

RODNEY GRAHAM

fig. 1

fig. 2

26th 1882. At this time the orchestra commenced playing through Humperdinck's No 89. Here is one possible universe, it entered into my supplement which it played, is playing, and will continue to play until the orchestra is again synchronised with itself, whereupon my *Parsifal* will join Humperdinck's supplement at No 89, before finally re-entering Wagner's opera at No 90. The Bayreuth Festival Orchestra will reach No 89 in the remotely distant future. I have accepted as the time of this event 7.30pm on Monday, June 18. 38. 969. 364, 735 AD as calculated by Chris Blake of the Department of Geophysics and Astronomy at the University of British Columbia. His calculations, however, were made on the basis of perpetual calendar algorithms which do not consider certain possible perturbations of time.*

The phase relations of the instrumental parts on the days exerpted on the CD recording were calculated by Gary Bourgeois and Daniel Congdon on the basis of an equinoctial year of 365 days, 5 hours, 48 minutes and 46 seconds.

* AH Batten of Herzberg Institute of Astrophysics argues against the possibility of computing a meaningful completion date for *Parsifal*:

July 24, 1990
Dear Mr Graham
Thank you for your fax of July 23rd. First, I have checked your arithmetic (at least to the first twelve significant figures) and agree with you as to the number of seconds involved. Contrary to my initial reaction on the phone this is, in years, much longer than you suggested – at least if I heard you correctly. With 3.156 x 10⁷ seconds in a year, your figure comes out at approximately 39 billion years – much greater than the presently believed age of the universe.

In view of this, I have thought more carefully about your request and have concluded that it is meaningless to attempt to compute a day of the week etc on which your 'opera' would end. Of course, as you yourself pointed out, the Sun would cease to shine long before that and who knows what the state of the universe will be by

then? Leave that on one side, however, and imagine for the sake of your argument that the Sun will shine at its present luminosity for ever. There are still difficulties. Let us also imagine, at first, that the Earth continues to go round the Sun at its present distance and to rotate on its axis at its present rate. Even under these unrealistic assumptions, our present calendar could not be used that far ahead: it would get so hopelessly out of synchronism with the seasons that several reforms like the Gregorian one would have to be made. Probably, our imaginary descendants would junk the whole thing and come up with some sort of world calendar of the type that presently provides a happy hunting-ground for cranks. In fact, as you are well aware, the length of the day, month, year are all changing. The present rates are known, but we cannot extrapolate them that far ahead. Even the most enthusiastic computer-modellers of the solar system wouldn't claim that they could do that! There is also the possibility, over such a long period, of the close approach of another star that would change everything. I think it would be a little irresponsible of me to pretend that I could compute a meaningful date for you for a time when the day and the month might will be equal and the year much shorter than it is now. In so far as I understand what you want to do, it seems to me that you have two possible courses of action. One is to choose a date and a day out of the hat – it could be a significant anniversary – but not to pretend it is an accurate calculation. The other is to emphasise that the 'opera' would transcend the whole life of the universe itself and is, in some sense, eternal. Since I gather there is some connection with Wagner, this might go down well. I sometimes have the impression that music-lovers are divided into two camps: those who wish Wagner's music would go on forever and those who fear it is doing just that!

I am sorry that this is a little inconclusive from your point of view, but my considered opinion is that the kind of calculation you have in mind would not be meaningful.
Yours sincerely
Alan H Batten

fig. 4 - Parsifal Phase Schema

38

CHRISTINE BORLAND

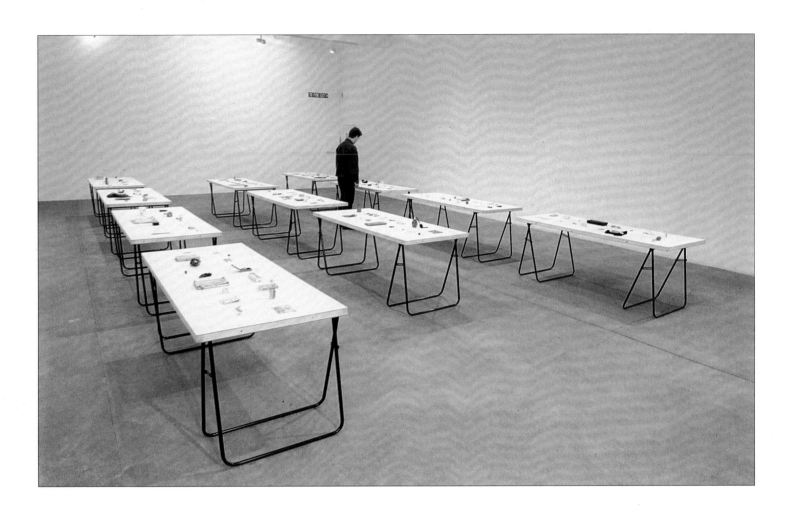

Chisenhale Gallery, Small Objects That Save Lives, *March 1993, 300 people from the gallery's mailing list were sent a letter asking them to choose an object in response to the above title. The objects were posted to the gallery and displayed bearing the names of their owners.*

Tony Arefin

Susan Johnston

Jill Henderson

Nicola White

Sian MacQueen

Tessa Jackson

Callum Innes

Tom O'Sullivan

Boris Achour

CHRISTINE BORLAND

Gordon Weinstein

Stephen Snoddy

Andrew Nairne

Rachel Bradley

Jonathan Watkins

Elizabeth Magill

Katherine Wood

Katrina Brown

Simon Patterson

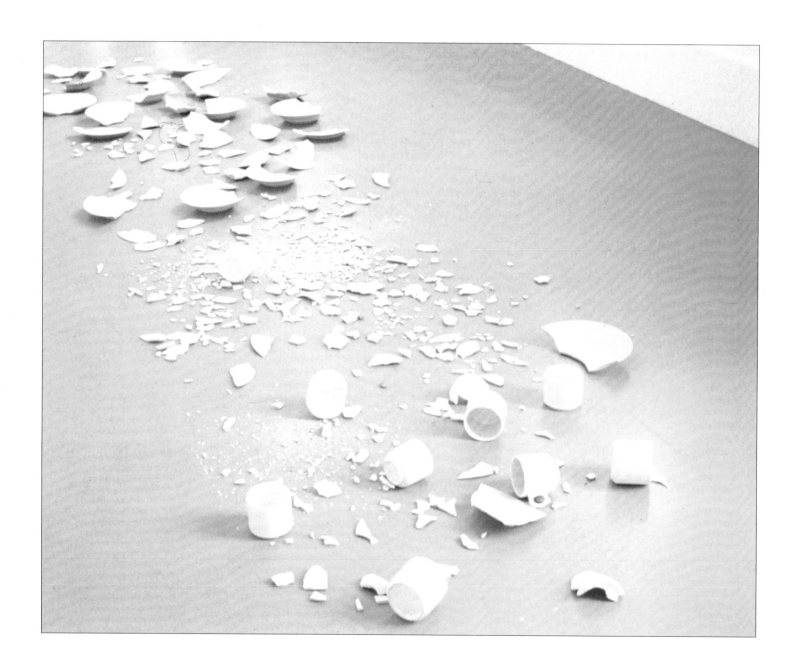

ABOVE: Weakness, Disaster, Old Age & Other Misfortunes, .38 Special Colt Commando Revolver, (detail), from Guilt by Association, Irish Museum of Modern Art, Dublin, Ireland, September 1992; OPPOSITE: A place where nothing has happened, 1993, portacabin off Broadchare, Newcastle upon Tyne

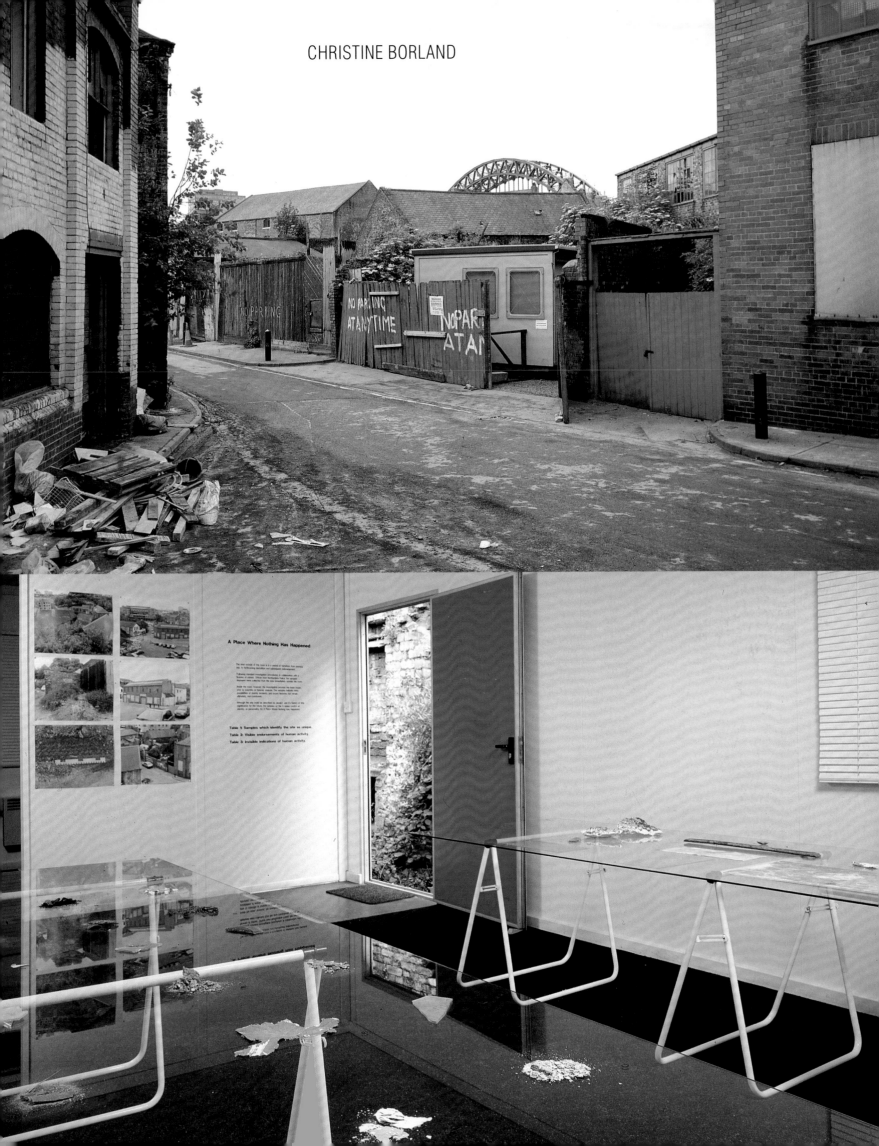

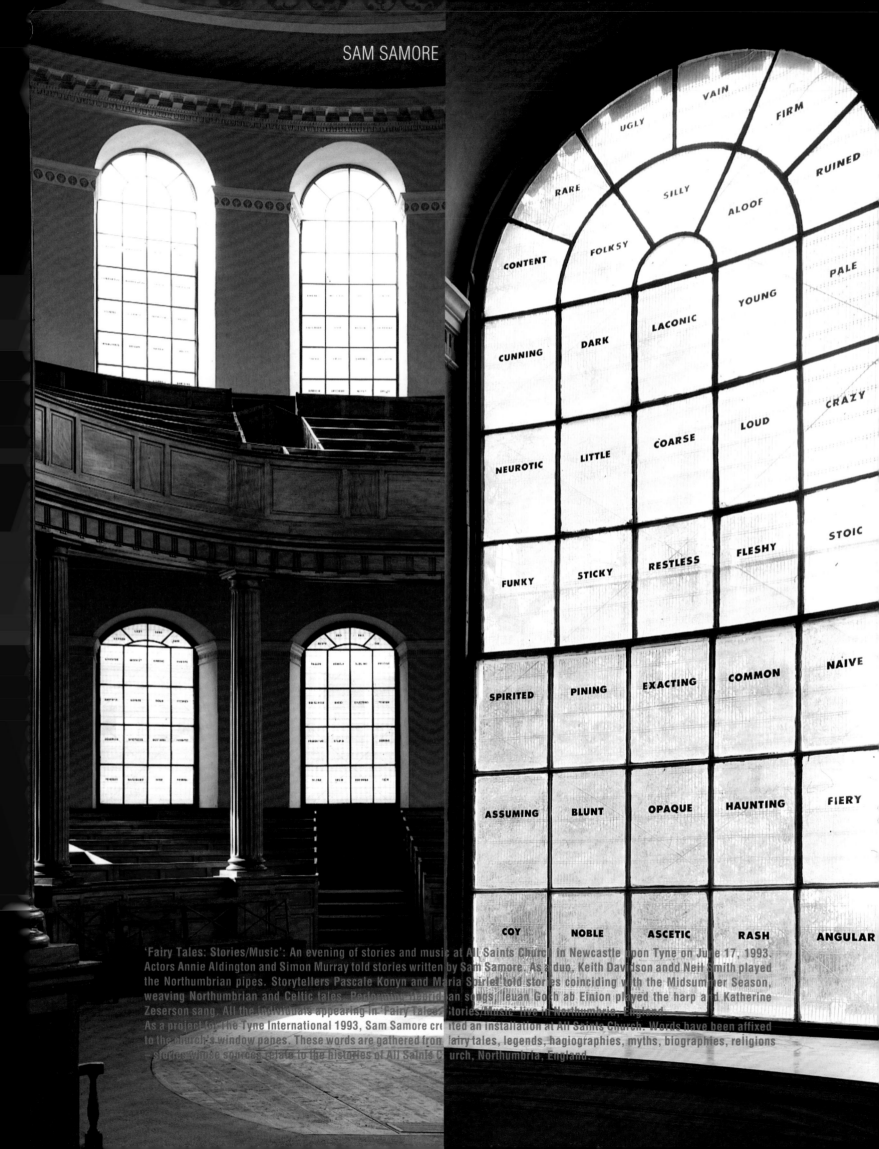

SAM SAMORE

UGLY VAIN FIRM RUINED

RARE SILLY ALOOF

CONTENT FOLKSY PALE

YOUNG

LACONIC

CUNNING DARK

CRAZY

COARSE LOUD

NEUROTIC LITTLE

STOIC

FLESHY

FUNKY STICKY RESTLESS

SPIRITED PINING EXACTING COMMON NAIVE

ASSUMING BLUNT OPAQUE HAUNTING FIERY

COY NOBLE ASCETIC RASH ANGULAR

'Fairy Tales: Stories/Music': An evening of stories and music at All Saints Church in Newcastle upon Tyne on June 17, 1993. Actors Annie Aldington and Simon Murray told stories written by Sam Samore. As a duo, Keith Davidson andd Neil Smith played the Northumbrian pipes. Storytellers Pascale Konyn and Maria Sbirlet told stories coinciding with the Midsummer Season, weaving Northumbrian and Celtic tales. Performing Hebridian songs, Ieuan Goch ab Einion played the harp and Katherine Zeserson sang. All the individuals appearing in 'Fairy Tales: Stories/Music' live in Northumbria, England.
As a project for The Tyne International 1993, Sam Samore created an installation at All Saints Church. Words have been affixed to the church's window panes. These words are gathered from fairy tales, legends, hagiographies, myths, biographies, religions stories whose sources relate to the histories of All Saints Church, Northumbria, England.

SAM SAMORE

JACK AND THE BEANSTALK

Once upon a time, there lived a cow Milky-white who took care of a poor widower, and his son, Jack who was a handsome, clever lad. The two depended upon Milky-white, since they sold her milk each day at the town market. But one day, Milky-white no longer gave milk and they had no money left to live on.

'All is lost!' cries the father.

'We'll manage somehow dad. I'll look for work', says Jack.

'There are no jobs to be found! We must sell Milky-white, and maybe we can open a store.'

That afternoon, Jack and Milky-white began their long journey to the market. They hadn't travelled very far, when they met a peculiar old woman standing by the side of the road. She appeared from out of nowhere.

'Good morning Jack', says she.

'Good morning to you', replies Jack, puzzled by how she knows his name.

'I'll trade your cow for these beans', says she, holding them gently in her gnarled hands. Some are pink, others are square. 'They're magic beans. If you plant them overnight, by morning they'll grow up to the sky!'

Well, Jack had no intention of selling Milky-white – they had played together since they were babes, but Milky-white says,

'Jack, if you take those beans, I know you'll find a treasure.'

So Jack traded Milky-white for the beans and ran home to tell his father the good news.

'How much did you get for Milky-white?' asks his father.

'You won't believe our luck! I traded her for a big handful of magic beans!'

'What! What kind of a fool are you?!'

Jack's father grabbed the beans and threw them out of the window.

'Now off to bed! We have nothing left to drink or eat tonight!' says the father.

Jack woke up to a bright, sunny morning, but something was odd because now his room was covered in shade. Jack rushed over to the window. What do you think he saw? Of course, the beans his father tossed away had sprung up

into a towering beanstalk, growing higher and higher until it disappeared into the clouds. So the crone had told the truth after all!

Jack ran outside and started climbing up the stalk. He climbed and he climbed and he climbed and he climbed until at last he reached the sky. At the top of the clouds he began sauntering along a path leading to an enormous house which spanned the length of three football fields. Sitting on the front doorstep was a very big tall man.

'Good morning', says Jack politely, 'I'm awfully hungry – do you have any lunch?'

'It's lunch you want is it?' laughs the very big tall man, 'I'm about to cook lunch for my wife and she gobbles up everything – she's a giant y'know.'

'Please! Please! I won't eat very much – I've not had a bite all morning!' cries Jack.

The giant's husband smiles and ushers Jack into the kitchen, pushing in front of him a slice of bread and cheese and a glass of juice. While Jack's gulping down his food, he hears a loud thump! thump! thump! The whole house begins to tremble with the footsteps of someone approaching.

'Oh no! It's my wife. I haven't finished making lunch', cries the giant's husband. 'She'll be mighty upset – no telling what on earth she'll do. Come on Jack – jump into the broom closet here.'

Jack hid away just as the giant strode into the kitchen. She was a big one, to be sure. Certainly she towered above the tallest tree in the forest. She had bulging muscles and a twinkle in her eye. Slung along her belt were six barrels of apples. She unhooked the barrels, letting the apples spill onto the table.

'Would you please make a bowl of apple sauce for lunch!' roars the giant.

'Hmm. What's this I smell – '

'Fee fi fo fum, I smell the blood of an Englishman.'

'Nonsense, dear,' grins her husband, 'You're dreaming. Why don't you sit down, read the newspaper, and I'll prepare lunch for you.'

After the giant eats a hearty meal, she walks over to a cabinet the size of a barn and takes from a shelf four bags of diamonds. Down she sits to look at them, making notes from time to time in her journal. Soon her head begins to nod, her eyes close and she's fast asleep.

Jack creeps out of the closet and tiptoes up to the four bags of diamonds lying on the table. He quietly stuffs one under his arm and off he runs to the

beanstalk. He slides down in a wink.

They lived on the bag of diamonds for quite some time, and of course Jack bought back Milky-white. Since she didn't have to worry about producing milk for their livelihood she enrolled at the University. But at last there came a day when only a few diamonds remained. Jack made up his mind to try his luck once more. He rose early in the morning and climbed and climbed and climbed up the beanstalk until he came upon the wide road. Again he arrived at the entrance to the enormous house, where the very big tall man was sitting on the doorstep.

'Good morning to you', says Jack. 'Could I have a bite to eat?'

'Go away my boy!' cries the very big tall man, both annoyed and amused. 'Aren't you the youngster who visited before? Do you know the same day you come, one of our bags of diamonds disappeared?'

'That's strange. I think I could tell you something about that if you'd kindly let me in for breakfast.'

The very big tall man is curious to hear the story, so he takes Jack in and gives him something to eat. But while Jack is munching on a scone, he hears the thump! thump! thump! at the giant's footsteps. Off he scampers to the closet.

All happens as it did before. In walks the giant and after her breakfast of eight loaves of bread and twelve bowls of cereal, she strides over to the coop – the size of a castle – to fetch the hen that lays the golden eggs. Back in the house, sitting at her rocking chair, the giant sings –

'Little hen, pretty hen
Please lay me an egg
As fast as you can.'

Out pops an egg of solid gold. She picks it up in her hand and carefully places it in a glass box. She sits down in her rocking chair to admire the egg, making notes in her journal. By and by the giant begins to feel drowsy, and pretty soon she nods her head. She's snoring so loud the house shakes like thunder.

Jack slips out of the closet, catches hold of the golden hen and off he goes down the beanstalk.

With the hen laying golden eggs every day, Jack and his father become very wealthy, so rich indeed that they built a large house, surrounded by gardens filled with fruit trees and shady arbours. But Milky-white was hardly around since she was lecturing abroad. Now there came a time when Jack grew restless.

He wanted something more. So he decided to climb the beanstalk one last time.

Up he climbs. Higher. Higher. Higher. Till he reaches the clouds. He arrives at the road again. He cautiously walks up to the enormous house and knocks on the front door. The very big tall man answers. He doesn't recognise Jack in his fine new clothes.

He tells Jack he's not inclined to invite him in. There was a time he had trusted a child asking for food and a place to stay, but in return the boy had stolen some of their treasures. But Jack seems sincere and the very big tall man, who wants to be hospitable, invites him in for supper.

In the evening the giant stomps into the house, roaring so loudly the door hinges rattle:

'Fee fi fo fum

I smell the blood of an Englishman.'

'Don't be foolish', says the husband. 'It's nothing but the smell of my mushroom pie.' Again Jack hides in the broom closet.

After a dinner of stew served in a bowl the size of a swimming pool, the giant calls out to her harp. It is the most exquisite harp you could imagine. The giant requests a song and the harp plays an enchanting melody. By and by, the lovely music lulls the giant into a deep, dream-filled sleep.

Jack too is enchanted by the music. Of all the treasures, the harp fill him with the most wonder. So he resolves to steal it. He tiptoes quietly, but when he clasps the harp and runs out of the door, it cries out, 'Help! Help!' The giant awakes with a mighty shout, and starts after Jack. She catches him just before he's about to slide down the beanstalk and then she carries him in the palm of her hand back to the house.

'Jack, my lad', says the giant, 'I've been meaning to have a word with you—but somehow I fall asleep after a hard day's work: and you've run off. This time I figure we should talk. Those particular diamonds were never important to me. Mind, I hope you're taking good care of my hen! Now I'll kindly lend you my magic harp, if you promise me you'll return with it every so often so we can share its marvellous sound together.'

Jack asked the giant and her husband to forgive him for all the trouble he had caused. He promised to gladly return each week to share the harp. He kept his word and they all lived happily and well for the rest of their lives.

PATHOLOGIQUE

FOOLISH STINGY CRUEL

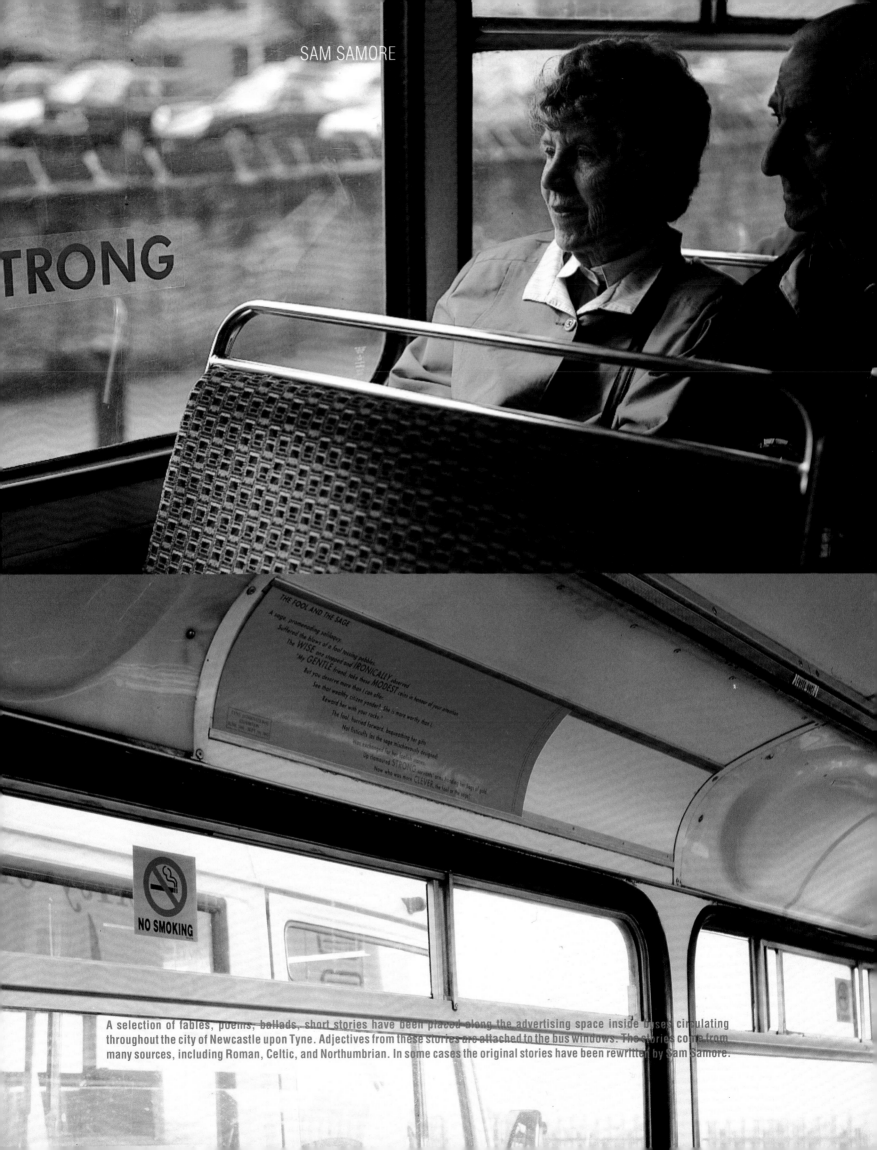

SAM SAMORE

THE FOOL AND THE SAGE
A sage, promenading soliloquy.
Suffered the blows of a fool tossing pebbles.
The WISE one stopped and IRONICALLY observed
"My GENTLE friend, take these MODEST coins in honour of your attention.
But you deserve more than I can offer.
See that wealthy citizen yonder? She is more worthy than I.
Reward her with your rocks."
The fool, hurried forward, bequeathing her gifts
Not fisticuffs los the sage mischievously designed
that exchanged for her foolish stones.
Up treasured STRONG serpents arm, hording her bags of gold.
Now who was more CLEVER, the fool or the sage?

A selection of fables, poems, ballads, short stories have been placed along the advertising space inside buses circulating throughout the city of Newcastle upon Tyne. Adjectives from these stories are attached to the bus windows. The stories come from many sources, including Roman, Celtic, and Northumbrian. In some cases the original stories have been rewritten by Sam Samore.

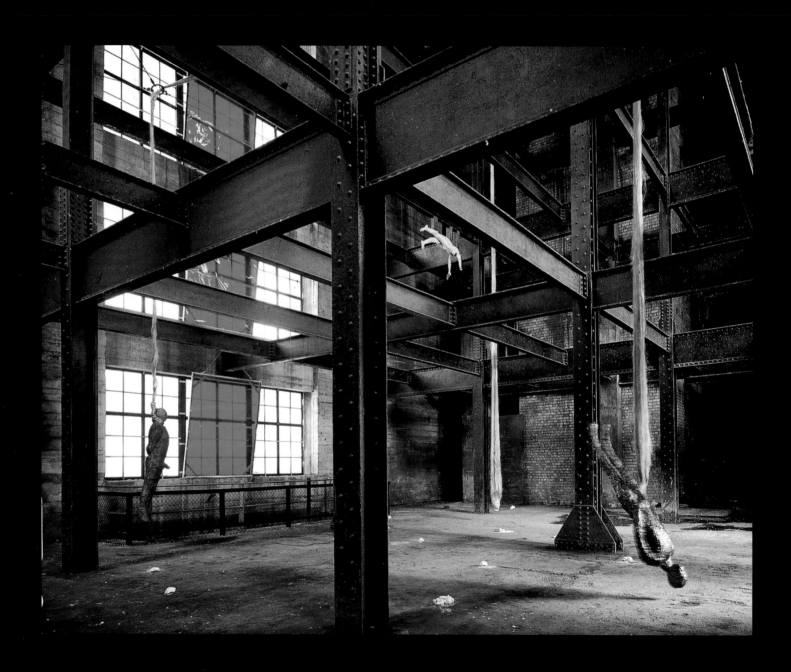

ABOVE: *Seeding Mermaids*, 1993, cast iron, rubber, copper wire, resin, latex,
installed in the South Tower of the Tyne Bridge

WHAT WERE THOSE BODIES DOING THERE?

I should have got rid of them, I could not have looked at them, but once there, never to forget them, it was too late. It is not that they were dead and from that situation would come my astonishment. They were not, and as for the place, I knew it was not a grave or a morgue. Maybe a cenotaph, I think, and for that reason, maybe, the uncomfortable unfamiliarity. That was not my case, I had other reasons to find the place, and mostly that scene, unfamiliar. It was necessary to investigate the peculiar nature of that icon. I do not believe in the foggy semiology, still less in improbable exegesis. Some mnemonic recollections showed clearly that I was a witness of the intentions that were present there. To attend to that emblem forced me to a meditation and I can affirm that I was referred by it to chimeras. Chimeras from a culture. What could be cultivated under that sign?

Yes, a phoenix, I would say, the way back, the recurrence, the obstinate return!

I could affirm something more concrete, however, as I remember that what I saw was the fruit of another culture, not less strange but much more evident. The construction of a garden, somehow different from the realms of Arenhaim but perhaps as intense as them. I was trying to cultivate specimens with the non-confessable aim of the 'occasional testers'. My prodigious garden was flourishing and I was concentrating slowly on a specific root. A rather peculiar one, anthropomorphic and of a prestigious reputation. Commonly known as devil's apple, or hanged man flower, the toxic intensity of this vegetable is well known; from it, the aphrodisiac, inebriant and even poisonous qualities. It is known that the Mandragora with black flower is the lily that adorns the doors of hell. That its root, with the shape of a female homunculus cries a poignant cry if torn away from its earthly

immersion. But - and moreover - it is known that there is only one way of planting such a selenacea, and it is by germinating it with the semen, from the human sperm, ejaculated during the erection from the penis of a hanged man. I devoted myself to that and what happened is therefore the fruit of such a culture. My conspicuous involvement with this vegetable brought me to the adorned black door which I referred to, through which I passed.

* * *

One more dawn was gone, a beautiful sun shone purple. I went to the shore of the small rocky bay for the morning show. Ethylic excesses the evening before gave me the impression of being internally water-logged. The slightly yellowish sun, still tepid, suggested to me a suitable ray which proceeded from my body. I began, therefore, to urinate a powerful flood and I felt this flood like electric amber emerging from myself. Noisily it dissolved itself in a small puddle, a small lake, a residue of sea water on the lithic beach. Slightly obfuscated I could perceive that on that lake a spheric object was floating. Going down some steps I slowly came closer to that brackish water and entered it up to my knees. My intention was to recognise the round object. A magnetic 'frisson' ran through my skin. The object that I found was my own cut off head. Despite the scabrousness of that fact, I thought it suitable to take it out from there. The task revealed itself a little bit difficult. My hair on that head had grown enormously and being wet and submerged, became a heavy burden. Yet, I did not give up and I tried to pick off that 'morbid trophy' wrapping the lengthy strings around my arm. With great effort, I seized that piece and went to the shore. I picked up the head by the root of its capillarities, and raising it over my own head. I started a slinging movement and little by little gave more and more string. In that way I shaped the

image of a dynamic circle some metres wide. With resolution in the gesture I threw the token into the sea so that it would find its proper last sepulchre. I was amazed by my own failure, the excessive weight made my effort vain for the large extension of the wires got stuck, becoming entangled to the sargasso and the shellfishes joined to the stones. However, my other head had attained its objective and was floating. Being attached to its hair it struck against the rocks painfully at the mercy of the waves of the rough sea. I succoured, appalled, to avoid the continuation of such an unpleasant vision. I looked out to sea and witnessed one more astounding finding. Not far from the head that was floating perfectly, a complete, entire body was sailing by the stream. It was in perfect condition and did not show any sign of violence or putrefication, if not for the peculiar absence of the element which I had just thrown away. It could not, however, be the complement of my head, that one was not my body for I noticed on it the most beautiful and well-shaped breasts as well as wonderful female genitalia.

* * *

A long time has passed and what I said came back to my mind through the vision of the sharp scene in the Bridge Tower.

I find myself far away from that garden, far away from that sea-shore, even further from the aphrodisiac intoxications through obscure roots of the obscure hanged man ejaculating by asphyxia and everything else...

I find myself at the door of this tower and the phoenix reappears, for now I am planting another garden, even if in a forest, sowing sirens, seeding mermaids, for you Cordelia.

Tunga

Exogen Cartilage

TUNGA

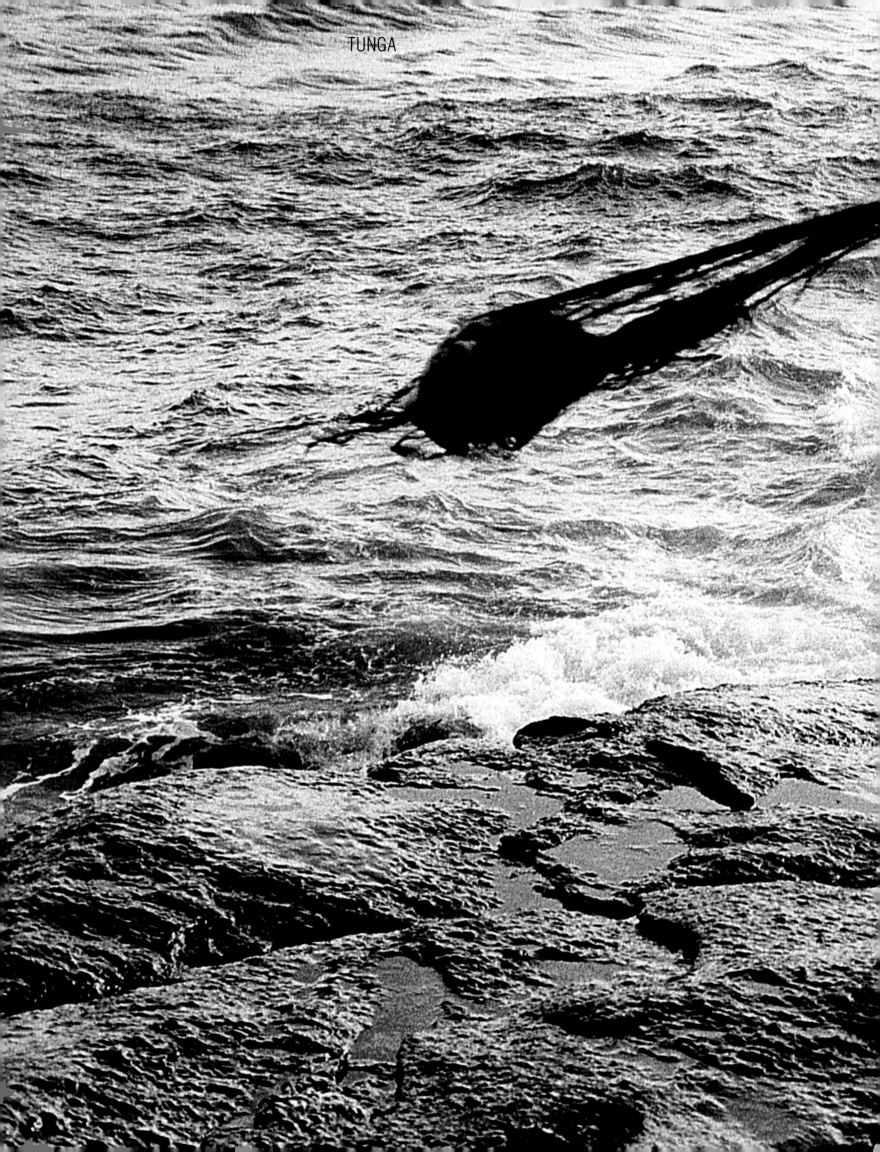

TUNGA

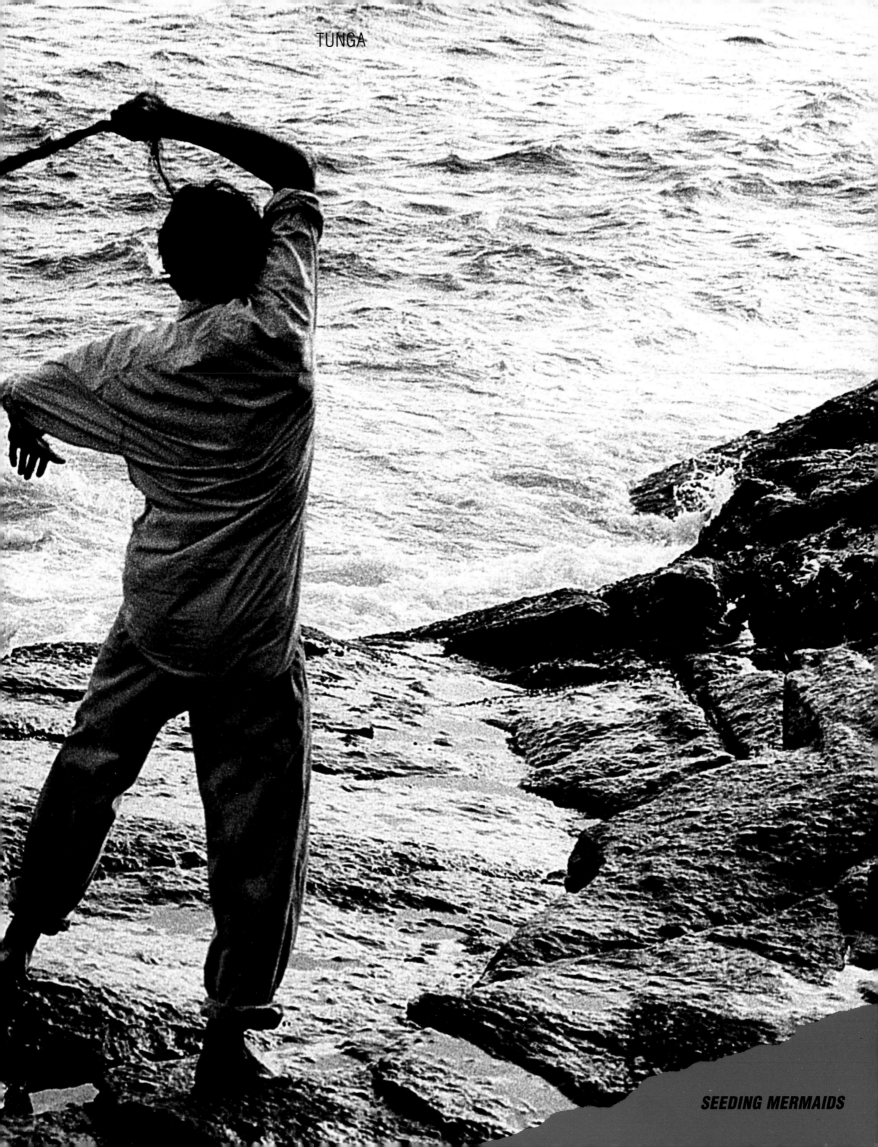

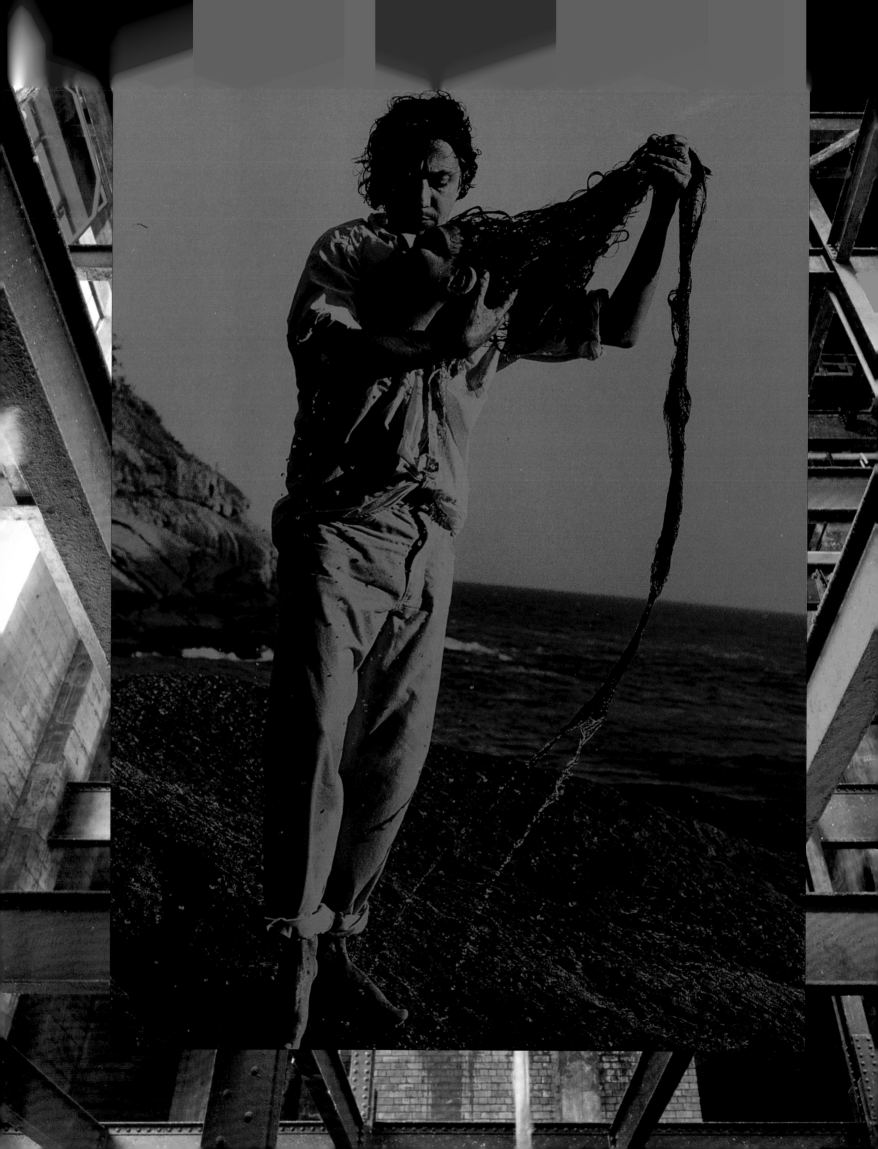

ORSHI DROZDIK

Manufacturing the Self,
The Nineteenth-Century Self

This self is a different self. It feels if it was created by me. I hear and read my words, and I feel myself attached to the century in which you imagined yourself.

Inside of the North Tower of the Tyne Bridge, Newcastle upon Tyne

Walking in the streets of Newcastle, a comfortable perversion arises in me. I am haunted by my own nineteenth-century self. I identify with the crisis of modernity, and this manifests itself as a space created from iron, coal and glass.

My iron self – industrial capitalism – is placed on the top of a glass bubble and is tiptoeing towards its past, towards my imaginary self.

My historic self is fluid and moves back and forth through the borders of geography, gender and time. It is fragile, like the body self, like myself.

ABOVE: Sketch for the Tyne International exhibition, 1993, drawing on paper;
BELOW: Sketch for the Tyne International exhibition, 1993, drawing on paper

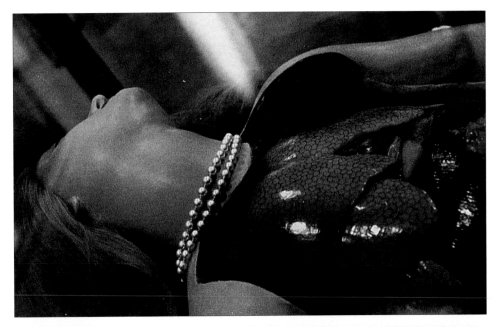

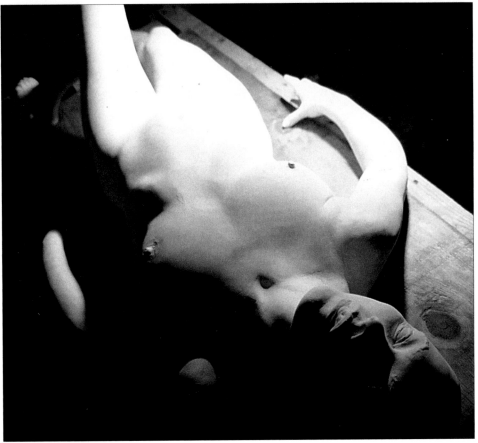

**The Body Self,
The Medical Venus**

Your body was wide open. The two mounds of your breasts rose over your relaxing arms. Your nipples almost touched the skin of those arms. Your lungs were exposed. Large and pink, they were like a beehive. In the middle of your chest was your heart, red and connected to the arteries. Under your right lung was your liver. Under your heart was your womb. A foetus was attached to it by an umbilical cord. Your left thigh softly folded on your right. The right knee almost touched the left. All the muscles in my body tensed while yours relaxed.

ABOVE: Medical Venus, *1984; BELOW:* Medical Venus, *body cast, 1993*

57

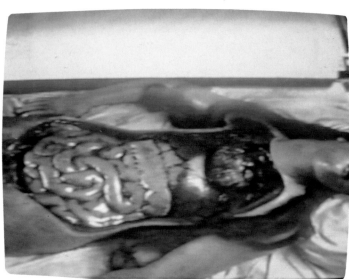

Your inner wound remains an inescapable psychic place of pain. I was inside you for so long, for so many years. My umbilical cord could not be cut from your body. I incubated inside your body for eight long years. Now, on the ninth, I emerge with you inside me. Can I free my body from you now?

When I sculpted your smile in the corner of my mouth, it was the same and became different. When I shaped your eyes, my eyes opened for certainty, and yours became closed. Casting myself into your pose, I embody your ecstasy in my physical presence. Via Narcissus, I cast Pygmalion.
From *The Love Letter to the Medical Venus*

ABOVE: Medical Venus, *stills from video tape, camera Bea Pasztor; OPPOSITE:* Manufacturing the Self; the Nineteenth-Century Self, *cast iron, coal, glass, 1993, installed in the North Tower of the Tyne Bridge*

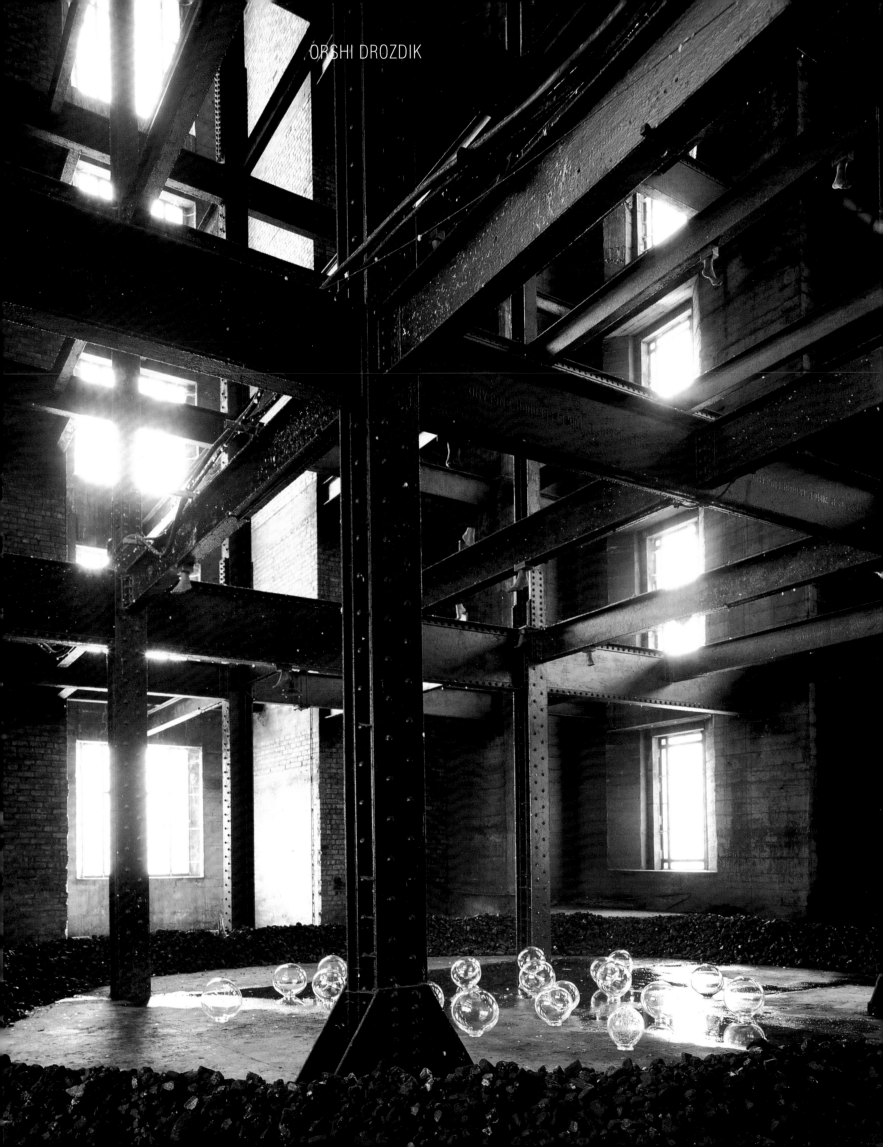

ORSHI DROZDIK

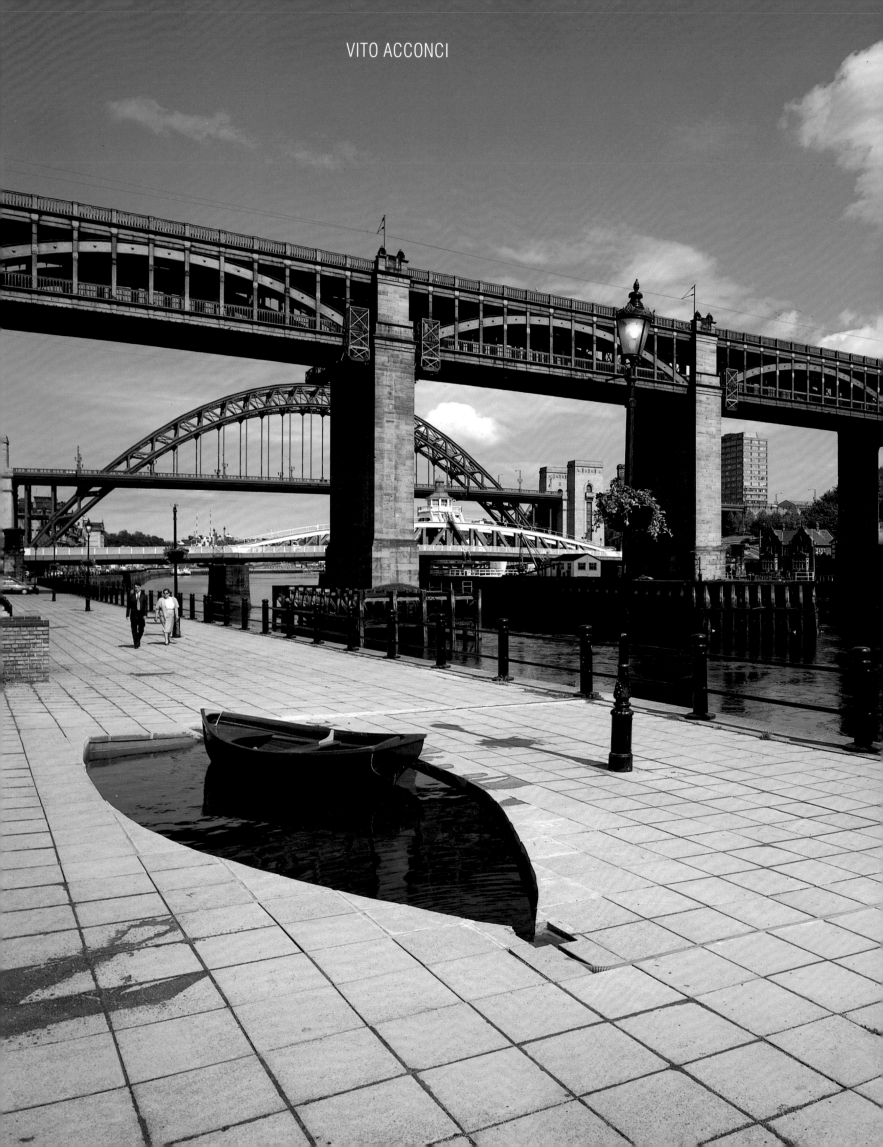

VITO ACCONCI

'Landscape' is an attempt to keep land in place, to keep land in one piece, lest it be fragmented and blown to bits by 'land mines' (definition) cavities in the earth that contain explosive charges, just below ground surface, and that are designed to go off from the weight of persons passing over them. On a 'landscape', you're in the world of science-fiction: passing over the earth in a space-ship, you have a vantage point from which to explore the earth, a map of the earth. On a 'land mine', you're in the world of detective-fiction, *film noir*: you don't have the luxury of looking around you and looking ahead, you have to keep looking at exactly where you are – one look to the side or to the front takes your mind off the earth at your feet, one look away and the earth takes over, the ground comes up from under you and blows you up off the ground.

In a long shot, in a panorama, land is 'landscape'. Close-up, land is either quicksand or hard rock. Either it sucks you in, or it resists you and keeps you out. As you move through the park, inch by inch, each particle of grass or dirt is so soft it becomes a swamp; the earth quakes, the land splits and spirals downwards, off the horizontal and into the vertical, underground. As you move down the street, inch by inch, each particle of sidewalk is so hard it becomes a reflective surface; buildings, that should have been at your side, are mirrored under your feet – the buildings fold and sandwich you inside. In a close-up world, there's no distance that allows you to draw back and look; in a close-up world, things blur out of focus and can't be named. To the body without eyes, the body without language, the land close-up becomes sea (since the grass and dirt are soft, you might as well dig through – sooner or later, water will seep through). To the body without eyes, the body without language, the land close-up becomes sky (since the concrete and asphalt are hard, and you can't break through, all you can do is rub it, polish it, until it reflects the clouds).

To get past notions of 'landscape', go, literally, past the land and down to the mines below the earth. The landscape is grounded on the pits and excavations below. Landscape architecture might be re-defined as architecture in and under and through the land. Landscape architecture is the architecture that escapes the land, that hides and goes underground; if building on top of the land is addition (the act of adding structures to the land), then building under the land is subtraction (the act of taking land away, so that structures can be fitted inside the land: the land is analysed – separated into bits). Landscape architecture is the architecture of basements: the building on a base – slippage occurs from the base to basic instincts, and baser desires. As a land mine, the land can be considered as an excavation, a hole, a cavern; or the land itself can be picked up, like a bomb, like a land mine, and exported elsewhere – a plot of land can be attached onto a building, like a leech (the leech will grow),or inserted into a building, and through a building, like a cancer (the cancer will grow).

A view *of* the landscape can be replaced by a view *to* the landscape, and *through* the landscape. The landscape, instead of being an object for the eyes, becomes an object for the body; instead of being an object of sight, it's an object of touch – an object of the body's insertion into the landscape. Instead of being the passive receiver of sight, the landscape becomes the active agent of motion: the landscape moves as it's subjected to motion, as it's moved into and moved through. The landscape rises and falls; it can be considered as a series of horizontal planes, parallel horizontal planes going from below ground to above ground. These parallel horizontal planes are the infrastructure of behaviour; they cut through the body as the body cuts through them. The body drifts through parallel planes of landscape, while parallel planes of landscape are driven through the body.

From *Bodies of Land,* 1992

OPPOSITE: Personal River, boat, pool, waterpump, 1993, installed at the Quayside

61

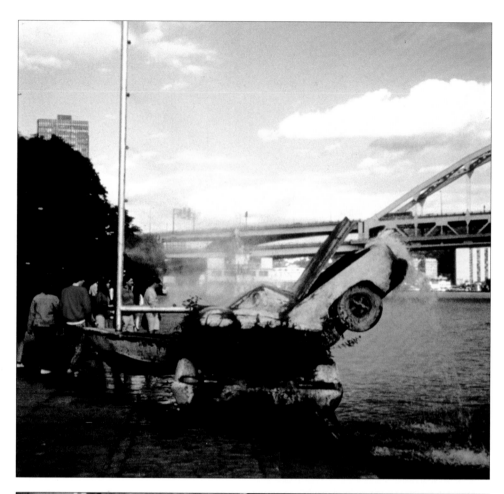

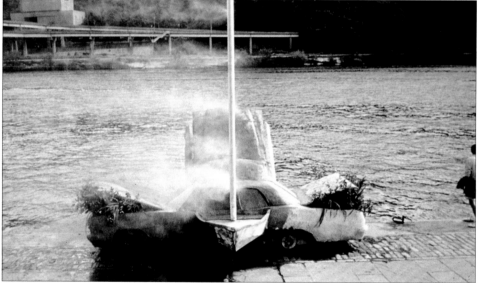

Birth of a Car/ Birth of a Boat

Three Rivers Festival, Pittsburgh, 1988

A concrete-covered car, parallel to the river's edge: plants grow wild out of its open hood and trunk.

Out of the car, another concrete car rises up, like a rearing horse, over the river: water is pumped up from the river into the car – the water shoots up out of the hood and back into the river (the car is a fountain).

On the other side, a concrete-covered sailboat emerges out of the grounded car, towards the promenade: water from the river is converted into steam – fog oozes out of the mast and boom, the boat came ashore like a ghost ship.

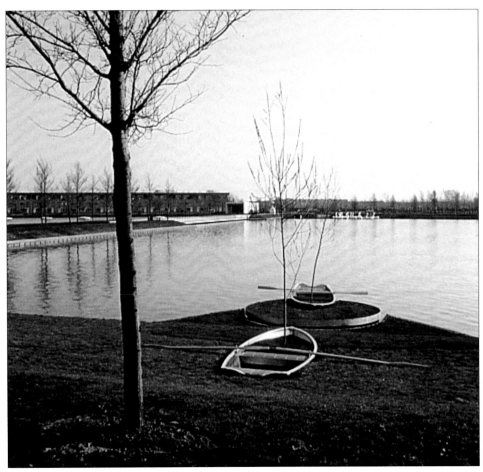

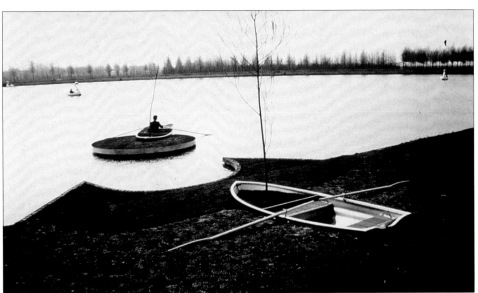

Personal Island

Allocations, Floriade, Zoetemeer, The Netherlands,1992

A row boat embedded in the ground, facing the water.

Another row boat, on water, wedged into a circular plane of land. The island fits into the shore: the island can be turned loose, and rowed out into the water.

Personal River

Tyne International, Newcastle upon Tyne, 1993

The Tyne River is borrowed, and imported onto the quay. It's as if the river is transported by boat: water, from the river, is pumped up to the quay, into the ground, into a boat-shaped basin sunk in the ground. The ground is cut by slivers of water: from the river, a channel of water shoots across the quay, into the bow of the boat-shaped basin, filling the basin – from the stern, another channel of water shoots across the quay into the Tyne (the miniature river drains off, back into the larger river that feeds it).

A boat floats in this personal river; we can use the boat, and have the Tyne for our own.

SHIRAZEH HOUSHIARY

Open Secret, *series of paintings (I, II, III & IV), acrylic and lead mounted on aluminium, 1993, each 1 x 1m*

SHIRAZEH HOUSHIARY

Open Secret, *view of installation in the CWS Warehouse*

SHIRAZEH HOUSHIARY

ISTHMUS

Only at the direction of the heart you set your head like a pen on the page of eternal love. Rumi

I'd like to start with asking this question. What is the meaning of my creative need? The objects and images which one creates, have their places in the outside world. But their essence and meaning flow primarily from the inner world where they were conceived. It is the creation of this inner world, which, within it one can throw some light on the meaning of creativity and its source the imagination. This imagination must not be confused with fantasy. Fantasy, unlike imagination, is an exercise of thoughts without the divine self. It mostly springs from the self as ego. We can see that fantasy exists in the space of the finite, whilst the imagination exists in the space of the infinite. It is by meditating upon this imagination that we will learn who we are.

One should ask where is the place of imagination? The place of imagination is in the psyche, the Greek word 'soul'. Rumi, the 13th-century Sufi poet wrote: 'Like mirror my soul displays secrets / I am able not to speak / but I am unable not to know.' In the Platonic story of Psyche or the soul, Psyche falls in the river and through the river she enters a valley where she sees a beautiful house which she enters. She reaches a momentary state of joy, but then the sudden recognition of the separation from Eros (the spirit) brings her pain. In all her time in the house or 'body' she longs for the union with Eros. Art or image making becomes the tool which releases her from the pain of separation from Eros. Through this process of art-making the language of the 'soul', union between Psyche and Eros manifests itself.

We can see that art-making happens in the intermediary realm, that which exists between the body and the spirit. Without this intermediary space we are left with the body as a frail image and spirit as the powerful image. As a result they have been in dramatic conflict. This world of the 'intermediary' where within it exists the creative imagination, is the world in which spirits are materialised and bodies spiritualised. To come to know this, is to know oneself. Here, self is not 'ego', but self is 'divine'. It does not divide us, but connects us. One could define it as the space of the temple. Its realm is the 'centre' of space and the 'present' in time. The Latin word for temple is 'templum', and originally meant a vast space, open on all sides, from which one could survey the whole surrounding landscape as far as the horizon. So here the temple suggests the field of vision. One could say that it is the dwelling-place of the divine presence.

In fact one realises that the nature of this space is light, the fiery light. To explain it is like saying that before existence, there is the unknown. This is the true darkness, it is impossible to see it, since it is sheer non-existence. This is the shadow which exists before light. Then there is the shadow which is created by light itself, also non-existence, but visible to the eye. Light is that intermediary between the two shadows. It is because of light that the unknown manifests itself. One would be able to learn that the nature of this light is like a mirror. It has a reflective surface which can reflect the Eros or spirit, or in other words can reflect the face of the beloved.

There is one more thing that could be said about this realm of the intermediary; that its colour is red. Why red? Because this is the realm of imagination, and imagination is divine in as much as the creator created the world through the imagination, so by entering the realm of imagination we can come close to the mystery of creation. Its colour is red because it is like flame, existing between light and clay. It is both subtle and dense at the same time. Flame expresses its freedom from clay in the way it shoots up towards the sky, but it is tied to clay by the substance which burns. All things in the world have this double movement, 'ascension' and 'descension'. It is like the phoenix which by beating her wings, ignites her own fire, burns, and from her ashes will rise the new phoenix and fly towards the sun.

I do not want to sound as if these ideas are from some mystical dimension which is not attainable by others. Ibn Arabi (the 13th-century Sufi from Spain) through simple observation makes it clear for us: 'A person perceives his own form in a mirror. He knows for certain that he has perceived his form in another respect and he knows for certain that he has not perceived his form in another respect . . . He cannot deny that he has seen his form, and he knows that his form is not in the mirror, nor is it between himself and the mirror . . . Hence, he is neither a truth-teller nor a liar in his words. "I saw my form, I did not see my form".' So one can begin to grasp that imagination is neither existent nor non-existent, neither known or unknown, neither affirmed nor denied. We could say that wherever we meet imagination, we are faced with ambiguity.

SHIRAZEH HOUSHIARY

Isthmus, *1993, sketch of installation to be constructed in the Castle Keep,*
Newcastle upon Tyne

SHIRAZEH HOUSHIARY

One has to understand that the energy produced by imagination is about continuous openness. Within our daily life we are in the state of closedness. Perhaps we were interested in the world when we were little children, but then we were taught how to deal with it by our parents. Our parents already had developed a system to deal with the world and at the same time to shield themselves from it. When we accepted that system we lost contact with this double nature of the world. We lost the freshness and curiosity of our childhood a long time ago. We find that in communicating with the world we are somewhat numb.

The quest is how to look at the world without a filter, or screen, to relate to the world so directly that it is as though we had no skin on our body. At this moment we can come to understand this when one says: 'I exist because I do not exist'. Or in other words, one could say 'I went in and left myself outside'. This is called the state of openness, which is the state of wakefulness. The state that we are usually in is closedness, because we are being solidly grounded in our experiences. The emotion that is manifested out of this state of openness transcends all, and in this way emotion has a tremendous ability of relating with the universe, and to accommodate for dualism.

This realm of the intermediary allows the mind to free itself from dependence on mere physical appearance and in that way prepares it for the journey from multiplicity to unity. Or one could say, prepares it for the presence of the infinite within the finite. This means man would not find himself isolated in the cosmos, moreover, the realm of the intermediary translates the human situation into cosmic terms. So he could avail himself and at the same time succeed in leaving his personal condition, moving towards a comprehension of the universal. As Rumi said: 'The truth so simple / The mind explodes / To meet itself / Running back in all things.' Here, we are talking about acquiring the knowledge of 'yes' and 'no', where we find the awareness of the dual nature of reality. The first meeting between the young Ibn Arabi and the older Averroes (they were both philosophers and metaphysicians living in Andalusia around the 13th century) will point to this. Averroes asked Ibn Arabi: 'What solution have you found as a result of mystical illumination and divine inspiration? Does it coincide with what is arrived at by speculative thought?' Ibn Arabi replied, 'Yes and no. Between the yea and the nay, the spirits take their flight beyond matter, and the necks detach themselves from their bodies.' At this Averroes became pale, understanding Ibn Arabi's allusion.

This space of the intermediary can be called an Isthmus existing between two seas, one is fresh and drinkable, the other is salty and bitter; or in other words, the spirit and the psyche, the formless and the formal. This space of Isthmus is the very mediator between the two seas. It seems that it separates the two seas, from a formal point. But it joins from the formless point.

By meditating upon this space, one will see that it is really the space of the centre within an individual. One realises that the Isthmus of man is his heart. Here we should understand the heart not as an organ, but as the space of infinite within finite. The source of imagination was none other than the heart. Truly the process of art-making happens within the heart. The heart is the creative space of man. It is through the heart that the lover unites with the beloved or the Psyche unites with Eros.

James Hillman writes: 'Love blinds in order to extinguish the wrong and daily vision so that another eye may be opened that perceives from soul to soul. The habitual perspective cannot see through the dense skin of appearance: how you look, what you wear, how you are. The blind eye of love sees through into the invisible, making the opaque mistake of my loving transparent.'

One could say that human love is a kind of a horizontal relationship, whereas divine love is a kind of vertical relationship. Isthmus is a vertical space, like the mountain whose top appears to be at the bottom of the lake. One should remember that the horizontal and the vertical are interdependent. As mentioned earlier, the Isthmus is the space which links the infinite to the finite. The infinite contains the image of the true self and contemplation brings it into focus like a dusty mirror which has been polished. The finite is our skin which separates us from our inner space (the infinite).

WENDY KIRKUP & PAT NALDI

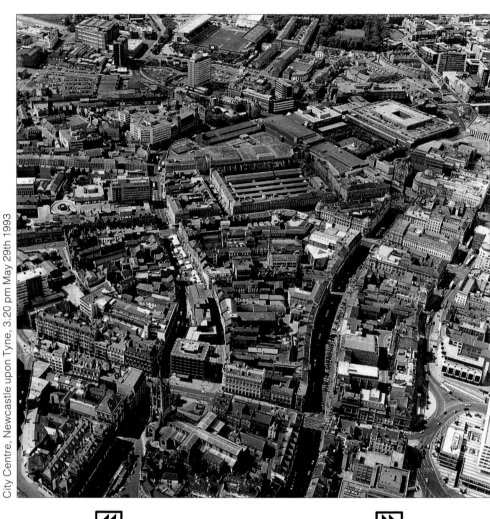

City Centre, Newcastle upon Tyne, 3.20 pm May 29th 1993

⏮ ⏭

└──── SEARCH ────┘

On Monday 17th May 1993 at 1pm, a synchronised walk took place in Newcastle upon Tyne city centre in two separate locations by Pat Naldi and Wendy Kirkup. This event was recorded on the 16 camera surveillance system recently installed throughout the commercial centre of the city by Northumbria Police. The systems radial vision can record 16 separate views of the city in any one second.

This 'neutral' vision deals with unedited time; it records rather than directly intervening. The purpose of the system is of replaying and reconstructing events. The cameras, positioned above street level, serve to objectify those territories we negotiate daily without seeing. As we enter the public domain we surrender our privacy to this voyeuristic technology. We relinquish control over our images which are legally classed as 'public'.

'Search' is an artist project made for television. it consists of 20 ten second sequences to be transmitted during the commercial breaks. It was broadcast on Tyne Tees Television between 21st June and 4th July 1993.
A co-production by Locus + and Tyne International

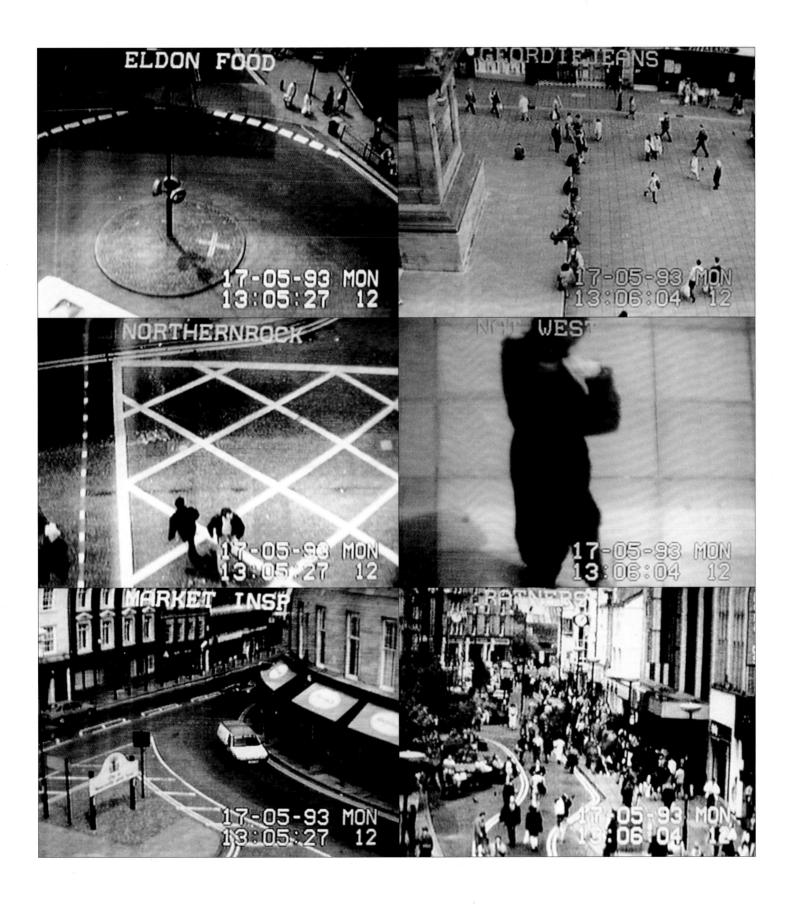

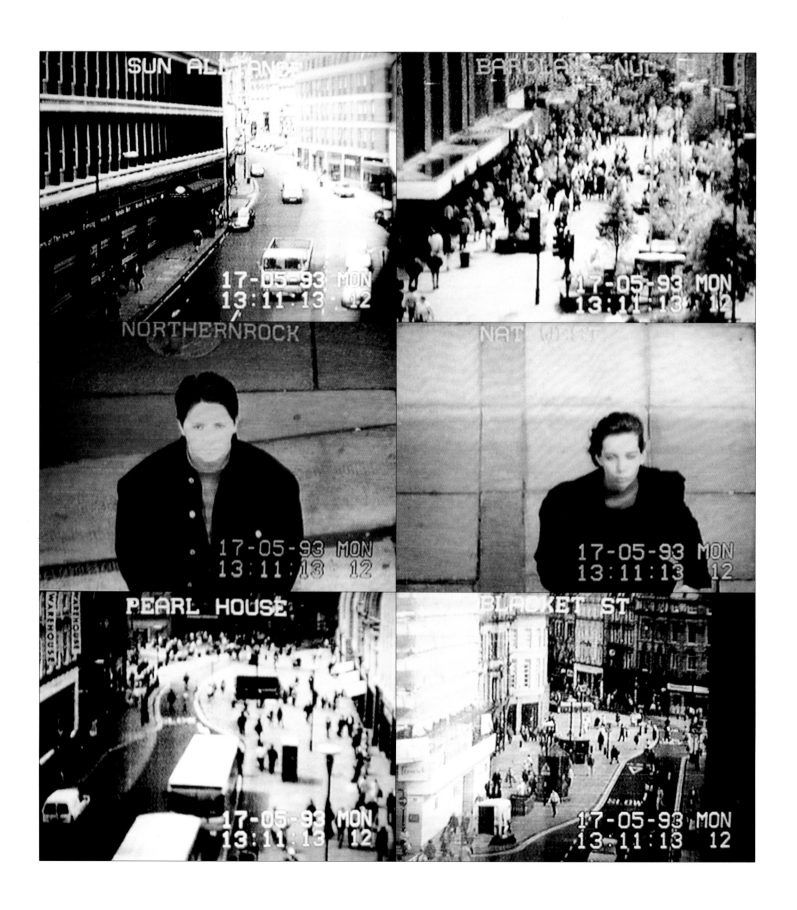

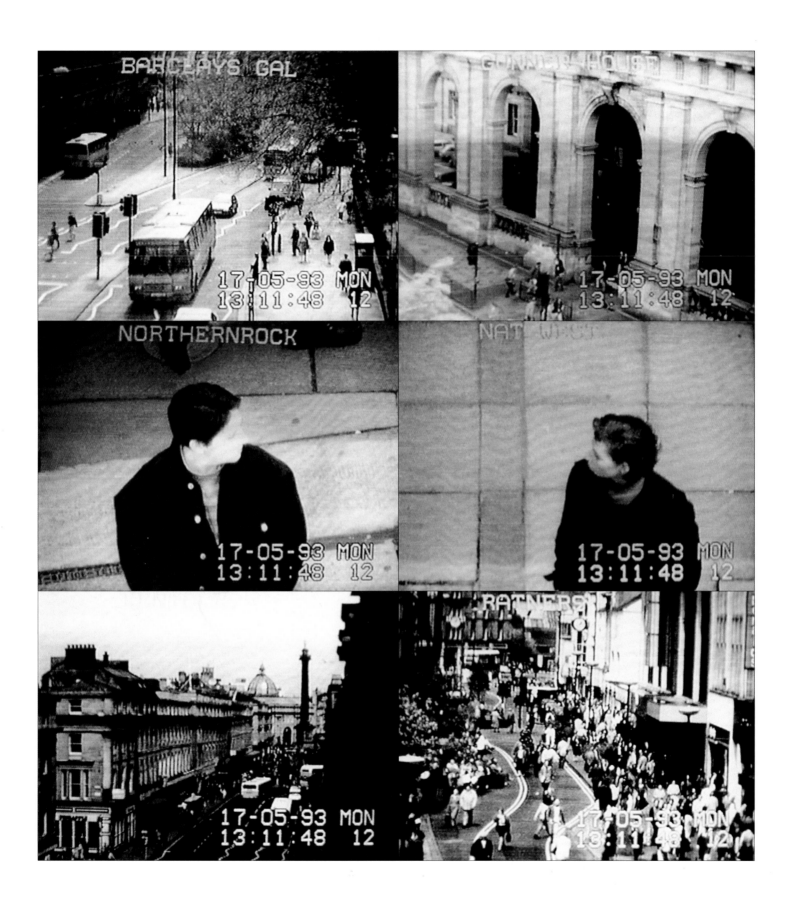

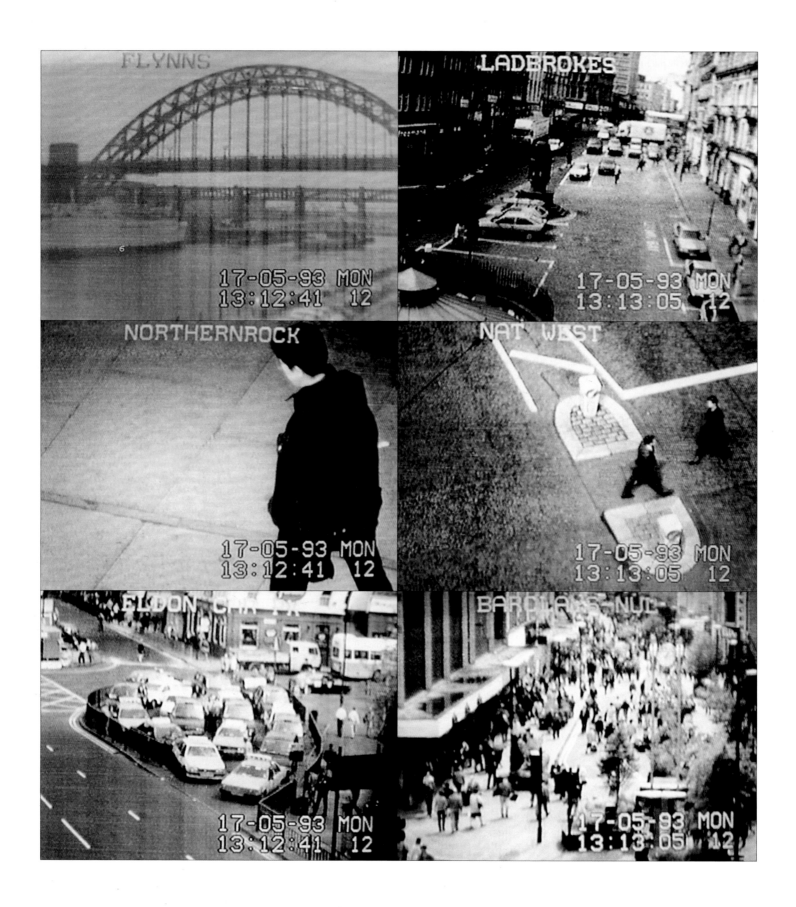

GONZALO DIAZ
THE DEBATABLE LANDS
Adriana Valdes

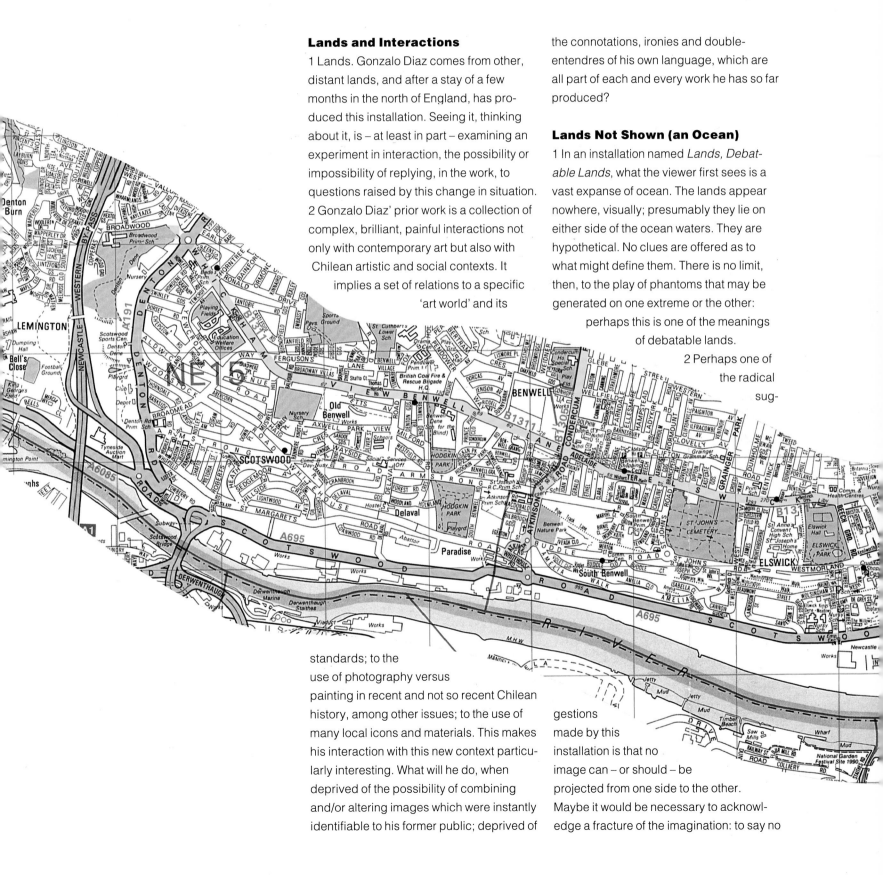

Lands and Interactions

1 Lands. Gonzalo Diaz comes from other, distant lands, and after a stay of a few months in the north of England, has produced this installation. Seeing it, thinking about it, is – at least in part – examining an experiment in interaction, the possibility or impossibility of replying, in the work, to questions raised by this change in situation. 2 Gonzalo Diaz' prior work is a collection of complex, brilliant, painful interactions not only with contemporary art but also with Chilean artistic and social contexts. It implies a set of relations to a specific 'art world' and its

the connotations, ironies and double-entendres of his own language, which are all part of each and every work he has so far produced?

Lands Not Shown (an Ocean)

1 In an installation named *Lands, Debatable Lands*, what the viewer first sees is a vast expanse of ocean. The lands appear nowhere, visually; presumably they lie on either side of the ocean waters. They are hypothetical. No clues are offered as to what might define them. There is no limit, then, to the play of phantoms that may be generated on one extreme or the other: perhaps this is one of the meanings of debatable lands.

2 Perhaps one of the radical sug-

standards; to the use of photography versus painting in recent and not so recent Chilean history, among other issues; to the use of many local icons and materials. This makes his interaction with this new context particularly interesting. What will he do, when deprived of the possibility of combining and/or altering images which were instantly identifiable to his former public; deprived of

gestions made by this installation is that no image can – or should – be projected from one side to the other. Maybe it would be necessary to acknowledge a fracture of the imagination: to say no

75

GONZALO DIAZ

continuum could exist between the two lands on either side of the ocean, as if both were unreal places, places made of dreams and misapprehensions that cross each other, but never meet. It might be a tactic designed to prevent an otherwise inevitable misunderstanding.

3 Stereotypes are – inevitably – misunderstandings. On either side of the ocean they help people to economise effort and thought, while depriving them of the possibility of being baffled by immediate experiences. In an extreme effort to avoid them, both lands are, in the installation, turned to unknown quantities. The effect of strangeness, of remoteness, coming like a strange breath across the ocean from another, un-

be a space as yet insufficiently defined in the imagination; not really included in the imperial project; shifting its position, as power shifts in the larger whole of which it is not really a part. Across the centuries, this installation would be a comment on the fate of debatable lands, a name once used for this part of the north of England, but whose scope is extended to include a contemporary land in the South America.

Lands Not Shown: The Names, The Angels

1 Ten names of lands are included in the installation: Murton, Seaham, Easington, Dawdon, Horden, Sacriston, Blackwall, Whittle, Ashington, Vane Tempest. They would be familiar to the viewer at Central Station in Newcastle upon Tyne, from newspapers, from public opinion surveys, from politics. Yet the

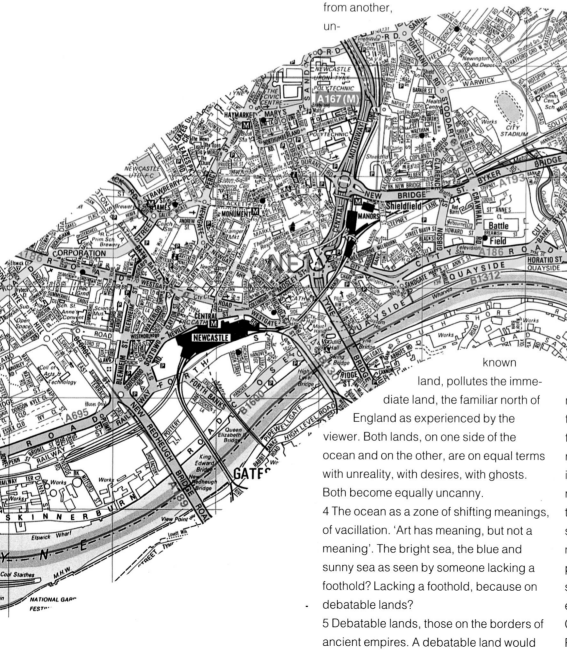

known land, pollutes the immediate land, the familiar north of England as experienced by the viewer. Both lands, on one side of the ocean and on the other, are on equal terms with unreality, with desires, with ghosts. Both become equally uncanny.

4 The ocean as a zone of shifting meanings, of vacillation. 'Art has meaning, but not a meaning'. The bright sea, the blue and sunny sea as seen by someone lacking a foothold? Lacking a foothold, because on debatable lands?

5 Debatable lands, those on the borders of ancient empires. A debatable land would

mention of those names is made in such a way as to both remind the viewer of such information and to neutralise its usual connotations. Besides knowing they are the names of coal mines which have been closed, they are perceived as included in an improbable series: in the hierarchy of angels, as established in the Middle Ages: Seraphim, Cherubim, Thrones; Dominations, Virtues, Powers; Principalities, Archangels and

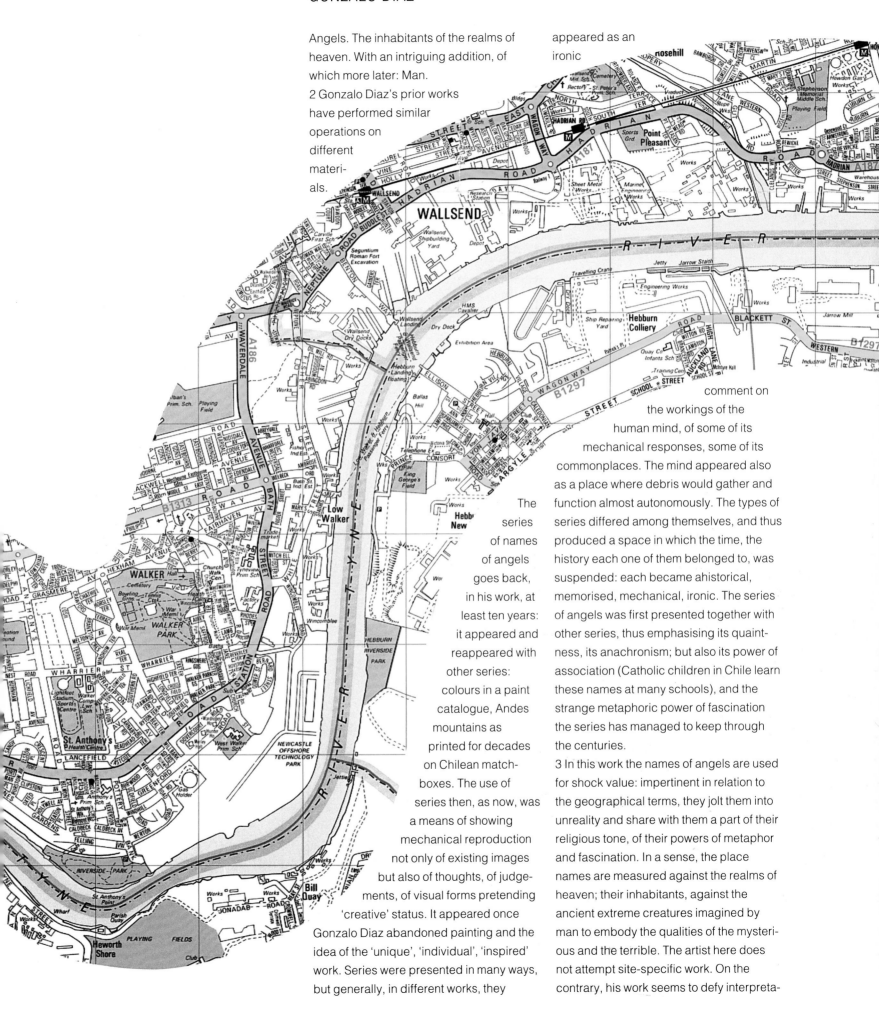

GONZALO DIAZ

Angels. The inhabitants of the realms of heaven. With an intriguing addition, of which more later: Man.

2 Gonzalo Diaz's prior works have performed similar operations on different materials.

appeared as an ironic comment on the workings of the human mind, of some of its mechanical responses, some of its commonplaces. The mind appeared also as a place where debris would gather and function almost autonomously. The types of series differed among themselves, and thus produced a space in which the time, the history each one of them belonged to, was suspended: each became ahistorical, memorised, mechanical, ironic. The series of angels was first presented together with other series, thus emphasising its quaintness, its anachronism; but also its power of association (Catholic children in Chile learn these names at many schools), and the strange metaphoric power of fascination the series has managed to keep through the centuries.

The series of names of angels goes back, in his work, at least ten years: it appeared and reappeared with other series: colours in a paint catalogue, Andes mountains as printed for decades on Chilean matchboxes. The use of series then, as now, was a means of showing mechanical reproduction not only of existing images but also of thoughts, of judgements, of visual forms pretending 'creative' status. It appeared once Gonzalo Diaz abandoned painting and the idea of the 'unique', 'individual', 'inspired' work. Series were presented in many ways, but generally, in different works, they

3 In this work the names of angels are used for shock value: impertinent in relation to the geographical terms, they jolt them into unreality and share with them a part of their religious tone, of their powers of metaphor and fascination. In a sense, the place names are measured against the realms of heaven; their inhabitants, against the ancient extreme creatures imagined by man to embody the qualities of the mysterious and the terrible. The artist here does not attempt site-specific work. On the contrary, his work seems to defy interpreta-

GONZALO DIAZ

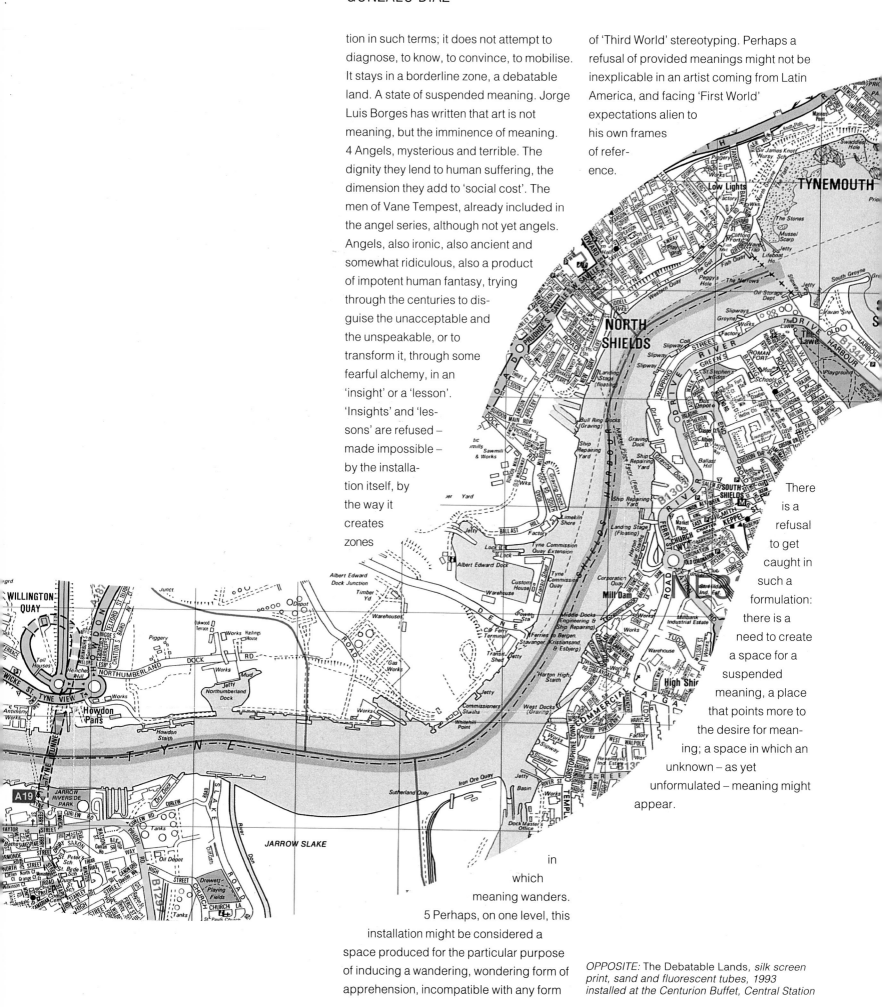

tion in such terms; it does not attempt to diagnose, to know, to convince, to mobilise. It stays in a borderline zone, a debatable land. A state of suspended meaning. Jorge Luis Borges has written that art is not meaning, but the imminence of meaning. 4 Angels, mysterious and terrible. The dignity they lend to human suffering, the dimension they add to 'social cost'. The men of Vane Tempest, already included in the angel series, although not yet angels. Angels, also ironic, also ancient and somewhat ridiculous, also a product of impotent human fantasy, trying through the centuries to disguise the unacceptable and the unspeakable, or to transform it, through some fearful alchemy, in an 'insight' or a 'lesson'. 'Insights' and 'lessons' are refused – made impossible – by the installation itself, by the way it creates zones

of 'Third World' stereotyping. Perhaps a refusal of provided meanings might not be inexplicable in an artist coming from Latin America, and facing 'First World' expectations alien to his own frames of reference.

There is a refusal to get caught in such a formulation: there is a need to create a space for a suspended meaning, a place that points more to the desire for meaning; a space in which an unknown – as yet unformulated – meaning might appear.

in which meaning wanders. 5 Perhaps, on one level, this installation might be considered a space produced for the particular purpose of inducing a wandering, wondering form of apprehension, incompatible with any form

OPPOSITE: The Debatable Lands, *silk screen print, sand and fluorescent tubes, 1993 installed at the Centurion Buffet, Central Station*

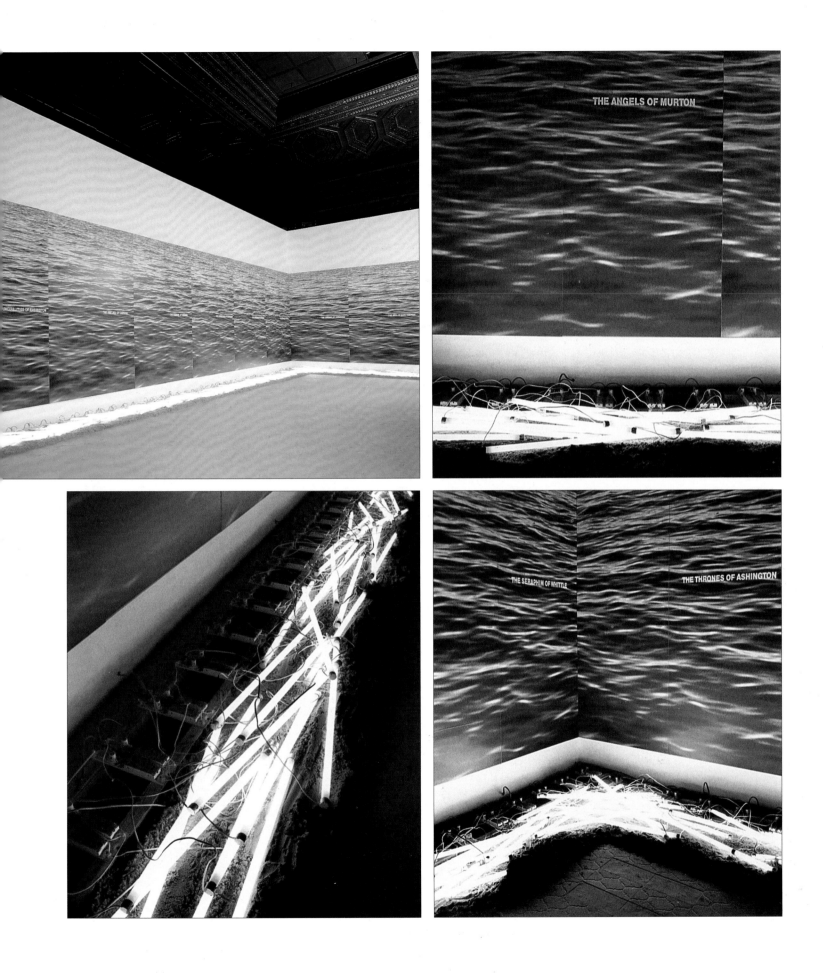

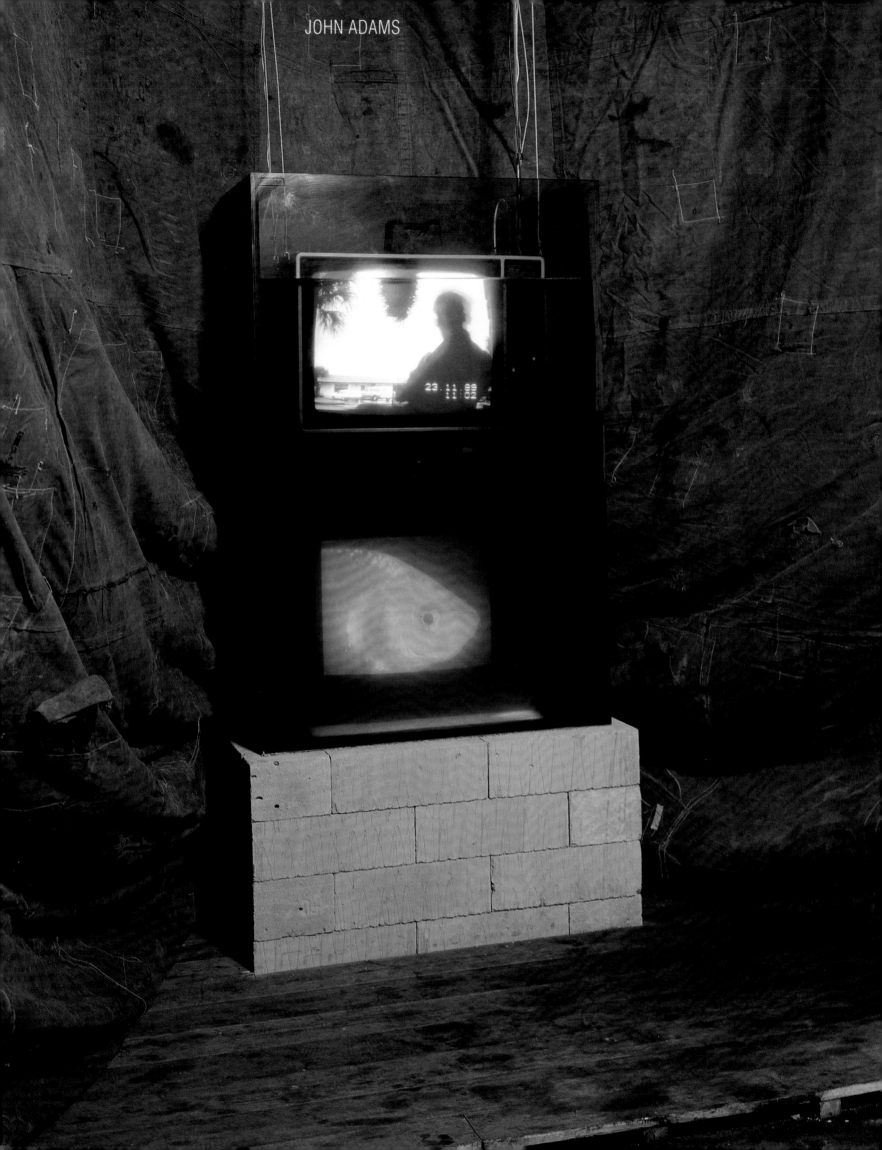

JOHN ADAMS

JOHN ADAMS
GOLDFISH MEMOIRS & THE THINK TANK

'Who are you?' said the doctor.

It was a good question but by now he was beginning to tire of these sessions which always ended the same way. 'Well these days, I suppose I would think of myself as a gardener.'

'Good – very good', said the doctor. 'We're making progress. A gardener. Yes. Agriculture is a very noble profession these days.'

'I used to be an artist but I'm over that now.'

'Good – very good. Same time next week? . . . And don't forget to keep writing that diary.'

WEDNESDAY JUNE 16
You know how it is when you're going through immigration after a long flight. The way the officials study your passport and then look into your face like you remind them of the country's most wanted. And they say, 'Just what exactly do you *do* as an *artist?*' Good question.

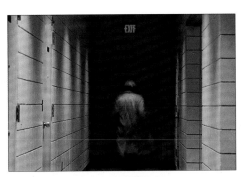

I forget precisely what was going on around that time but the thing is, everything started to get out of hand. So I took the first plane to a hot climate. It was a *foreign* country – I mean being English, I couldn't speak the language of course but that was OK by me.

I rented a cabin by the ocean and spent my days on the beach, reading the same book over and over. It was a short book but every time the ending seemed different. I remember that it was some kind of autobiographical novel but the title escapes me now. My memory is not what it used to be. I worry sometimes about Alzheimer's – especially because my mother used to cook everything in aluminium pans. They were very trendy in the 50s I believe, but now we know better – and cast iron is really the thing to use if you want to be up to the mark.

OPPOSITE: Goldfish Memoirs and the Think Tank, *video installation and mixed media, colour, 1993 (camera, Ken Slater; music Nigel Collier), installed in the CWS Warehouse*

JOHN ADAMS

I developed a habit of rising at dawn to watch the fishermen trying to land sea bass. One old man was friendly but although I laughed at his jokes, nothing he said made any sense to me. Eventually I bought a dictionary and a tape recorder – one of the small jobs that tabloid reporters use to shove in the faces of disgraced politicians. After that I would tape his stories and spend the rest of the day trying to translate.

One time he said, 'As usual I was fishing at dawn, when the light is still purple and red! My line got caught on something in the water – a very heavy thing! I managed to pull it in – it was a struggle! At first I thought that it was seaweed but suddenly I realised that it was the head of a man! As you would expect the head was lifeless but curiously, the hair was several metres long! I was very afraid and ran to call for help! Eventually the police came and asked many questions! The sergeant told me that the night before, they had found a female torso washed up on the beach! My wife works in the hospital and the pathologist said that the head and body matched *exactly*!'

I don't know whether I translated his story correctly but it sounded like an urban myth to me. I forgot all about it until a few days ago when I was reading this catalogue. Anyway, I came back to England eventually to face the music. On the plane I read that book one last time. It seemed like the ending had changed again and I still can't recall the title.

They stopped him at Customs as they always do and went through the passport thing. The guy said, 'What exactly do you grow as a gardener?'

He said, 'Well, I grow Mandrake plants, mainly for export.'

'You mean the *Hanged Man Flower*, otherwise known as the *Devil's Apple*?'

The Customs guy gave him one of those long looks and said, 'Would you mind opening your bags sir?'

Good question.

NAN GOLDIN

The *Ballad of Sexual Dependency* is the diary I let people read. My written diaries are private; they form a closed document of my world and allow me the distance to analyse it. My visual diary is public; it expands from its subjective basis with the input of other people. These pictures may be an invitation to my world, but they were taken so that I could see the people in them. I sometimes don't know how I feel about someone until I take his or her picture. I don't select people in order to photograph them; I photograph directly from my life. These pictures come out of relationships, not observation.

People in the pictures say my camera is as much a part of being with me as any other aspect of knowing me. It's as if my hand were a camera. If it were possible, I'd want no mechanism between me and the moment of photographing. The camera is as much a part of my everyday life as talking or eating or sex. The instant of photographing, instead of creating distance, is a moment of clarity and emotional connection for me. There is a popular notion that the photographer is by nature a voyeur, the last one invited to the party. But I'm not crashing; this is my party. This is my family, my history.

My desire is to preserve the sense of peoples' lives, to endow them with the strength and beauty I see in them. I want the people in my pictures to stare back. I want to show exactly what my world looks like, without glamorisation or glorification.

I want to be able to experience fully, without restraint. People who are obsessed with remembering their experiences usually impose strict self-disciplines. I want to be uncontrolled and controlled at the same time. The diary is my form of control over my life. It allows me to obsessively record every detail. It enables me to remember.

From The Ballad of Sexual Dependency,
Aperture, 1986
The slide show, The Ballad of Sexual
Dependency, *was performed on the
quayside at Newcastle Upon Tyne, July 15,
1993*

FROM ABOVE: Self-Portrait After Being Battered, *NYC, 1984;* Self-Portrait in the Light, Eyes Inward, *1989;* My Room in the Lodge, Belmont, *1988*

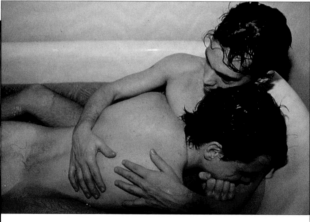

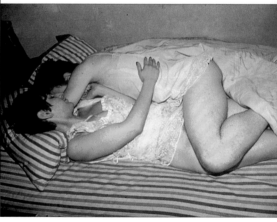

NAN GOLDIN

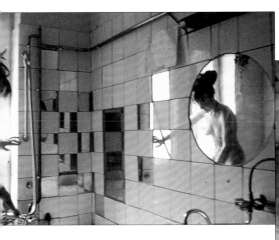

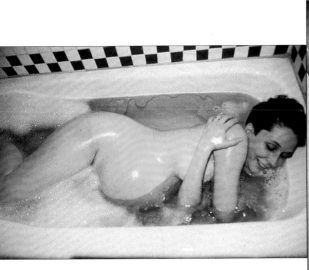

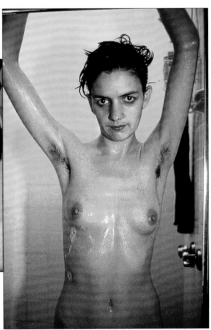

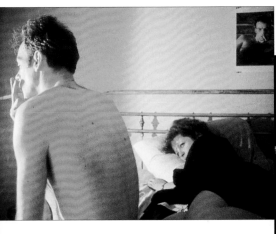

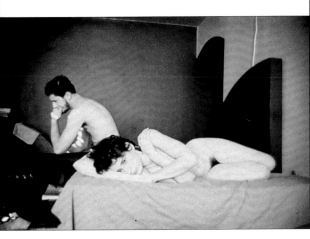

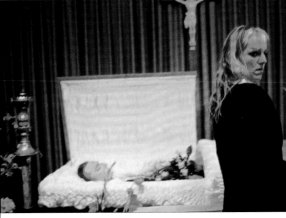

Cookie Mueller, 2 March, 1949 – 10 November, 1989
I used to think I couldn't lose anyone if I photographed them enough. I put to-
gether this series of pictures of Cookie from over the 13 years I knew her in order
to keep her with me. In fact it shows me how much I've lost.
New York City, September 1990
From Cookie Mueller *(Pace/MacGill Gallery, New York, 1991)*

OPPOSITE AND ABOVE, L TO R: Jesse in Witches Hat, *London, 1991;* Siobhan at
Hornstra, *Berlin, 1992;* Cookie at Tine Pan Alley, *NYC, 1983;* Kathe in the Tub, *Berlin,
1984;* Butch in the Tub, *NYC, 1988;* Siobhan in the Shower, *NYC, 1992;* Lynette and
Donna at Marion's, *NYC, 1991;* Matt and Lewis in the Tub, *Cambridge, MA, 1988;* Man
and Woman in Slips, *NYC, 1980;* Nan and Brian in Bed, *NYC, 1983;* Couple in Bed,
Chicago, 1977; Cookie at Vittorio's Casket, *NYC, 1989*

RAUL RUIZ
BETWEEN TWO EXILES
Film Season at Tyneside Cinema

'De las cuatro pa'delante
Linda palomitay
No bay cantina que me aguante
forasterito soy
mañana me voy
pastorcito soy
con mis sueños voy'

'De la tumba o del desierto
la soledad no me espanto
la soledad que yo temo
es la soledad del alma'

Popular songs from the Peruvian Sierra

'From four o'clock forth
Sweet love,
there's no bar that will welcome me,
an outsider I am,
tomorrow I will go,
a shepherd I am
with my dreams I will go'

'From the grave or the desert
Solitude does not scare me,
the loneliness I dread
is the solitude of the soul'

Years ago a film came to me. The image concealed a risk: the colourful and exasperating presentation of a double-edged metaphor. Its theme could be summed up as 'every exile is a voyage and every voyage is an exile'. The idea was sparked by the many stories that masked the death in life and the life in death of a sailor whose tempestuous existence beyond the grave gradually reveals, amidst digressions and lamentations, a melancholy allegory of exile: a sailor travels the world and in remote lands meets men and women who (only through his own choice) will constitute 'his family'.

Without knowing it I was foreboding to myself the imminency of a second exile. To begin with, exile meant no more than being away from the native home; afterwards the native home would shatter and its fragments would have to be sought throughout the world. This is not very different from the metaphor of the broken vessel of the Hasidic Jews.

I thought I had reached the very limits of exile (if that proposition makes sense). I was wrong. I still had to go through that very last stage (at least that was my hope).

For many years now I have been overcome by the urge to continue every book I read into another and then another, as if to remain for a long time in the company of a single character, a single plot, a single author was an unnatural act. Not long ago, I realised that every film I saw reminded me of a different one; yet, the links between them were almost never obvious. I said

to myself, 'it is only natural that one plot should remind you of a similar one or that this actor makes you think of another film in which he has taken part'. But what could be the connection between *Pueblerina*, a Mexican film by Emilio Fernandez, and *The Best Years Of Our Lives* by William Wyler? Or between *2001* by Kubrik and *Black Rain* by Imamura?

Gradually, I became aware that a new kind of exile was forming within me: it was not exile from the mother country nor from mankind but exile from human works. If a film made me think of another (not just any one but one in particular) it was because what I was looking for between them was the abyss that separates them. That abyss was the land of exile, that *terra incognito* into which I (and many like me) were entering.

The films that we are bringing out today try to reproduce the feeling of exile (let us call it exile of the third degree) that I have tried clumsily to convey.

In some cases (I am thinking of *Stromboli* paired with *The Exterminating Angel*) both the links and the rifts between films are almost obvious: exile and confinement, the social game as enigma, as unforgiving weapon.

In other cases the link is obscure even to me. It is enough to know that always, in every pair of films proposed, the same anguish, the same disturbing strangeness, the same feeling of horror and liberation are present.

Welcome to the voyage of no return!

CORINNE DISERENS

TRANS – FILM AND VIDEO PROGRAMME
Tyneside Cinema and CWS Warehouse

TRANS doesn't manifest itself only in given places:
here and there, it transmigrates.
TRANS has no place. It takes place.
Everywhere.
(Jon Gibson/Kuntzel/Mouraud, Paris, January 8, 1977)

L'Autre Film *En termes idéalistes, il en serait des
films comme des eaux: naturel, transparence, fluidité.
Dans le couloir, le film court – et passe sur l'écran:
coulées sonores et mouvements coulés, il bouge,
change, glisse, avance, canalisé par le récit, le sens,
inexorable descente diégétique et formelle, rivière
sans retour: je me laisse emporter, aller, flotter, flouer
par ce flux, ce courant, ce délicieux liquide – lisse,
plein, onctueux. Que le temps coule, un 'voeu'
accompli par le film classique: que le temps coule
d'une seule coulée orientée: temps chronologique,
temps lié, temps du représenté.*

The Other Film Ideally, there could be films like
water: natural, transparent, fluid. Running in the
corridor, the film slips onto the screen: resonant
flowings and gelled movements shifting, changing,
sliding, advancing, chanelled by the narrative – an
unrelenting, digestive, formal descent, a river of no
return: I let myself be carried off, float along, tricked by
this flux, this current, this delicious liquid – smooth,
full-bodied, unctuous. *Let time flow*, a promise fulfilled
by the classic film: time flows in one focused flow:
chronological time, bound time, symbolised time.
Thierry Kuntzel

The cinema was a place, a territory . . . A world with no
history but that spent all its time telling stories.
J-L Godard

The past is like a foreigner: it's not a question of
distance but of having crossed a border. *C Marker*

Such are the things of my country, my imagined
country, a place I've totally invented, totally invested, a
place that displaces me to the point of no longer being
myself except in this displacement. My dis-place.
C Marker

TRANS presents a selection of films and videos
that unsettle our relationship to country and to
our identity as individuals in a society. TRANS
looks in the fringes for those ailments and
occasional pleasures caused by different kinds
of exile – forced or voluntary. Physical exile: that
of political exiles, refugees, expatriots by
choice, immigrants, or 'wanderers' . . . Mental
exile: that of the insane, the alienated, the
depressed, the marginalised, the oblivious, the
creative . . . Confinement, separation, and
solitude. Like the novel, film and video are forms
of 'transcendental homelessness'.
 The choice of works is totally subjective,

Solitude of History
The dream of a state is to exist alone, whereas the
dream of an individual is to make two.
J-L Godard History of Solitude

Heimat, wo dieser Begriff sich verschärft: in Berlin,
wenn ich Woche um Woche die Mauer sehe, von
beiden Seiten, ihr Zickzack durch die Stadt,
Stacheldraht und Beton, darauf das Zementrohr,
dessen Rundung einem Flüchtling keinen Griff bietet.
Die Wachttürme und Scheinwerferlicht auf Sand, wo
jeder verbotene Schritt sofort zu sehen ist.
Wachthunde, und hüben und drüben dasselbe Wetter
und fast noch die gleiche Sprache; die verbliebene
Heimat, die schwierige Heimat und die andere, die
keine mehr wird. *M Frisch*

The main enemy is at home. *(Lenin's wartime slogan)*

What really is an identity, if not a biography? *R Peck*

She tells the story of what she does not remember / But
remember one thing: Why she forgot to remember
R Tajiri

The homeland is found neither in the language nor in a
territory but in memory and waiting. *B Jelloun*

I am like a piece of silk / Floating in the midst of the
market, / knowing not into whose hands it will fall /
Sitting on a reed, leaning against an apricot branch /
Between the peach tree to the East and the willow to
the West / Who shall I befriend for a lifetime?
Trinh T Minh-Ha

Hope is alive when there is a boat, even a small boat.
From shore to shore small crafts are rejected and sent
back to the sea. The policy of castaways has created a
special class of refugees, the 'beach people'.
The boat is either a dream or a nightmare. Or rather,
both. A no place. 'A place without a place, that exists
by itself (and) is closed on itself, and at the same time
is given over to the infinity of the sea.
Trinh T Minh-Ha

resisting easy categorisation. Nevertheless, it
was decided to exclude 'classic' or journalistic
documentary – the form that has come to
dominate all other methods of representing
'reality' – showing a sequence of images
overlayed by commentary that tells you what to
see in those images. We have also excluded the
classic narrative fiction film, as well as the purely
experimental film.
 Many of the selected works, by rejecting the
conventional distinction between fiction and
documentary – indeed, between history and
representation – avoid the construction of an
argument, chronological sequencing, and the

demands of geographical proximity. They present places or biographical fragments and construct a different understanding of the way people live by dealing with sequences of memories, unlike those more didactic works that rely upon the rational in their attempt to explain things systematically.

These films and videos mix dream, narration, journals, and documentary footage, often to the limit of a kind of fiction that takes us beyond the border between 'us' and the 'outsiders' to the dangerous territory of not-belonging: This is the place where people were banished in primitive times, and where in the modern era immense aggregates of humanity loiter as displaced persons. Much of the exile's life is taken up with compensating for disorientating loss by creating a new world to rule . . . The exile's new world, logically enough, is unnatural and its unreality resembles fiction. (E Said, *Reflections on Exile*)

Geographical displacement, whether it is wished for or involuntary, is as old as civilisation. But this physical and cultural dislocation has expanded and accelerated to an extent that was previously unimaginable. Advanced technologies make easy the continual transmission of information and commodities to different corners of the globe. The very notion of cultural purity has become a kind of nostalgia. It is this dramatic reordering of the world and our perception of it through media that film and video deal with – as they explore the themes of migration, exile, and alienation and struggle against the obliteration of memory. As Daryl Chin has remarked, distinct cultural influences should be defined in terms of assimilation or dissonance, or rather, in terms of a 'melting pot' or a multicultural 'mosaic'. Hybridisation in film practice has continuously come up against monocultural notions of national cinema and the structures of mimetic realism.

In *Film Journal*, Mekas states that it is necessary to distinguish between two types of voyagers: those who leave of their own free will, who go to see the world, who make their voyage into a tale of experience, and those others who are the displaced persons of the 20th century, uprooted, torn from their country, and seemingly condemned to scrutinise nostalgia. The first film that he wanted to make in 1949, *Lost, lost, lost*, describes the state of mind of a displaced person who has not yet forgotten his country of birth but who has not yet 'earned' a new one. Mekas then published a number of volumes of poetry in Lithuanian. In 1971, he returned to his country to shoot what would be called *Reminiscences of a Journey to Lithuania*, 'To be an exile is to be condemned in a certain way to the surfaces of others and things. The strength of the exile is that he is going to overinvest the surface, study it infinitely, hyperdevelop his perception almost to the point of hallucinating it.' Mekas became interested in films as a stranger to himself – a different or experimental kind of underground film – a minority cinema rejected by the dominant cinemas. There is a fusion

between the experience of the exile and the experience of film.

'In a way the surface of beings already is film and film has only to do with surface, it's only about recording others: it's an art of the surface'. When Mekas reviewed his filmed journal he noticed that it contained everything that New York *didn't have*, that it was the opposite of what he originally thought he had been doing. In fact, he'd filmed his childhood, not New York. His is a fantasy New York – a fiction. His work is unique – in it his whole life has become an auto-cinegraphy, an immense proliferating text. Mekas, like many other filmmakers, has understood in his relationship to exile and to film that it is necessary to break away, to expose oneself to the outside, but at the same time to retrace one's steps, go back over one's own tracks. The movement of exile is the proverbial trip around the world.

One of Mekas' statements reminds us of numerous works by Viola: 'Film is definitely not a dream machine; rather, it's the recording of a body asleep.' Both artists have constantly researched that edenic state of film or video; desire and dream returning to an original state of the moving image, where the genres are not yet divided, with fiction film in one category, the documentary or the family film in another.

In TRANS, the tension occurs in combining fiction with documentation – both made volatile by the intersection of the political with the everyday personal and the situating of the image at that intersection. Film and video makers such as Hahn, Tarkovsky, Marker, or Bender made the effort to construct a different kind of story, another framework for time, space, social intercourse, language. They may also imagine that this will be possible some time, some place, in the future. The future becomes a richly imaginative site for speculation, for otherness, which puts you in the realm of 'science fiction'. (Leslie Thornton's letter to Trinh Minh-Ha)

Like Tajiri's *History and Memory*, Marker's *Sans Soleil* mingles personal history with the history of the world at a certain moment in time. His treatment of sound and image make the process a visionary one. Marker specifically deals with two 'extreme poles of survival', Japan and Africa, and creates a lengthy meditation on space, time, memory and forgetting. 'One doesn't remember, one rewrites memory as one rewrites history. How does one remember thirst?' 'Four thousand and one, the epoch during which the human brain reaches the stage of full employment. Everything will work perfectly, everything that now lies dormant, including memory. The logical consequence: total memory recall is total anaesthesia. After many stories of men who have lost their memory, here is one of a man who has forgotten how to forget . . .'

In the book *Le Depays*, Chris Marker, speaking of a Japan that can conceal another, writes that the materialist civilisation of Japan is

perhaps obsessed with the spirit in the same way as Christian civilisation was with the flesh. He remembers a proposition that a certain fanatic enunciated during that legendary time of Mao Tse Tung thinking. Its pataphysical depth has never ceased to amaze him: it was a matter of a famous battle between two lines, and 'the *characteristic* of one was to make itself pass for the other'.

Including in this programme such films and videos as those by Marker, Dindo, Rocha, Erice, Varda, Hahn, Viola, Hill, Depardon, and Faber questions in a very different way the notion of country and freedom, of territory and identify than do the films or videos by Cozarinsky, Downey, Trinh T Minh, Hatoum, Tajiri, Tanaka . . . which were nourished by the experience of exile and separation. It seemed to us particularly interesting to put the voices of those who have never been forced to move or to live in direct censure, but who suffer, or rather, are 'smothered' by a hypocritical democracy, side by side with the voices of those who have been exiled by force. Asking Raul Ruiz to make a selection of films also responds to this desire for a bipolar vision (see page 86). The works presented by TRANS are at the edges of several shifting categories, stretched to the limits, in a space between history and memory.

I remember the sentence 'I am not Stiller' repeated endlessly in Stiller's notes when he was in prison; it is through the words of this identityless character with no specific origins, who was arrested at the Swiss border holding American papers, but 'accused' of being a Swiss sculptor, an old fighter of the International Brigades who fought Franco and disappeared . . . that Frisch, in 1954, came to terms with his own country:

'My lawyer is wrong; I don't hate the Swiss, but their penchant for lying. That is the fundamental difference, even if, in the long run, it comes back to the same thing. In so much as I am a prisoner, it is possible that I am particularly sensitive to their slogans about freedom. But what the devil are they doing then with this legendary freedom? As soon as it risks costing them dearly, they show that they're as conservative as any German. Besides, who could permit himself to have a wife and children, a family and all that it entails, as it should be, and at the same time have freedom of opinion about anything other than unimportant details? For that, you need money, so much money that there's no need for orders, customers, or society's good will. But anybody who has so much money that he can really allow himself perfect freedom from opinion is, at any rate, satisfied with the current state of affairs. Which means? It means that even in this country it's money that makes the law. Then where is their glorious freedom hiding – the one they stick behind their mirror like a laurel branch? Where in day-to-day reality is it hiding? It's possible that the kind of freedom they claim

Continued page 92

TONY FRETTON
THE VIDEO INSTALLATION

The installation is situated in the ground floor of the CWS warehouse on the quayside of the River Tyne. The structure of the building is particularly interesting because it is of reinforced concrete of unusual design, and is an early example of that form of construction.

All of the buildings which surrounded the warehouse have been demolished to make way for the construction of an extensive commercial development. Visitors to the installation will cross the construction works to reach the warehouse.

The windows in the ground floor exist in only part of one elevation, so that a quarter of the floor space is brightly lit, and the remainder is dark. In the layout of the installation, visitors enter the light area, locate themselves and then walk into the increasing darkness to see the work.

Within the rationalised and systematic space of the interior are places that the designer of the warehouse had not willed or recognised and which are direct and natural. The space of the loading bay, which is clearly part of the system, was unpredictably altered by the ground works preceding the development which raised the level of the quayside outside. The specific works of video are positioned in these places.

A projection video that runs for a long time is placed in the loading bay. The sound-track is delivered close to the audience from small speakers, and the projected image is very large so that the audience seated close to the screen will be engrossed, but the work can also be casually sampled at a distance from the entrance bridge.

For short videos or a single ambient video, four monitors are arranged so that people will stand together facing in different directions.

The medium length video programme is provided with seating which has the quality of an arena, but at the scale of an armchair where the audience can both focus on the work and be aware of itself.

Between the locations a video is projected on to the wall of the building and the small seated audience becomes part of the work.

The installation provides a range of ways to become engaged with video, from sampling to deep absorption, and offers them in ways that may be already understood through seeing a TV behind a bar, a closed circuit TV monitor, or a home video.

The layout is not sequential and can be entered or left from a number of points. As in a city, visitors can become side-tracked, recover their direction and make their own sense of the place in which they find themselves.

At the entrance, the roller shutter opening is filled with a hoarding within which is a sound control lobby. This is as innocently constructed and diagrammatically purposeful as the construction hoardings. In being accurately sized for its function and to fulfil the regulations it is a body sized space between the larger scale of the outside and inside.

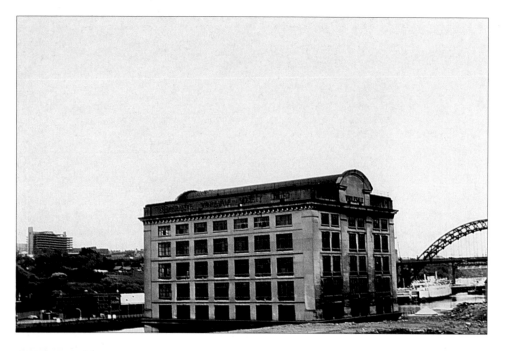

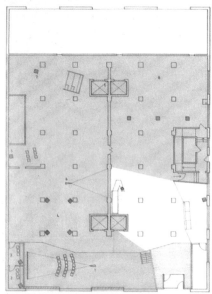 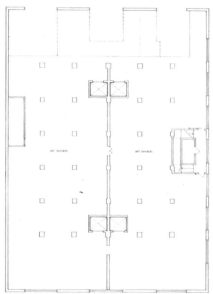

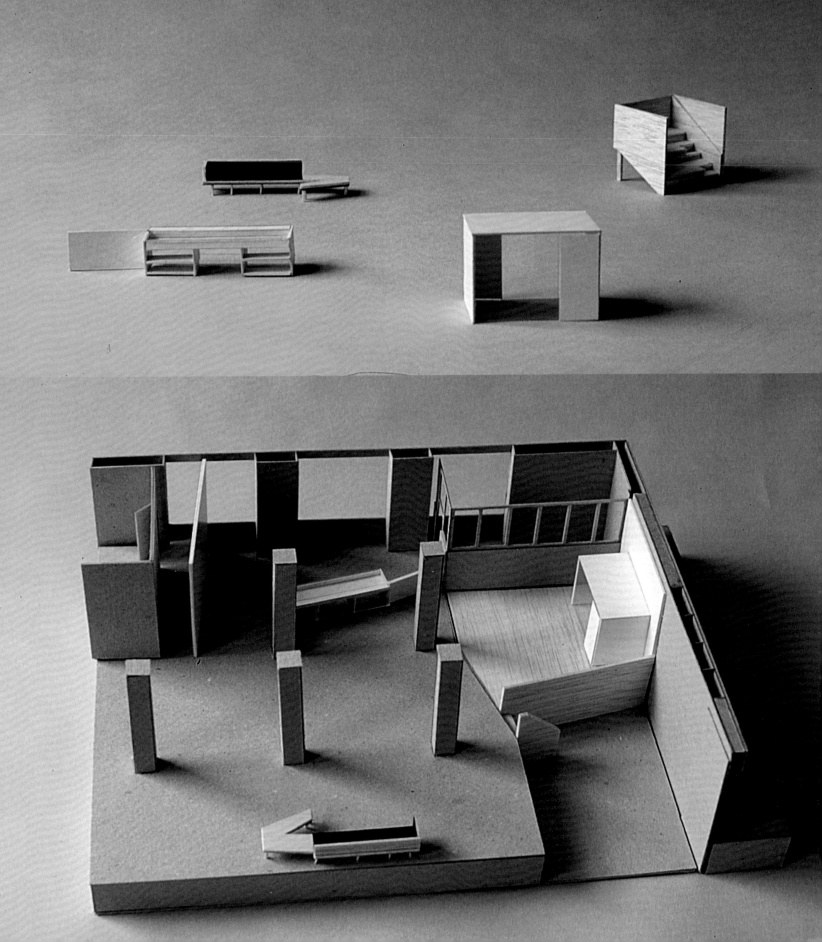

TRANS: FILM AND VIDEO PROGRAMME

Continued from page 88

to possess here cannot exist; it exists only in the degree of lack of freedom, and I willingly admit that, comparatively, they have a fairly mitigated form of non-freedom here. They won't shoot me . . . I am truly grateful to them for this, of course, but that doesn't oblige me to like their penchant for lying. I am fully aware that they call it something else, the most dangerous kind of lie, the kind that is presented with a flag and pretends to be sacred and invisible; calling it love of country . . . They'll never take the risk of putting it in question. Isn't this the sign of a total lack of freedom of mind? They can easily conceive of the eventual disappearance of France and Great Britain; but not Switzerland. God, unless he became Communist, would never tolerate it, since Switzerland is innocence. I have, besides, noticed how many times my lawyer, in order to justify Switzerland makes references to Russian misdoings, not to those of Hitler, of course, since as a Swiss he feels proud of the concentration camps existing elsewhere; but how does he hope to use such a thing in favour of this country? Some day I risk saying: 'you were lucky, Counsellor, that Hitler threatened your sovereignty and therefore your trade; thanks to that your evolution to fascism wasn't possible. But all the same, you don't seriously believe that the Swiss would be the only citizens in the world to feel no attraction to fascism if, instead of threatening their trade, it had caused a boom? Proof of this will come along some day, dear Counsellor, I'll be curious to see what happens . . .'

'And their fear, of life, their fear of dying without life insurance, their multidirectional fear, their fear of seeing the world transformed, their almost panicked fear of the intellectual adventure . . .'

This speech could almost be that of a European citizen after the Gulf War . . .

I still think of the words of another Swiss resident, Godard, his response to Daney concerning the lack of news on television about the state of the world, the provincial point of view of television in comparison to what that of film used to be: 'For me, this became clearer when I noticed, after a certain number of years, that they hadn't shown the concentration camps. That they had talked about them, generally, but not shown them. I became interested, undoubtedly, because of what you were saying, because of my guilt, my social class, etc. But the camps, they were the first thing that should have been shown, the same way Marey showed how man walks with his chronophotographic gun, or something like that. They didn't want to see them. And that's where it stopped and I thought, the Nouvelle Vague wasn't a beginning but an end.' For Godard, cinema disappeared at that moment. It disappeared because it had foretold the camps. Chaplin, who was a unique case, whom everyone believed when he made *The Great Dictator*, wasn't believed either. When Lubitsch dared to say, 'So they call me Concen-

tration Camp Ehrhardt,' people said: 'What are you talking about?' That's when Godard as a filmmaker told himself he was in occupied territory. He was in the Resistance.

'But television became a whole other thing. I believe the cardinal points have been lost. Film had done East and West, from Moscow to Hollywood, with Central Europe in between (because that's where film comes from, only from there). There's a great — like this. Film is made to spread out, to flatten . . . And then there's something else: its direction, which is to say, its cardinal points. Now, television falls back on East-West, and doesn't go North-South; yet it was up to television to do North-South. That was what film couldn't do, hadn't to do'.

Dindo, like Godard, has never stopped exploring through the continuum of years the memory of the world, our memory, and also speaks about resistance: 'The Americanisation of the world and of Europe in particular signifies the total standardisation of thought and the utter commercialisation of everyday life. And this new kind of totalitarianism is passed on by the media, which functions as a Trojan horse in this process that has global and historical dimensions . . . We are at war. It is a commercial and cultural war taking place in and through the media. Now in war, you're either a collaborator or a resistor. . .' For Dindo, to resist America through the media would mean to oppose it with your memory, because this is what America hates. It lives eternity in an instant, out of all duration, without any notion of time. Dindo opposes an actual philosophy of memory, which recalls in many respects the works of Minh-ha, Erice, and Peck. As politics have ceased to exist for Dindo, the only territory left or where there is still something to do in Europe is culture, as an object of memory, object of resistance and object of Utopia.

As soon as one speaks of chosen exile, the exemplary filmmaker Bunuel comes of course to mind. In 1927-28 he left for Paris to return to Spain in 1932 and to leave again in 1939 for New York, Mexico, and France. He was not interested in nationality, which he considered a secondary thing, but in the mind, culture, the Spanish sensibility. As is true for a number of artists, being a foreigner serves to affirm this identity while constantly criticising it. It is a game of the multiple gaze. Almost immediately he understands that the reality of the world depends upon a correlation of forces, a correlation of violence that nothing can ever stop. There is only desire and need in a society that has established a split between desire and need. There are deviations from this, diversions almost – illnesses, neuroses, which lead to desire having to try to overcome obstacles by borrowing deviances that make it lose both its object and its need. In Bunuel, desire surges from the deprivation of need, in order gradually to become the desire for need then the need for desire. The violence of Bunuel's discourse comes from the fact that what it says no one dares say, and what it says is definitely forbid-

den by the dominant ideologies. (Conference by J Douchet). Bunuel's exile is not simply exterior, but perhaps also the expression of a true interior exile facing this fundamental desire but rejected by all of society.

The same desire can also be found in the films of Depardon, yet it is imprisoned or restrained. Confinement is a theme that haunts the works of Depardon. He films institutions. Serge Daney writes that, 'he films them as great agitated bodies of micromovements between the structural lie and the sincerity of detail. Result: shock in the way we perceive our own society, within a vision of new worlds. Inventor from day to day of his own vivid life'. In 1980, Depardon filmed *San Clemente* – the life inside an asylum that was being phased out; he follows the interactions among caretakers, patients, and families. 'The prison, lovers and the asylum, Italy and the world ought to know how to avenge your deaths. I couldn't give a fuck and I speak like the criminals . . . Full of shit . . . You and the asylum . . . Here, you'll find the crazy, the street tough, and the bum, in Italy and also at San Clemente . . .' says one of the patients with deranged lucidity.

This film exorcises Depardon's fear of confinement and his fascination with the walls he saw at Villefranche sur Saone and through his experiences in Berlin, Chad and Beirut, but he's also endlessly fascinated by the desert, a place that emanates the strongest impression of confinement, which arises from limitless spaces.

He will next make the film *Urgence*, the psychiatric Emergency Room at the Hotel Dieu in Paris, an aesthetic sounding of the problems of mental and social alienation. As in the videos of Tanaka Oursler, or Faber or the film of Loden Kazan the true insanity produced by the composition of these works is not only that of social 'emergencies', but as Guattari has noted, one that also takes aim at our 'emergency', we spectators 'mass-medially' accustomed not to want to know about anything happening not very far below the surface of our social codes. These films and videos give us access to the inner world of insanity and delinquency.

Most of the film and video makers in TRANS work with the notion of time in such a context that they resist that very notion of time that is synonymous with action. Trinh-Ha mentioned Kristeva's writing about extra-subjectivity and cosmic time, as a form of *jouissance*. This kind of 'time' inserts itself in history even as it refuses the limitations of history's time – linear time. His film takes on this pensive quality, whereby the filmic image becomes a thinking image. In this regard, the videos of Viola, Hill and Hahn are exemplary. They work on the periphery of phenomena. Time and metaphorical spaces for texts to unfold are the parameters with which Hill begins: 'Video embodies a reflexive space of difference through the simultaneous production of presence and distance . . .' As in Hill's *Incidence of Catastrophes*, Hahn's work is full of incidents where the logical path proves to be a dead end, whereas mirror incidents open up

important vistas (Alan McCluskey). Hahn, Hill, Viola are particularly interested in the dreaming state. 'One of the main differences between dream consciousness and waking consciousness is that in dreams we don't have physical barriers: everything is present in one single moment without having to go through time and space to get there. The only reason there is linearity in memory is because of the flux of language.' Organised by superimposition and transformation, the images flow together reflecting a timeless, preconscious state of awareness. Hill's and Viola's tapes bring about transformative cycles of life and death, we are 'bathed in the texture of a dream with its images of the cusp of memory in the liquid blackness' (Pia Massie). In both cases, the video makers themselves are the voyagers, and it is through their eyes that we see the different landscape – urban or wild nature and unleashed water – interspersed with episodes of unfolding dreams or nightmares. Viola has written: 'The people float on the earth, like boats on an opaque sea. The most fundamental past of America is, to begin with, that of 'the other', a separated race of dispossessed, rejected people . . .'

To conclude, I will again cite a statement of Godard: 'The greatest history is the history of film because it projects, whereas other histories reduce themselves.' And in an interview with Daney: 'Alas, my goal is like that little poem by Brecht: "I examine my project carefully, it is unrealisable".' Because it can only be done on TV, which reduces. Or it projects you, the viewer, but then you lose consciousness, you're rejected. Whereas in film the viewer was attracted. But we can make a memento of this projectable history. It's the only history that projects, and it's all we can do. But it's the greatest history and it's never been told.'
Translated by Bruce Benderson

Selected Sources

Commentaires 2, Chris Marker, 1967
Le Depays, Chris Marker, Paris, 1982
Jonas Mekas, Catalogue, Galerie Nationale du Jeu de Paume, 1992
Framer Framed, Trinh T Minh-Ha, 1992
Son + Image, Jean-Luc Godard, MOMA, 1992
Depardon/Cinema, 1993
The Hybrid State films, Exit Art, 1991
Les cinéastes en exil, conferences J Douchet, E Cozarinsky . . . 1992-93
Max Frisch, Journal I-III, Richard Dindo, 1981
Locarno film festival newsletters, A Gitai, R Dindo, 1992
SCOPE magazine no 1 1992
TRAFFIC 3, 1992
Stiller, Max Frisch 1954
Out There: Marginalisation and Contemporary Cultures, MIT, 1990

Chantal Akerman
'Letters to Home', Belgium, 1986, 104 mins
Until her death in 1963, American poet and writer Sylvia Plath exchanged no less than 696 letters with her mother. In 1984, Rose Leiman Goldemberg made a play from the correspondence. Chantal Akerman subsequently made this video which recreates the closed space of the stage – two characters in one set. It is an encounter between two voices, two monologues creating an interchange between space and time. The word is the paradoxical link which focuses and blurs the memory, and the wandering of people being always in exile. Letters held by mother and daughter are both objects of emission and reception, Akerman recording the passage of the voices and memories and fixing the painful link before death.

Ante Bozanich
'Pale of Night', USA, 1986, 6 mins
A psychodrama expressing alienation and terror of the self. Using his own apartment as metaphor for the self, Bozanich miniaturises and gives media interpretations to rituals with pets and symbolic props, to create a feeling of our increasing reduction and isolation within microcosms.

Gretchen Bender/Sandra Tait
'Volatile Memory', USA, 1989, 12 mins
Starring Cindy Sherman, this prototype cyberpunk fiction has strong overtones of William Gibson's contemporary classic novel *Neuromancer*.

Juan Downey
'The Motherland', USA, 1986, 7 mins
An ironic parable of Downey's native Chile. Returning to Santiago, he finds a society in the grips of General August Pinochet's military dictatorship. In an unsparing indictment of the economic and political reality of the dictatorship, the work offers the Prophet as sacrifice to the goose-stepping ranks of Pinochet's junta. This savage allegory, in which church and state conspire to oppress society and the individual, merges subjective and cultural, autobiographical and political.
'Return to the Motherland', USA, 1989, 27 mins
An elegy of Downey's native Chile, the tape merges a fictional narrative with video-verité documentary footage from the streets of Santiago and New York. A provocative and multi-layered work, it evokes the importance of memory – both personal and political. Ironically contrasting Pinochet's brutal violations with the studied theatrical pomp of Chilean military, Downey underscores human-rights issues that will not disappear, using both individual and political contexts of contemporary Chile.

Marcelo Expósito
'Los libros por las piedras', Spain, 1990/91, 7 mins
Based on Francisco Franco's texts, the tape draws on José Saenza de Heredia's film *Raza*, sounds of the traditional Pakistani religious canticle Mersiyet, images of World War II victims' tombstones at Maastricht cemetery and of Spanish Civil War refugees crossing the French border in 1939.

Esti
'Les fous', France, 1990, 14 mins
'Several years earlier, in a closed place, locked up, I discovered the gift of Life. The liar has become a patient amongst others. Deliriums fell back like echoes into my ears. My demons thought they were in heaven! Little pavilions placed next to one another. Surrounded by trees, lawns and flowers. You could walk on paths of white stones. The dining room, the workshops, the doctors' offices . . . 16 years later I went back to the hospital, not as patient or doctor, but with a camera. To film the mornings, noons and evenings of the lives of those who are still there.'

Mindy Faber
'Delirium', USA, 1993, 23 mins
Defiantly humorous in tone, Faber's tape reflects on her mother's personal experience with what has been categorised as a 'female hysteria'. Whilst never reducing her mother's conviction to one single explanation, *Delirium* firmly and convincingly links her mother's mental illness to the historically embattled position women hold in a patriarchal culture. The work seamlessly and evocatively layers haunting imagery and humorous iconoclasm and makes reference to everything from television episodes of *I Love Lucy* to Charcot's 19th-century photographs of female hysterics, suggesting that in many instances women's reactions of violence, anger and depression are not expressions of madness, but sane reactions to abhorrent situations.

Stephane Goel
'L'importance du Temps Passe; Oublier', USA, 1991, 4 mins
This deals with the Utopian desire to run away from one's roots and subsequent idealisation of a new space. An adaptation of a poem by the Swiss author Gustave Roud – who lived his entire life in the small village where Goel's father was a farmer – Goel's words are connected with images and impressions of his childhood as well as from his present life in New York.
'Random (Loin du Coeur)', France, 1989, 3 mins
Images of urban aggression, text and a voice describing a place dying and transparent as a dream, two music scores symbolising death and rebirth intermixed, and an old African legend are some of the elements in this video which forms an experimental account of culture clash, the distance between impressions – urbanism, violence, love – and of identity.

Alexander Hahn
'Dirt Site', USA, 1990, 15 mins 30
This takes as its starting-point a 10th-century idea that the Cosmos is a counterfeit made by Satan. The narrative is suffused with Milton's poetry as Lucifer's fall to earth and loss of divinity is described. Instead of a second heaven, mud and chaos reign, urban and rural interlaced and amalgamated into a vision not only of the earth's squalor, but also of its diversity and vitality. Hahn's tape could be called an electronic memory play staged in the labyrinth zone of the human psyche, evoking from beneath fractured and codified images of urban, technological environments a tropical and prehistoric landscape of the past, a devolution from the neo-cortex to the reptilian brain.

Mona Hatoum
'So Much I Want to Say', UK, 1985, 8 mins
The work was performed live for the Wiencouver IV event, held at Western Front, Vancouver in 1983. A series of still images unfold – one every eight seconds – revealing the close-up face of a woman which fills the screen. Two male hands repeatedly gag the woman, obscuring parts of her face, sometimes covering it completely. The sound track repeats over and over the words 'so much I want to say'.
'Measures of Distance' UK-Canada, 1988, 16 mins
Focuses on the artist's separation from her family, especially her mother whose letters from Beirut form the soundtrack. Struggles of identity and sexuality become inseparable in a narrative exploring historical and political issues against a background of exile and displacement.

Steve Hawley
'A proposition is a picture', UK, 1992, 23 mins
The male narrator sets out to look for his father, a neurologist with an interest in artificial languages. The video uses humour as a paradox to examine notions of truth and the difference between words and pictures.

Gary Hill
'Incidence of catastrophe', USA, 1987/88, 45 mins 51
Inspired by Maurice Blanchot's novel *Thomas the Obscure* and the experience of observing his child acquiring speech. In Hill's heuristic work the viewer is grounded in the activity of creating the text through a succession of evocative scenarios and motifs which detail a gradual descent into language and its labyrinth of representational configurations.

Tom Kalin

'Nation', USA, 1992, 1 min

Parodying a standard musical video, the tape starts with a montage of mouths in close-up, each saying the word 'nation'. Using sound and text over corresponding images, many different 'national' identities are presented – 'queer nationalism', 'Aryan nationalism', 'Black nationalism', etc. The work comments that even as international mass media conflates notions of distinct and separate cultures, increasingly disturbing battles are being waged over issues of national, economic and sexual identity.

Carole Ann Klonarides

'Relocations and Revisions: The Japanese-American Internment', USA, 1992, 30 mins

This video tape serves as a catalogue for an exhibition of the same name and takes an in-depth look at the art and personal histories of ten Sansai or third-generation Japanese Americans who investigate the experience of their parents. The interviews with the artists: (Kristine Yuki Aono, Matthew Fukuda, Margaret Honda, Dorothy Imagire, Tom Nakashima, Roger Shimomura, Rea Tajiri, Qris Yamashita and Bruce & Norman Yonemoto) are moving testimonials to the continuing impact of an unjust and little acknowledged period – a chapter of our history that is still in the process of being revealed.

Julio Medem

'Las seis en punta', Spain, 1987, 14 mins 30, 16mm shown in video

Ignacio, seven years old, goes to tea with his neighbour Paula who is celebrating her 30th birthday. When he hands over his present of an old wrist watch, the big hand disappears and Paula is dematerialised.

Angela Melitopulus

'Transfer', France, 1991, 12 mins

Imagery in the work derives from the Paris Metro. With much of the footage shot in low light, there is consequently a graininess throughout the tape which is unusual in video. Much of the sound and image is also slowed down, giving it a dreamy, 'other world' quality. We see people's automatic behaviour, common to any large transport system, and their faces which are blank, impersonal and unselfconscious, unaware of the camera's unblinking gaze.

Branda Miller

'LA Nickel', USA, 1983, 10 mins

The last hours of a skid-row area scheduled for demolition are seen from the lens of a surveillance camera. The viewer, almost a voyeur, is given a 'real time' sense of access to the almost primal and desperate interactions between the residents, this followed by a journey through the area's streets, culminating in a moving aural and visual climax which also indicates the dangerous presence of authoritarian rule.

Marcel Odenbach

'Dans la vision peripherique du temoins', Germany-France, 1986, 14 mins

Once again the struggle to clarify the relationship between official history on one hand and personal history on the other has to take place. Three vertical strips change the conventional video frame into slits which either show or do not. Paradoxically, both the idea of completeness and incompleteness are increased. What is it that the witness can't see? A 'costume drama' in Versailles, Odenbach running away, a conversation in costume in a park and images of architecture and daily life. A monologue in the form of a dialogue between an old and a young man, borrowed from Robert Musil. Gasps of tiredness and lechery.

Tony Oursler & Joe Gibbons

'On our own', USA, 1990, 47 mins

Oursler and Gibbons team up to address psychiatric de-institutionalisation from a comic angle. After years of being cared for, budget cut-backs force Tony, Joe and their dog Woody into the outside world.

Dan Reeves

'Sabda', USA, 1984, 15 mins

The tape, based on verse by North Indian mystical poet Kabir, sees the routines of Indian life as embodiments of Bakti philosophy. The synthesis of fluid streams of images and sound with a subtext of written poetry attempts to push through the worlds of events and appearances.

'Sombra a sombra', USA, 1988, 15 mins

Based on Peruvian Cesar Vallejo's poems, this tape is an elegy of remembrance and meditation on the architecture of abandoned places. Taped between 1983 and 1987 in deserted villages and houses in the Spanish mountains, it explores that space in the human heart which is shaped by the departure of the people and things of this world.

Su-Chen Hung

'East/West', USA, 1984, 6 mins

Using split-screen techniques, Su-Chen Hung responds to questions about US citizenship simultaneously in English and Chinese. The way she thinks over her responses forces the viewer to repress one language in order to listen to the other. Not surprisingly, one voice in the tape only frustrates the other.

Elia Suleiman & Jayce Salloum

'Muquaddimmah Li Nihaayaat Jidal', USA, 1989/90, 45 mins

The tape mimics dominant media representations of Western stereotypes of the Arab world, subverting the media's methodology and construction. A process of displacement and deconstruction is enacted, attempting to arrest the imaginary and ideological, de-colonising and recontextualising it to provide a space for a marginalised voice which is consistently denied expression in the media.

Jonathan Swain

'POW Interview', UK, 1992, 23 mins

Swain is the sole performer on this tape, which seems at first to have been transmitted on faulty equipment from a dungeon in somewhere like the Middle East. However, as he reads his text, prepared as if by his captors, it is soon apparent he is forcing us to confront our own unsatisfactory political and social situation rather than issues of a far-away war.

Rea Tajiri

'History and Memory', USA, 1991, 30 mins

This tape represents the 'search for an ever-absent image' of the artist's family during the internment of Japanese Americans in the Second World War. Skilfully interweaving interviews, memorabilia, fragments of seemingly unconnected narratives and appropriated images from official version – wartime propaganda films, archival documentary footage and Hollywood movies – the artist challenges our assumptions about the split between recorded historical document and remembrance, drawing attention to the problems of representing the past.

Janice Tanaka

'Whose gonna pay for these donuts anyway?', USA, 1992, 58 mins

About Tanaka's father, resident in a home for the chronically mentally ill, and her uncle, a successful retired businessman, both of whom suffered the inequities of disenfranchisement and indignities of internment, the tape attempts to understand concepts, as defined by convictions of the dominant culture, of right versus wrong, normal versus abnormal, rules versus people and words versus experience.

'Memories from the Department of Amnesia', USA, 1989, 13 mins

An experimental biographical video eulogising the artist's mother who was interned at Manzanar during the Second World War. It deals with her mother's death, the process of grieving, the way memory operates and the emotions it arouses. The tape enunciates the painful phases of grieving; the claustrophobic results of dealing with the inevitability of death; the traditional void

between being comfortable with one's life and nothing, a new sense of clarity where images from the past resurface from the abyss of forgetfulness. This work is an elegy to Tanaka's mother whose attempts at balance and security were constantly disrupted by social, cultural, political and personal forces beyond her control.

Luis Valdovino

'Work in Progress', USA, 1990, 14 mins

Combing documentary interviews, folk ballads, animation and movie clips, this piece examines the conditions of Mexican illegal immigrant workers and the formation of American attitudes towards those designated as 'aliens'.

Bill Viola

'Anthem', USA, 1993, 11.5 mins

A video taking as its form the religious chant – here produced by manipulating the sound of a single scream emitted by a young girl, who looks almost like an alien figure. The tape's singular soundtrack and the juxtaposition of images often startling in their own right creates a deep sense of mystery and displacement as the world we inhabit is observed. We see it once-removed and sense a spirituality that material society often suppresses.

'The Passing', USA, 1991, 56 mins

A haunting visual fugue made up of spectral, optical phenomena and impressions from the edge of consciousness. To striking effect the video spirals around a simple leitmotif – that of Viola, the restless sleeper undergoing what might be described as a 'dark night of the soul'. His unquiet slumbers are interrupted by surging, primal memories and then, when brought sharply awake, by intimations of mortality.

Bruce & Norman Yonemoto

'Green Card: An American Romance', USA, 1992, 79 mins 15

The final instalment of the Yonemoto's 'Soap Opera Series' uses the deadpan syntax of television melodrama to tell the story of Sumie, a young Japanese woman who marries an American surfer/film-maker for the Green Card which will enable her to pursue her artistic career. Falling prey to the Hollywood fantasy of romantic love, she loses her 'American dream' of independence. Casting an ironic eye on the LA lifestyle and art scene of the early 1980s, the stylised narrative asserts that the delirium of Hollywood 'reality' – the collective memory of the media – manipulates the 'truth' of our personal lives.

'Vault', USA, 1984, 11 mins 45

In this tour de force of stylised deconstruction, the Yonemotos rewrite a traditional narrative of desire: boy meets girl, boy loses girl. Employing the hyperbole and melodramatic syntax of Hollywood movies and commercial TV, they decode the Freudian symbolism and manipulative tactics which underlie media representations of romantic love and expose the power of media 'reality' to construct personal fictions.

ALSO SHOWING

Arthur Omar

'O Nervo de Prata', Brazil, 1987, 20 mins

The unexpected and paradoxical universe of Tunga's work combines and transmutes itself in the experimental cinema of Arthur Omar. In this video, the viewer is thrown into the interior of a tunnel with no beginning or end, where uncommon scenes are channelled: Xiphopags twins linked by their hair, plaits formed by snakes, thoros, etc and many other curious surprises.

Roman Signer

'Filme: 1975-1989', Switzerland, 1989, 190 mins

100 short films by Roman Signer.

ARTISTS' BIOGRAPHIES

JOHN ADAMS

Lives and works in Newcastle upon Tyne, England

Lapsed video artist. Freelance director and editor of corporate, commercial and broadcast productions. Part-time lecturer in video, Media Production BA, University of Northumbria.

VITO ACCONCI

Born 1940, New York, USA
Lives and works in New York, USA

Selected exhibitions
1993
Österreichisches Museum für Angewandte Kunst, Vienna, Austria (solo)
Barbara Gladstone Gallery, New York, USA (solo)
303 Gallery, New York, USA (solo)
Photoplay: Works from the Chase Manhattan Collection, Center for the Fine Arts, Miami, USA
Live in Your Head, Hochschule für Angewandte Kunst, Vienna, Austria
Art and Application, Turbulence, New York, USA
1992
Museo Luigi Pecci, Prato, Italy (solo)
Allocations/Art for a Natural and Artificial Environment, Zoetermeer, Netherlands
The Power of the City/The City of Power, Whitney Museum of American Art, downtown at Federal Reserve Plaza, New York, USA
Functional Objects by Artists and Architects, Rhona Hoffman Gallery, Chicago, USA
Surveillance, Nancy Drysdale Gallery, Washington DC, USA
Still, Andrea Rosen Gallery, New York, USA
Animals, Galerie Anne de Villepoix
Habeas Corpus, Stux Gallery, New York, USA
Tattoo, Andrea Rosen Gallery, New York, USA
In Through the Out Door, Nordanstad/Skarstedt Gallery, New York, USA

CHRISTINE BORLAND

Born 1965, Scotland
Lives and works in Glasgow, Scotland

Selected exhibitions
1993
Christine Borland & Craig Richardson, Chisenhale Gallery, London, England
Aperto, Venice Biennale, Italy
Fontanelle, Kunstspeicher, Potsdam, Germany
1992
Artists Show Artists, Galerie Vier, Berlin, Germany
In and Out/Back and Forth, 578 Broadway, New York, USA

Guilt by Association, Irish Museum of Modern Art, Dublin, Ireland
Love at First Sight, The Showroom, London
Contact, Transmission Gallery, Glasgow

GONZALO DIAZ

Born 1947, Santiago, Chile
Lives and works in Santiago, Chile

Selected exhibitions
1992
Entre Tropicos, Artes Contemporáneo Latinoamericano, Conac, Museo Sofia Imber, Caracas, Venezuela
Latin American Art of the XXth Century, Museum of Modern Art, New York, USA and touring to Seville, Paris and Cologne
A Palabra Gravada, X Mostra da Gravura Cidade de Curitiba, Brazil
1991
Arte Contemporáneo desde Chile, American Society, New York, USA
Imagen y Palabra de Chile, Fundación Santillana, Santillana del Mar, Cantabria, Spain
IV Bienal Internacional de la Habana, Havana, Cuba
La Declinación de los Planos, Campus Oriente, Catholic University of Chile (solo)

ORSHI DROZDIK

Born in Budapest, Hungary
Lives and works in New York, USA

Selected exhibitions
1993
Manufacturing The Self: Convent, Maubuisson Abbey, Saint-Quen l'Aumone, France (solo)
Manufacturing The Self: Medical Erotic, Galerie d'Art Contemporain, Herblay, France and Tom Cugliani Gallery, New York, USA (solo)
Boundary Rider, Sidney Biennale, Anthony Bond, Sydney, Australia
1992
Science Fiction, Mit List Visual Arts Center, Cambridge, USA
Brain; Internal Affairs – Manufacturing The Self; Brains On The Wheels, Gorinchem, Netherlands
Nature of Science, Pratt Manhattan Gallery, New York, USA and Rubelle & Norman Schaeler, Gallery
Healing, Wooster Garden, New York, USA

TONY FRETTON

Lives and works in London, England

Set up his own architectural practice in 1980 and carried out the two buildings of the Lisson Gallery in 1986 and 1990. Current work includes a group of co-operatively owned artists' studios, a product design studio in London and a gallery in Reading.
Exhibitions include *Reality and Project*, 9H Gallery in 1990 and *The Art of Process*, the Royal Institute of British Architects in 1993.

NAN GOLDIN

Born 1953, Washington DC, USA
Lives and works in New York, USA

Selected exhibitions
1993
Whitney Biennale, Whitney Museum of American Art, New York, USA
Pace/McGill Gallery, New York, USA (solo)
La Vida sin Amor no Tiene Sentido, Fundación la Caxia, Barcelona, Spain
Dress Codes, ICA, Boston, USA
Vivid: Intense Images by American Photographers, RAAB Galerie, Berlin, Germany
1992
Galerie M, Bochum, Germany (solo)
DAAD Galerie, Berlin, Germany (solo)
Obsessions, Orangerie, Munich, Germany (solo)
Separate Lives, Kunstwerke, Berlin, Germany (solo)
PPS Galerie, Berlin, Germany (solo)
Galerie Stelling, Leiden, Netherlands (solo)
New Visions in Photography, Whitney Museum of American Art, New York, USA
Desordres, Galerie Nationale du Jeu de Paume, Paris, France
Fotoforum, Bremen, Germany
Wewerka + Weiss Galerie, Berlin
Gitanes, Hotel de la Villette, Paris, France
Voyeurism, Jayne H Baum Gallery, New York, USA
Photography as Theater, Fourth Wall Foundation, Amsterdam, Netherlands
The Sexual Self, Tanja Grunert, Cologne, Germany
AIDS Show, Kunstverein, Hamburg, Germany and Kunstmuseum, Luzerne, Switzerland

RODNEY GRAHAM

Born 1949, Vancouver, Canada
Lives and works in Vancouver

Selected exhibitions
1993
Galerie Micheline Szwajcer, Antwerp, Belgium (solo)
Canada, une nouvelle génération, Musée Municipal, La Roche-sur-Yon, France
Binaera; 14 Interaktionen – Kunst und Technologie, Kunsthalle, Vienna, Austria
1992
Rodney Graham et Ken Lum, Galerie Nelson, Lyon, France
Camera Indiscretes, Centre d'Art Santa Monica, Barcelona, Spain
Art by Numbers, Angles Gallery, Santa Monica, Barcelona, Spain
Los ultimos dias, Galeria del Arenal, Seville, Spain
Documenta IX, Kassel, Germany
Stars Don't Stand Still in the Sky – Hommage a Stéphane Mallarmé, Kunstmuseum Winterthur, Switzerland
The Binary Era: New Interactions, Musée Communal d'Ixelles and touring to Vienna and Japan

BIOGRAPHIES

SHIRAZEH HOUSHIARY
Born 1955, Shiraz, Iran
Lives and works in London, England

Selected exhibitions
1993
Camden Arts Centre, London, England (solo)
University of Amherst, Massachusetts, USA and touring USA and Canada (solo)
Venice Biennale, Italy
Lisbon Biennale, Portugal
1992
Galeria Valentina Moncada, Rome, Italy (solo)
Istmus, Lisson Gallery, London, England (solo)
Rhizome, Haags Gemeentemuseum, The Hague, Netherlands

WENDY KIRKUP
Born 1961, Hong Kong
Lives and works in Newcastle upon Tyne, England

Selected exhibitions
1993
Intervening Spaces, Darlington Arts Centre, England (collaboration with Pat Naldi)
1991
0836-785555, 15 Framlington Place, Newcastle upon Tyne, England (collaboration with Pat Naldi)

CILDO MEIRELES
Born 1948, Rio de Janeiro, Brazil
Lives and works in Rio de Janeiro, Brazil

Selected exhibitions
1993
Latin American Art of the XXth Century, Museum of Modern Art, New York, USA and touring to Seville, Paris and Cologne
Body to Earth, Fisher Gallery, University of Southern California, Los Angeles, USA
De la Main a la Tête, l'object Theorique, Centre d'Art, Kerguehennec, France
1992
America Bride of the Sun, Royal Museum of Fine Arts, Antwerp, Belgium
Pour la Suite du Monde, Musée d'Art Contemporaine, Montréal, Canada
Documenta IX, Kassel, Germany
Galeria Luisa Strina, São Paulo, Brazil (solo)
Encounters/Displacements, Luis Camnitzer, Alfredo Jaar, Cildo Meireles, Archer M Hunter Art Gallery, Austin, USA

PAT NALDI
Born 1964, Gibraltar
Lives and works in Newcastle upon Tyne, England

Selected exhibitions
1993
Intervening Spaces, Darlington Arts Centre, England (collaboration with Wendy Kirkup)
1991
0836-785555, 15 Framlington Place, Newcastle upon Tyne, England (collaboration with Wendy Kirkup)

readymades belong to everyone®
Founded in 1987, New York, subsidiary opened in Paris, France, 1988

Selected exhibitions
1993
Autoportraits Contemporains – Here's looking at me, Claire Burrus exhibition, ELAC, Lyon, France
Backstage, Readymades belong to everyone, Kunstverein, Hamburg, Germany
1992
Werbung, Werbung, Georges Verney-Carron, Meta 1, Künstlerhaus, Stuttgart, Germany
Un Cabinet d'Amateur, Künstlerhaus, Stuttgart, Germany
Scusate, ma non abbiamo potuto aspettarvi, Daniella Betta, Bruna Girodengo, Tulio Leggeri, Giancarlo Politi, Galleria Massimo Minini, Brescia, Italy
Jean Brolly, Alain Clairet, La Caisse des dépôts et consignations, *Documenta IX*, Kassel, Germany
Une seconde pensée du paysage, Marc Blondeau exhibition, Domaine de Kerguehennec, France
Übergänge, Eva Felten, Ingvild Goetz, Stephan Goetz, Werner Lippert, Arendt Oetker, Alexandra Tacke, Joseph Zander, Kunstraum, Munich, Germany
München, hin und zurück, Christopher Sattler, Edition du Kunstraum, Munich, Germany

SAM SAMORE
Lives and works in New York, USA and Europe

AMIKAM TOREN
Born 1945, Israel
Lives and works in London, England

Selected exhibitions
1993
Gallery HAM, Nagoya, Japan (solo)
Moving into View, Royal Festival Hall, London, England and touring
1992
And What Do You Represent? Anthony Reynolds Gallery, London, England
With Attitude, Galerie Guy Ledune, Brussels, Belgium
15/1, Melania Basarab, London, Engalnd
Surface Values, Kettle's Yard, Cambridge, England

TUNGA
Born 1952, Palmares, Brazil
Lives and works in Rio de Janeiro, Brazil

Selected exhibitions
1993
Fisher Gallery, University of Southern California, Los Angeles, USA
Latin American Art of the XXth Century, Museum of Modern Art, New York, USA and touring to Seville, Paris and Cologne
1992
Six Brazilian Sculptors, Galeria RBI, Rio de Janeiro, Brazil
Museu Nacional de Belas Artes, Rio de Janeiro, Brazil
Sero te Amavi, Galeria Saramenha, Rio de Janeiro, Brazil and Galeria André Millan. São Paulo, Brazil (solo)
Arte Amazônia, Museu de Arte Moderna do Rio de Janeiro, Brazil
Désordres, Galerie Nationale du Jeu de Paume, Paris, France
Antigas Minúcias, Galerie Lê & Marilia Razuk, São Paulo, Brazil (solo)
Klima Global, Staatliche Kunsthalle, Berlin, Germany

RÉMY ZAUGG
Born 1943, Jura
Lives and works in Switzerland

Selected exhibitions
1993
Reflexionen auf und über ein Blatt Papier, Barbara Gross Galerie, Munich, Germany (solo)
Jemand, Westphälisches Landesmuseum, Munich, Germany (solo)
Schau, was du siehst, Galerie Sima, Nürnberg, Germany
DRAUSSEN, ein Bild im Werden, Gesellschaft für Aktuelle Kunst, Bremen, Germany (solo)
Autoportraits Contemporains – Here's looking at me, ELAC, Lyon, France
Expositions, Sous-sol, Ecole Supérieure d'Art Visuel, Geneva, Switzerland and Université de Rennes, Haute Bretagne
1992
Kunstverein, Hamburg, Germany (solo)
Ein Blatt Papier, Mai 36 Galerie, Zürich, Switzerland (solo)
Reflexions sur et d'une feuille de papier, Musée Rath, Geneva, Switzerland (solo)
Wiener Secession (solo)
Frammenti, interface, intervalli, Museo d'arte contemporanea, Villa Croce, Geneva, Switzerland
Block's Samling, Statens Museum for Kunst, Copenhagen, Denmark
Une forme, une surface, un volume, Galerie Gisele Linder, Basel, Switzerland
Word and Image, Brook Alexander Editions, New York, USA
Génériques, le visuel et l'écrit, Hôtel des Arts, Fondation Nationale des Arts, Paris, France
Repeticion/Transformación, Museo Nacionale Centro de Arte Reina Sofia, Madrid, Spain
Das offene Bild, Aspekte der Moderne in Europa nach 1945, Westphälisches Landesmuseum, Munich, Germany
Über Malerei – Begegnung mit der Geschichte – Kurator: Rene Block, Akademie der Bildenden Künste, Vienna, Austria
More Light, Galerie Chantal Crousel, Paris, France